Lab Coats in Hollywood

Lab Coats in Hollywood

Science, Scientists, and Cinema

David A. Kirby

The MIT Press
Cambridge, Massachusetts
London, England

For information about special quantity discounts, please email special_sales @mitpress.mit.edu

This book was set in Stone Sans and Stone Serif by Toppan Best-set Premedia Limited. Printed and bound in the United States of America.

Library of Congress Cataloging-in-Publication Data

Kirby, David A.
Lab coats in Hollywood : science, scientists, and cinema / David A. Kirby.
 p. cm.
Includes bibliographical references and index.
ISBN 978-0-262-01478-6 (hardcover : alk. paper) 1. Science in motion pictures.
2. Scientists in motion pictures. I. Title.
PN1995.9.S265K57 2011
791.43'66—dc22

 2010011961

10 9 8 7 6 5 4 3 2 1

To Laura. A true bean.

Contents

Acknowledgments

The transition from bench scientist to humanistic researcher was not easy. The difficulty was not adapting to a new research style—empirical research is empirical research whether evidence comes from a DNA sequencing gel or a film. The challenge was convincing other academics that such a conversion was worthwhile. There were, however, many people who made this road an easier one to travel from the time I left my tenure-track job in American University's biology department to undertake a National Science Foundation-funded postdoctoral retraining fellowship in Cornell University's department of science and technology studies (STS).

Wolfgang Stephan, my PhD advisor at the University of Maryland, was not initially happy to see me leave the field of molecular evolution, but he supported my decision, knowing that good research only comes from a passion for the subject. I am grateful that my postdoctoral sponsor at Cornell, Bruce Lewenstein, encouraged me that this project was worth pursuing and has continued to support my endeavors. I also want to thank Mike Lynch from the STS department for his helpful advice over the years. My brief year teaching in Duke University's Center for Teaching, Learning, and Writing helped sharpen my own writing skills considerably.

I have also appreciated the support of colleagues in the Centre for the History of Science, Technology, and Medicine (CHSTM) at the University of Manchester, including support from the Centre's head, Mick Worboys. I want to thank Jeff Hughes and James Sumner from CHSTM, in particular, for providing useful comments on the manuscript. I have also spent many hours in the pub discussing science in movies with my student Ray Macauley, whose thoughts were always welcome.

I need to recognize all the scientists and filmmakers who spent hours speaking with me, sharing their excitement for the subject of movie

science. My thanks also go to Margy Avery of the MIT Press for the enthusiasm she has shown for this project.

A version of chapter 9 was published previously as an article in *Social Studies of Science* 40, no. 1 (2010). The following archives were used in the research for this book: Robert A. and Virginia Heinlein Archives, University of California, Santa Cruz, Special Collections; George Pal Papers, University of California, Los Angeles, Arts Library Special Collections; Samuel Herrick Collection, Archives of American Aerospace Exploration, Virginia Polytechnic Institute and State University (Virginia Tech), Blacksburg, VA; Warner Brothers Pictures Archive, University of Southern California, Los Angeles; Willy Ley Papers, Smithsonian Institution Archives, Washington, DC; and the Eric Burgess Papers, Manchester, UK.

I want to recognize all the cats in my life whose purring kept me calm while writing and editing. Finally, I need to thank my family for their constant support and encouragement. I have them to thank for a love of cinema whether it was the family trip to see *Star Wars* in 1977 with my father Robert, discussing Woody Allen films with my mother Susan, or watching *Son of Svengoolie* on Saturday afternoons in Chicago with my brothers Bob and Randy. Most importantly I owe an enormous debt of gratitude to my wife Laura Gaither who has looked at versions of this book more times than one would think humanly possible. It is correct to say that the book could not have happened without her and her influence on the book's ideas cannot be measured.

Preface

In 1992 Michael Braverman, executive producer of the pioneering television program *Life Goes On* (1989–1993), convened an unusual meeting bringing together the writers, director, and actors, as well as science consultant Wayne Grody of UCLA's School of Medicine and HIV/AIDS consultant Rod Garcia, an HIV-positive activist.[1] The meeting's subject was the storyline for HIV-positive character Jesse McKenna.[2] Garcia recommended that Jesse forego the standard treatment of antiretroviral pills in favor of alternative therapies such as acupuncture and a macrobiotic diet. Grody could sense as Garcia made his recommendation that he was the only person in the room who did not approve of Garcia's proposal.

From a narrative point of view Garcia's suggestion was reasonable. Many AIDS patients were trying options outside of mainstream medicine, so it would not have been an unrealistic option for this fictional character. From Grody's scientific perspective, however, he knew that Garcia's proposed storyline would have real-world ramifications for HIV/AIDS research. This meeting took place just as the Federal Drug Administration had approved the use of "cocktail" therapies combining the first antiretroviral drug AZT with other antiretroviral therapies such as ddC. The only means by which scientists could determine these cocktails' efficacy, however, was to run large double-blind clinical trials that required a significant number of volunteers.

Grody's argument for keeping the fictional Jesse on his medicine was not about maintaining scientific "realism." He had no evidence that the new antiretroviral cocktails would be any more effective than Garcia's macrobiotic diet, but he knew that scientists needed the opportunity to find out. As the first HIV-positive recurring character on television, Jesse was an icon in the AIDS community whose members closely monitored

his depiction. If Jesse ceased taking his medicine his actions would have influenced thousands of real-world AIDS patients to do the same,[3] which, in turn, would have drastically reduced the number of volunteers available for the clinical studies needed to establish the cocktail therapies' efficacy.

Grody appreciated the value of Garcia's presence within the production since he could speak personally to actors and writers about his experiences living with a disease that, at that time, was a certain death sentence. But Garcia was not a scientist. He was approaching the question from a different frame of reference. For him, drugs failed while a macrobiotic diet seemed to work. In the end, the television producers put their trust in the expertise of their science consultant and Jesse continued taking his antiretroviral medicine.

HIV/AIDS researchers did not know that Wayne Grody was working as a science consultant on *Life Goes On*. Yet, his presence in that meeting saved them from a potential public relations disaster. In fact, very few people ever knew that a single scientist was able to significantly influence the depiction of AIDS therapy in this groundbreaking television show. This is because, as a science consultant, Grody's decision making and his negotiations with entertainment professionals including writers, actors, special-effects technicians, prop masters, directors, and producers all took place behind the scenes. Television and film productions are complicated processes where multiple participants have competing agendas for science. Given these conditions, contributions by scientists to the production of entertainment texts such as movies and TV shows are not often recognized outside of Hollywood. Yet, Grody's successful battle to ensure that a fictional character continued taking his antiretroviral medicine illustrates the substantial influence that science consultants can have on the depiction of science, technology, and medicine in entertainment products.

This book is an attempt to uncover science consultants' backstage role in entertainment production. It is also about the reciprocal relationship of how fictional texts in turn impact real-world science. A growing belief within the entertainment industry that scientific verisimilitude translates into bigger box office receipts and higher television ratings has led to an ever-increasing reliance on science consultants to examine scripts, participate in preproduction meetings, and serve as on-set advisors. It would be

rare indeed to find a contemporary science-based television or film production that lacked a science consultant in some capacity.

One point of clarification concerns the term *science consultant*. There are two distinct categories of science consultants for the entertainment industry. One category, also referred to as technical consultants, involves scientists who consult on the development of new cinematic and televisual technologies whether they are mechanical or digital, hardware or software. My concern is not with technical consultants; the focus of my study is not on scientists whose advice shapes the technology itself, but rather on the second category of science consultants, whose advice shapes the narrative and visual content of specific cinematic texts. These consultants are brought in to comment on scientific matters involving the script, the actors, the sets, the props, and any other relevant factor during production.

Previous research on science in entertainment media tends to treat media texts as discrete entities (content) that are isolated from the act of production (process).[4] It is always important to keep in mind that the content of media texts is determined entirely by choices made during production. Audiences may interpret episodes of *Life Goes On* in a wide variety of ways, but the texts from which they are drawing meanings would have been radically different without the presence of scientist Wayne Grody on the production staff. When a high-profile film like *Deep Impact* (1998) or *The Day After Tomorrow* (2004) makes an obvious intrusion into scientific culture we cannot attribute their influence to a disembodied "movie." These texts are the sum total of filmmaking and consulting decisions made during production and we need to acknowledge the agency of those who made these decisions. Therefore, I want to move beyond approaches based on close textual analysis and cultural analyses in order to explore entertainment media as vehicles of communication.

The ascent of the expert throughout the twentieth century has paralleled the commodification of knowledge in our society. This growing valuation of expertise has led to increasing collaborations between two communities whose objectives seem to be at odds: the entertainment industry and the scientific community. The recent influx of scientists into Hollywood provides an opportunity to examine science's role in entertainment products. By examining science consultants' impact on

entertainment media this book addresses salient questions in science studies concerning the production and dissemination of scientific knowledge, the deconstruction of expertise as a concept for both scientists and filmmakers, and the relationships linking media, science, and society. To get at these issues the book will examine cinematic depictions of science across three areas: scientists and the practice of science, scientific knowledge and plausibility, and the relationship between science/scientists and other elements of society.

1 Scientific Expertise in Hollywood: The Interactions between Scientific and Entertainment Cultures

Space may be the final frontier but it's made in a Hollywood basement.
—Red Hot Chili Peppers, "Californication," 1999

In 2009 the National Aeronautics and Space Administration (NASA) hired Hollywood filmmakers to digitally enhance footage of the *Apollo 11* Moon landings for the Apollo program's fortieth anniversary.[1] NASA had taped over the original video footage and alternative footage was grainy. To clean up the images NASA employed Lowry Digital, which had previously remastered copies of *Citizen Kane* (1941) and *Casablanca* (1942). Of course, the filmmakers' collaboration played into the claims of those who consider the Moon landing itself to be a hoax. This vocal minority believes that the pinnacle of humanity's scientific achievement *was* made in a Hollywood basement.

More accurately, many hoax proponents think that director Stanley Kubrick created the footage of Neil Armstrong and Buzz Aldrin walking on the Moon in Shepperton Studios of Surrey, England. Kubrick's vision of space travel in *2001: A Space Odyssey* (1968) was so impressive and the visuals were so realistic that hoax supporters have claimed that the film was the means by which NASA tested the cinematic techniques for creating the hoax films. Alternatively, they argue that NASA only lent its assistance in making *2001* to coerce Kubrick into staging the Moon landings on the same sets.[2] The televised images coming from the Moon bore too much resemblance to media images that the hoax supporters had previously seen in Kubrick's film and in other realistic space movies like *Destination Moon* (1950) and *Conquest of Space* (1955). *2001* can easily be called the most scientifically accurate film ever made for its time. Kubrick's film *felt* authentic and the scientific authenticity of this fictional text made it

easy to see how some people believed filmmakers could fake the Moon landings.

Kubrick used cinematic language in *2001* as a means to explore complex ideas about the relationship between humanity and technology as well as humanity's place in the universe. For Kubrick, explorations of complex ideas did not emerge through simplification. Instead, they came about by displaying *every* detail of these complexities. Scientific verisimilitude was crucial for Kubrick not only in creating a visually rich film but also in putting the complexity of his questions into science, technology, and meaning on display. Kubrick's attention to detail was legendary, so it is not surprising that he went to great lengths to imbue his film with as much scientific accuracy as possible.

Influenced by both Italian neorealist films of the 1940s and the experimental style of the French New Wave movement of the 1960s, Kubrick's goal for *2001* was the transformation of science fiction movies from juvenile adventure stories into a medium of intellectual exploration comparable to science fiction literature.[3] To this end, the filmmaker hired former NASA space scientist Frederick Ordway as his primary science consultant to work on the film for almost three years (figure 1.1).

Ordway had founded an aerospace consultancy and thus had contacts with every major organization working on rocket development. A glance at the list of organizations contributing scientific and technical advice for *2001* dwarfs such input for any other film before or since. With Ordway's assistance the production staff consulted with over sixty-five private companies, government agencies, university groups, and research institutions.[4] In addition, Kubrick hired Ordway's business partner, aerospace engineer Harry Lange, as a production designer. Lange had previously worked for NASA illustrating advanced space vehicle concepts including propulsion systems, radar navigation, and docking techniques. Piers Bizony describes Lange's job at NASA as visualizing "as-yet-unborn vehicle concepts, so that NASA and its associated army of corporate collaborators could communicate their ideas for the future."[5] Essentially, Kubrick was asking Lange to do the same for his film.

Kubrick needed assistance in planning how to portray on film events that were not even remotely in the near future. A manned trip to the Moon was right around the corner, certainly, but Moon bases were not on the agenda in the 1960s, nor were orbiting space stations and manned trips to

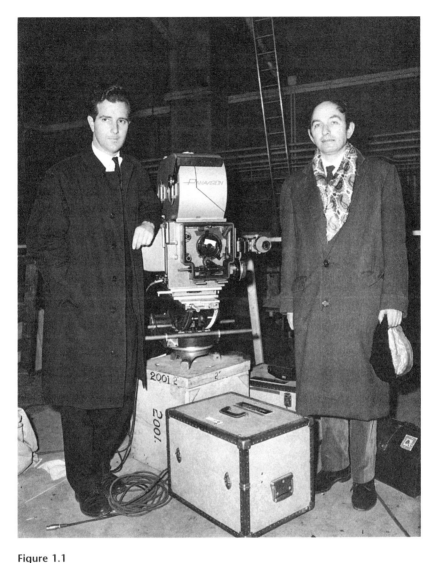

Figure 1.1
This production photo shows *2001*'s primary consultant Frederick Ordway (left) next to statistician I. J. Good who provided Stanley Kubrick advice on supercomputers.
Source: I. J. Good Collection (VTA0002), Digital Library and Archives, University Libraries, Virginia Tech.

Jupiter. In order to speculate on future space missions Ordway and Lange not only had to come up with suitable technology based on current thinking in the space sciences, but also had to provide logical explanations for why this technology would exist, how it would fit into *2001*'s narrative, and how it would impact the film's visuals. Ordway had to use his experience within the space science industry—whose experts were just beginning to work out these details for themselves—to extrapolate from current trends to future realities. So, for example, the "Cavradyne engines" used for *2001*'s spaceships were based on an assumption that continuing advances in gaseous-core nuclear reactors and high-temperature ionized gases in the 1960s would make this technology feasible by the 1990s.[6] In this way, Ordway, Lange, and Kubrick developed comprehensive background information for the spaceships, space stations, and manned missions that was logical and narratively integrated.

Although we most often associate *2001* with its groundbreaking displays of space and space travel, we forget that the film actually begins with the "Dawn of Man." Therefore, Kubrick also required scientific advice about the nature of early hominids. To get this advice Ordway brought in the famous anthropological father-and-son team of Louis and Richard Leakey.[7] Kubrick and Arthur C. Clarke, the screenplay's coauthor, also spoke with anthropologists about using anthropology to underscore one of the film's major themes concerning human evolution. Because Kubrick wanted the hominids' encounter with the alien black obelisk artifact to transform his hominid characters from vegetarians into omnivores, Clarke visited anthropologists Harry Shapiro and Ike Asimov to determine if such a biochemical change was possible in so short a time as a couple of weeks.[8] Ordway also helped Kubrick work out a logical explanation for the film's one truly fantastical element: the alien black obelisk.

Kubrick was balancing a desire for scientific verisimilitude and a need for plausibility with his artistic and technical judgments as to the viability of incorporating science: "I think there were two problems in the design of anything. One was, is there anything about it that would be logically inconsistent with what people felt would actually exist; and the other one was, would it be interesting? Would it look nice?"[9] Kubrick faced a series of choices. For example, should he incorporate a shiny, silver "look" for the interiors of his spacecraft because it was visually interesting and because audiences expected this depiction given the conventions of previous space

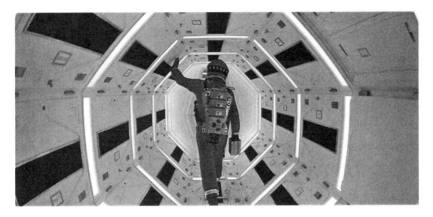

Figure 1.2
Kubrick employed a white, ceramic look inside the spacecraft designed for *2001*.

films? Or should he work with the white ceramic look that NASA acknowledged it was using for its real-world designs (figure 1.2)?[10] Should Kubrick ignore, as most filmmakers have done, the accepted fact that any long-term space voyage requires some means to generate artificial gravity? Or should he pay the Vickers Engineering Group $750,000 to spend six months building an actual working centrifuge (figure 1.3)?[11] On the one hand, Kubrick's obsessive pursuit of scientific authenticity in the face of the same filmmaking constraints found in every film production (budget, aesthetics, dramatic needs, filmability, technical capacity) is what separates *2001* from other films. With both the ship's interiors and the gravity wheel (as shown in figures 1.2 and 1.3, respectively) Kubrick decided that authenticity was worth overcoming these constraints.

On the other hand, even the detail-oriented Kubrick had to sacrifice scientific authenticity when it conflicted with his creative desires or his sense of commercial necessity. Arthur C. Clarke related a story in which scientists working on the recently declassified Project Orion passed on documents to Clarke and Kubrick. Orion was a theoretical propulsion system, based on the generation of thrust using a series of nuclear explosions that push against a drive plate, which many scientists saw as the only hope for long-distance space travel. As Clarke told it, no matter how excited scientists were about this propulsion system it was abandoned because Kubrick "decided that put-putting away from Earth at the rate of 20 atom bombs per minute was just a little too comic."[12] The Orion system

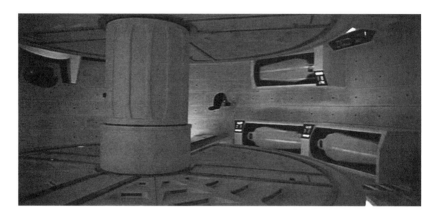

Figure 1.3
Kubrick built a full-scale rotating "gravity wheel" set for scenes in the *Discovery* spaceship for *2001*.

did not conform to Kubrick's sense of visual drama so it was not included no matter how authentic it was.

It is also the case that some aspects of *2001* look inaccurate today even though these same aspects were considered highly accurate at the time. This is not because the special effects look dated but, rather, because the "facts" Kubrick used at the time have themselves become out of date. In order to design the surface of the Moon, for example, Ordway secured pictures from Boris Polikarpov, the Soviet science attaché in London, and from astronomer Zdenek Kopal of the University of Manchester. As Ordway recalled, these images were soon to prove inaccurate after the Moon landing of 1969 but they were the best information available when those scenes were filmed in 1966.[13] This need to rely on science at the cutting edge also meant that several science consultants used the film's fictional nature to work through some of their own conjectural ideas. Ordway, for example, worked with several scientists on the film's astronaut hibernation scenario. One of the scientists, Ormond Mitchell of the New York College of Medicine, published an academic article based on the ideas that came out of his work on the film *2001*.[14]

Stanley Kubrick and MGM were not the only ones to profit from the large audiences for *2001* in 1968. Most of the consultants involved benefited from their association with the film's vision of the future and the space program. Kubrick traded screen time and publicity for access to

dozens of organizations including IBM, Bell Telephone, Honeywell, RCA, Pan Am, and General Electric. They happily shared information on future technological developments and designs for free, just for the chance to have what I call "preproduct placements" that established their brand as "futuristic" in this high-profile film and to feature their film participation in their advertising. *2001* contextualized space travel for audiences in the same manner as Fritz Lang's *Frau im Mond* [*Woman in the Moon*] (1929) and George Pal's *Destination Moon* (1950) had done in previous eras. Unlike those two films, however, *2001* was not establishing the technological capabilities and societal necessity of space travel. Manned space flights had been taking place since 1961. What *2001* did was contextualize for audiences the cultural and social potential of space travel now that it was possible. Film scholar Robert Kolker contends that the power of *2001*'s images and narrative established the film as a modern myth: "2001 is not only a narrative of space travel but a way of seeing what space travel *should* look like" (emphasis in original).[15] *2001*'s vision of space travel with its space stations, transport shuttles to the Moon, and interplanetary space ships is still influential.[16]

It is tempting to view *2001* as an outlier regarding its utilization of science consultants. No other film can claim the amount and range of advice that *2001*'s filmmakers received during production. Despite Kubrick's obsession for details, however, *2001* only differs in degree, not in kind, from the other films I will discuss in this book. An examination of *2001* reveals the same features of science consulting found in other films with regard to both film production and cinema's impact on scientific culture. The exceptional feature of *2001* is that it demonstrates every facet of scientist/filmmaker and science/cinema interactions. Scientific experts were called upon to help filmmakers create scientific visuals, to check facts, to provide logical explanations for speculative and fantastical situations, and to help the cast act like scientists. At the same time Kubrick and his team exerted their creative control over these elements using their own expertise to decide how to incorporate science. By the same token *2001*'s science consultants had an opportunity to realistically visualize their conceptions of the natural world and technological possibilities in an extremely high-profile film that disseminated their ideas to a mass audience.

Scientists working on entertainment productions certainly increase the chances that a film will contain a higher percentage of accurate science. It

is important to note, however, that *2001* was successful, both critically and financially, not because of the volume of accurate science but because Kubrick used science as a creative tool to make the film visually remarkable and intellectually appealing, thereby increasing its box office potential. Kubrick's filmmaking genius was his understanding that for *this particular film* box office success could be achieved through an adherence to scientific authenticity as his consultants defined it within the confines of aesthetically interesting design.

Not every film can, or should, approach the level of accuracy found in *2001*. Kubrick's attention to detail and rigid notion of accuracy would pose financial and technical problems for most filmmakers and with the likelihood of minimal box office gains. In addition, such an approach to scientific accuracy can make a film tedious—the opinion of many people who watch *2001* today. At the time, however, Kubrick's choice to lean heavily toward verisimilitude paid dividends given the cultural context in which *2001* was released. What this book demonstrates is that the goal for science consultants is to let filmmakers negotiate scientific accuracy within their own context of narrative, genre, and audience. Scientific expertise is incredibly valuable in helping filmmakers create plausible and visually interesting films. Yet their advice is only useful in cinematic productions if it allows filmmakers to better use their own creative expertise.

The Nature of Scientific Expertise in Hollywood

Expertise is central to interactions between scientists and the entertainment industry. The concept of scientific expertise, however, is not a simple delineation between those who possess scientific knowledge and those who do not. This is especially true of scientific expertise in Hollywood where expertise is an extremely fluid concept. It is clear from *2001*'s production history that filmmakers look to science consultants to contribute to areas of expertise beyond knowledge of scientific facts. The same is true of many other films: What does the surface of Mars look like? What equipment does a molecular biology lab contain? What would a paleontologist do if confronted by a living dinosaur? How can the surface of a comet contribute to a film's drama? What goes on in a United Nations meeting on climate change? How could nanotechnology be used to create a

monster? I have identified the following aspects of expertise that scientists bring to the fantastical realm of Hollywood cinema:

· Fact checking is not a consultant's only duty, but it is certainly a major one. As I will argue throughout this book the question of accuracy in film is actually open to debate. Rather than fixating on scientific *accuracy* I try to understand how scientists and filmmakers negotiate their perceptions of this term.

· Filmmakers expect consultants to help shape science's iconography. Visual elements are of primary concern for filmmakers. Thus, they will seek out expert advice concerning visual aspects such as the look of scientific spaces and technology before they even think about other scientific elements. Iconography also includes advising actors on how to "act" like a scientist on the screen.

· One of the most important functions of a science consultant is to enhance the plausibility of cinematic events. Scientists' contributions to the believ-ability of a film's narrative, representations, and events—the text's "film logic"—are even more important than scientific verisimilitude. Plausibility directly relates to maintaining an audience's suspension of disbelief, and thus, affects filmmakers' ability to make money.

· Scientists' expertise helps position science into its cultural contexts, which contextualizes science's implications for society, its value as a human activity, the consequences of its use or misuse, and its ideological status. This expertise requires consultants to understand issues relating to political, economical, and social uses of science.

· Consultants are asked to use science in order to provide opportunities to create drama. Filmmakers look to scientists for help using science as a tool for drama and for tapping into the creative and speculative aspects of scientific thought.

· Studios prominently feature their consultants' scientific expertise in pub-licity material. By hiring scientists, studios borrow their expertise to claim legitimacy for the science on the screen.

Scientists offer more than just advice on particular aspects of scientific thought; their expertise can be used to examine film scenarios holistically. Scientific training develops an ability to parse through small details, but it

also gives scientists a capacity for understanding and seeing the connections within complex systems, a skill that proves invaluable for screenwriters, producers, and directors as they flesh out the structural foundations of their film plots. It is important to keep in mind, however, that filmmakers have their own expertise. Therefore, the interactions between scientific and entertainment cultures are about prioritizing expertise or finding ways in which scientific expertise can complement filmmaking expertise. Scientific expertise provides both necessary constraints and flexibility that help filmmakers utilize their own expertise as creative and commercial artists.

Is Science Entertaining? Interactions between Scientific and Entertainment Cultures

The scientific community refers to inaccurate science in entertainment texts as "bad science." Scientists external to the production process believe there is a tension in filmmaking between accuracy and entertainment. For filmmakers there is no tension. There is only entertainment. Accuracy is only important if filmmakers believe it generates entertainment value. Any science that detracts from an audience's enjoyment of a film is bad for a filmmaker whether it is accurate or not. I have sat in workshops with scientists and filmmakers and heard scientists ask variations on the question: "How can we make the science in entertainment products more accurate?" This is the wrong question. The more useful question is to ask filmmakers: "How can accurate science make your film better?" Science in cinema should never be obvious; instead it should be seamlessly integrated into the story and visuals. Science should conform to Lionel Trilling's notion of theatrical "sincerity": acting as the performance of not performing.[17] "Scientific sincerity" means taking scientific content as part of the film's natural landscape.

Technologist John Underkoffler of Oblong Industries, who has consulted on several films including *Minority Report* (2002), *Hulk* (2003), and *Iron Man* (2008), provides an apt metaphor for the ways in which science is often incorporated into cinematic texts: "Science in movies tends to be slapped on, like spackle, over a hole in a wall. No matter how much you paint over it that hole still shows."[18] To be effective, science in movies should be fully integrated; to continue Underkoffler's metaphor it should

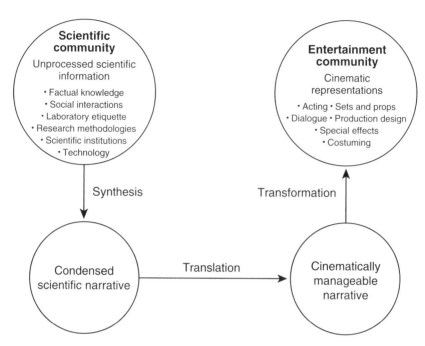

Figure 1.4
Schematic of the science consultant's process.

become part of the wall itself. The goal of filmmaking is to produce an entertaining story that may happen to have scientific content. This means that the process of science consulting is not a simple transfer of knowledge. The process involves the synthesis of information from the culture of science, the translation of that information into the culture of entertainment, and finally the transformation of the information into a finished cultural product (figure 1.4).

Even the smallest pieces of advice from a science consultant can impact a movie's dramatic and visual potential. Astronomer Carolyn Porco of the Space Science Institute was surprised when director J. J. Abrams asked her only a single question for her job as science consultant on *Star Trek* (2009): "I've got the *Enterprise* [U.S.S. *Enterprise* starship] coming back into the solar system and I want to hide it from the Romulans somewhere. Where should I hide it?"[19] She told him the *Enterprise* should come out of warp drive in the cloudy atmosphere of Saturn's moon Titan, then reemerge in a visually striking way—"submarine style," with Saturn's rings in the

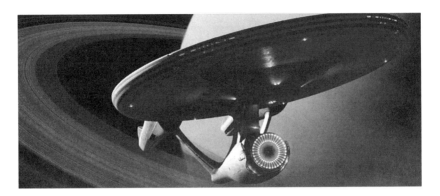

Figure 1.5
Carolyn Porco's scientific advice led to this stunning visual in *Star Trek*.

background (figure 1.5). Although she later spoke with special effects tech-
nicians about how to visualize Titan and Saturn, this one answer was the
extent of her input into the narrative. Yet it turned out to be a significant
piece of advice. It gave filmmakers exactly what they wanted: a visually
interesting *and* dramatic scene that had a logical explanation.

I do not want to ascribe too much influence to science consultants. For
one, a film's content is influenced by factors external to the filmmakers
themselves such as marketing priorities and studio politics.[20] Science con-
sultants do have an influence—sometimes significant—on a text but it
would be a naïve view to believe that scientists have as much control over
the science in a film as the director or the production designer. Filmmaking
is a complex and chaotic process that involves hundreds of people who
have a limited amount of time and money to bring a film to its comple-
tion. In addition, film cultures are not egalitarian communities. Instead
they have a very rigid hierarchy of superiors and subordinates. Donna
Cline works as both a professional science consultant and as a storyboard
artist.[21] As a storyboard artist Cline knows exactly where she fits into the
hierarchy: she is in the art department. If she needs to bring something to
the attention of the director or production designer she goes through her
superior, the art director. As a science consultant, however, she does not
have a fixed place within this well-established hierarchy. Therefore, she
has to understand the rules for interacting with any individual within this
hierarchy. As she tells it, she needs to know how to "toe a political line"
with every individual.

In addition, several consultants told me that they had to be very careful about the ways in which they phrased their advice to filmmakers. They said that filmmakers as a group are sensitive to criticism and take offense if they are told they are "wrong." In scientific or academic culture, such a critique is a valued social norm because scientists understand that their colleagues are just "telling it the way it is." In filmmaking culture, however, the perception is that scientists are overtly demonstrating their superiority and undervaluing filmmakers' own knowledge. Not only were consultants wary of straight-out telling filmmakers their fictional science was wrong, the consultants also had to provide realistic alternatives to replace any cinematic elements they were critiquing.

Barnard College mathematician Dave Bayer experienced the vagaries of the consultant's place in the filmmaking hierarchy while working on *A Beautiful Mind* (2001): "There's a lot to take in, to be an active participant in a film, more than simply knowing one's subject matter and being flexible about adapting it for dramatic purposes. A film is a far more socially charged environment than academics are accustomed to."[22] Bayer had established a good level of trust with screenwriter Akiva Goldsman, but this did not automatically extend to other members of the production crew. In one instance the art department made some mistakes copying coordinates on the panels that actor Russell Crowe's character uses when cracking an encryption code. Instead of "busting their chops" Bayer decided to allow the coordinates to stand and he had Goldsman modify the script.

Unfortunately for Bayer, a graphic designer made another replacement panel showing the initial coordinates and this panel was incorporated into the set. Rather than asking Crowe to memorize new lines Bayer attempted to fix the problem by substituting in the original panel, which put him in conflict with another filmmaker. Recalled Bayer, "It turned out that the production designer Wynn Thomas had spent many hours using the various panel tones to turn this set into a work of art, and I was not to touch the panels. . . . He proceeded to give me a withering dressing down about my place in the production, in front of the assembled crew." In the end, Bayer convinced Thomas that the original panel better served the interests of the production and Thomas rearranged the set. Bayer, however, realized that even though he had direct access to filmmakers at the highest production levels, such as director Ron Howard, he was still an outsider in this community and those on the inside had no qualms about letting him

know this. His "authority" on the set only extended as far as anyone in a position of power was willing to grant him.

A consultant's influence over the science in a film depends to a large extent on when they become involved in a production. This can occur at any point from informal discussions with a scriptwriter before preproduction to discussions with special effects technicians days before a film's release. Several consultants made the point to me that the earlier you get involved the more influence you have over the final product. According to *Minority Report*'s production designer Alex McDowell, "the story drives many of the most significant decisions, so the early integration of a science advisor on a film allows the story and the design logic to become inextricably entwined, and to minimize the potential conflict."[23] Sometimes a director will make a decision to incorporate a science consultant's suggestion during production even if it costs time, money, or resources. This occurred when Jet Propulsion Laboratory scientist Richard Terrile came on board as consultant for *2010* (1984) and told director Peter Hyams that his rotating set for the *Discovery* spaceship was flawed.[24] As Terrile tells it, "The first day I was there I cost [Hyams] a lot of money but if he had hired me a week earlier it would have saved him fifty thousand dollars." Hyams did not have to act upon Terrile's suggestion, especially at such a substantial cost. In this case Hyams believed that an accurate set was worth the time and cost to make this change.

For the most part, however, advice that could easily be changed at the script stage is more likely to be disregarded in the middle of production if it conflicts with work that has already been undertaken. This is not to say that scientists coming into a production later cannot have an impact on a film, rather, it is to say that the momentum of a film production makes it harder for filmmakers to accommodate a consultant's recommendations in later stages. Regardless, Terrile's suggestions for *2010* and Porco's advice for *Star Trek* would have been meaningless if their respective employers had not taken them seriously. Successful science consultants, then, are those who are best able to convince filmmakers that their advice represents what's best for a film.

Cinema's Impact on Science and Technology

Ultimately, my interest as a science studies scholar is to understand how representations and narratives in entertainment media impact scientific

culture. The cinematic apparatus actually emerged out of the animal movement studies of Eadweard Muybridge and Etienne-Jules Marey in the late nineteenth century. Since that time, moving pictures have remained an integral part of scientific research.[25] But cinema impacts science beyond being a research tool. Popular films impact scientific culture by effecting public controversies, enhancing funding opportunities, promoting research agendas, and stimulating the public into political action. Several recent studies of science popularization demonstrate that the *meanings* of science, not public knowledge, may be the most significant element contributing to public perceptions of, and attitudes toward, science.[26] According to Alan Irwin, the public makes sense of science—constructs its "science citizenship"—in the context of people's everyday lives, preexisting knowledge, experience, and belief structures.[27] Entertainment texts, like popular films, significantly influence people's belief structures by shaping, cultivating, or reinforcing the "cultural meanings" of science.

Moreover, entertainment texts can influence scientific thought by foregrounding specific scientific ideas and providing narrative reasons to accept them as representing reality. Lily Kay offers the useful notion of "technoscientific imaginary" to account for shared representational practices both within science and in the broader culture.[28] The technoscientific imaginary represents a "master" narrative that encompasses all the narratives, both scientific and public, that frame an issue and give the issue its cultural value. Science consultants can significantly impact the technoscientific imaginary by assisting in the creation of cinematic depictions.

Beyond its impact on public discourse, dissemination of scientific ideas through entertainment media has the potential of impacting scientific knowledge production. Numerous studies of science in public, from the spectacle of nineteenth-century electrical displays to the twentieth-century news coverage of the cold fusion affair, show that scientific popularization is not just a "sharing" of scientific knowledge with the public, but is also a component in the making of that knowledge.[29] Such social, cultural, and historical studies of science show a destabilization of the boundaries between activities that constitute science's "inside" and "outside." Sir Richard Owen jumped at the opportunity to serve as advisor to sculptor Benjamin Waterhouse Hawkins in the creation of concrete, life-size dinosaur models for exhibit at the Crystal Palace in 1853 after his scientific rival Gideon Mantell turned down the offer. As such, audiences in the mid-nineteenth century saw enormous sculptures that matched Owen's

notions of "rhinocerine" quadruped *Iguanodons* instead of Mandell's conceptions of bipedal animals with short forearms. These sculptures became representations that were important in Owen's ideological battles over evolutionary thought.[30] Just as Owen's opportunity to advise on these influential statues helped promulgate his ideas, consultants working on cinematic texts can disseminate their ideas through the visual medium of cinema. Any time a scientist discusses, or portrays, scientific information it is an act of persuasive communication, and as such it can have an impact on scientific practice.

Entertainment Experts, Authenticity, and Scientific Culture

The overwhelming financial success of *Jurassic Park* (1993) has led contemporary filmmakers to believe that "realism" is a necessary component in producing a highly profitable movie blockbuster. Film realism, however, has three distinct components incorporating naturalism (visual realism), narrative integration (dramatic realism), and authenticity (scientific realism). Science consultants have an influence on all three categories. Chapter 2 fleshes out some of the theoretical issues encompassing the understudied relationships between visual and narrative realism and scientific verisimilitude. Media representations can be a strong determinant in the production of technoscientific knowledge. Film's reality effect renders scientific representations plausible because it naturalizes images and events within the fictionalized world. Films act as virtual witnessing technologies by permitting large sections of the public to observe objects and events without the need to directly witness these phenomena. Popular films are particularly effective virtual witnessing technologies because their financial success is tied to how well they convey a sense of realism. Cinema's status as a virtual witnessing technology, then, is both a boon and a bane for popularized science since it naturalizes all scientific images whether they are accurate or inaccurate.

Chapter 3 examines the motivations the disparate communities of entertainment and science have for entering into a relationship. On the one hand, the need for realism is clearly a significant incentive for studios to hire science consultants, but their value as a publicity investment makes them even more desirable. On the other hand, the best way for scientific institutions or scientists to control their media image is to become involved

in the production of media texts. The various forms of compensation scientists receive for consulting reflects a tension inherent in contemporary scientific culture between an obligation to science advocacy and a belief in the value of scientists' specialized knowledge.

Chapter 4 concerns science consultants' contributions to two of the most crucial cinematic elements: acting and visuals. Audiences have become more sophisticated and no longer accept obvious stereotypes so willingly. Filmmakers' recent emphasis on scientific realism has extended to actors' performances, and so producers hire scientists to teach actors how to act like a "real" scientist. Filmmakers also look for scientists to help them with the "look" of scientific spaces and technologies. Ultimately, filmmakers ask consultants to provide the symbolic cues that convey to audiences that "science" is on display.

A large proportion of fact checking for film productions involves scientific knowledge for which there is a strong consensus within the scientific community as to what represents natural law. Chapter 5 explores the variety of constraints (budget, drama, production schedule, etc.) filmmakers face when incorporating established facts into fictional texts. The notion of *flexibility* plays a central role in how scientific facts are negotiated in film production, meaning flexibility on the part of filmmakers and science consultants, but also flexibility as to what represents an "accurate" depiction. It is clear that filmmakers' treatment of facts depends to a large extent on the public's familiarity with a given scientific fact. The more well known that fact is, the less likely it is to be compromised. This flexibility with facts can be problematic regarding public discourses about science, especially for those facts that significantly impact the cultural meanings of science.

During "science in the making" several competing visions of nature have valid claims to representing "fact." Chapter 6 investigates how filmmakers and scientists grapple with scientific knowledge in flux. Scientific uncertainty provides flexibility since multiple sides of a scientific dispute can stake a claim to representing natural law. No matter which side filmmakers incorporate, they can honestly maintain they are adhering to scientific verisimilitude. Consultants generally welcome this flexibility, but they become rigid defenders of what they believe to be the "correct" side if they have a significant stake in a debate. Cinematic images can be a powerful force in knowledge production and it is highly advantageous for

a scientist to have their position "naturalized" on the screen. This natural-
ization of disputed science troubles scientists who do not agree and who
find other public outlets—news media, popular magazines, the Internet,
and so on—to promote their own conceptions about what represents a
"true" scientific representation.

For Hollywood films to be successful, audiences need to believe that the
extraordinary events behind increasingly perceptually realistic cinematic
spectacles are *possible*. This need for plausibility presents a dilemma for
filmmakers: how can they make movies both believable *and* sensational?
Chapter 7 explores how scientific explanation for fantastic and extraordi-
nary events became the default position for filmmakers. Because scientific
work involves logical deduction filmmakers perceive that scientists
have an expertise in "thinking" that I refer to as an "expertise of logic."
Filmmakers combine scientists' expertise of logic with their own creative
expertise to construct stories that are both believable and spectacular.

Consultants have found the popular medium of film to be an effective
means of convincing the public that a scientific issue needs more attention.
This is especially true for areas where scientists believe inaction will lead
to disaster. Chapter 8 considers scientists' belief that plausible "scientific
disasters" in popular films will lead to the prevention of these disasters by
arousing public fear. For science consultants, the key is to help make the
film plausible enough to become an asset and not a liability. Consultants
believe that the more realistically a scientific disaster is visualized in a
fictional world, the more motivated the public will be to fund scientific
research in order to prevent the event from occurring in the real world.
Regardless, a basic level of scientific authenticity is essential to stave off
the worst critical attacks by scientific and political opponents.

Consultants can also utilize cinematic representation to reduce anxiety
and stimulate a desire in audiences to see potential technologies become
realities, as discussed in Chapter 9. Cinematic depictions of future tech-
nologies are what I call "diegetic prototypes." These technologies only exist
in the fictional world—what film scholars call the diegesis—but they exist
as fully functioning objects in that world. Diegetic prototypes foster public
support for potential or emerging technologies by establishing the need,
benevolence, and viability of these technologies.

Chapter 10 concludes that the scientific community and the entertain-
ment industry both benefit from their collaborations. These collaborations

provide members of the scientific community the means to disseminate their visions of science as an activity and an institution, and their conceptions of the natural world through a culturally powerful visual medium. Entertainment industry practitioners clearly benefit through their interactions with scientific culture. Science adds to a story's plausibility and visual splendor and, thus, to the audience's enjoyment. Consultants' costs are minimal at worst and free at best. The challenge now facing both communities is in maximizing the full potential of scientific thought in the arena of entertainment. Ultimately, science consultants challenge our understanding about the place of science in entertainment, conceptions of expertise, and the role of informal communication in scientific practice.

2 Cinematic Science: Scientific Representation, Film Realism, and Virtual Witnessing Technologies

The firefighters didn't know what to expect from the white container covered with warnings that it contained "teratogenic and mutagenic agents." Someone spotted it in a field Oct. 15 and called the county health department. The health department called the county Emergency Management Agency, which called the city Fire Department. The firefighters approached warily—then discovered it was a Thermos vacuum bottle used to carry chicken soup, not biohazardous material. The Thermos was part of the marketing blitz that accompanied the summer blockbuster film *Jurassic Park*. It was made to look like containers in the movie that held material used for cloning dinosaurs.
—From a 1993 newspaper article titled *"Jurassic Park* Jug a Cause for Alarm."[1]

There is certainly a tongue-in-cheek element to the newspaper story quoted here, whose alternative title could easily have been "Trained Professionals Confused by Toy." The playful juxtaposition of "chicken soup" as the Thermos's possible contents with the frightening and dangerous-sounding "teratogenic and mutagenic agents" is consistent with the lighthearted tone of the reporting. Despite this flippant tone, however, there is a serious undertone about the very real likelihood of mistaking a harmless children's lunchbox Thermos for a container full of toxic biological chemicals. Imagine a firefighter who sees a white container with "WARNING: BIO-LOGICAL MATERIAL" emblazoned above the international biohazard symbol along with the words "Teratogenic and Mutagenic Agents Present!" and you can understand their concern about a potentially hazardous situation (figure 2.1).[2] While it is easy to view the Thermos story as an amusing anecdote with a simple point about the shortsightedness of corporations or the vigilance of local health officials, or both, it is also a striking example of how a fictional entity with the veneer of scientific authenticity can create fear and distrust.

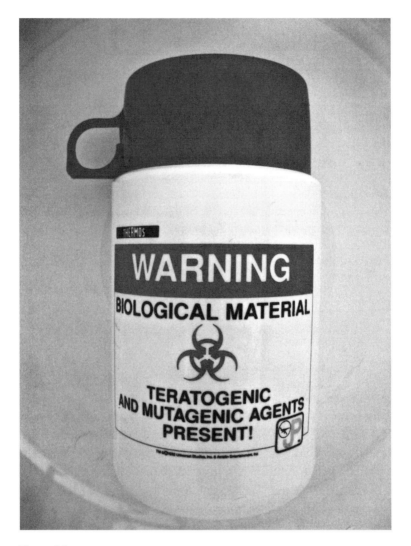

Figure 2.1
Thermos associated with the release of *Jurassic Park*.

Many in the scientific community believe that scientific depictions in fictional media have been detrimental to science literacy and to public attitudes toward science. In fact, television and movie science has become something of a cultural "bogeyman" for scientists. Entertainment media's scientific critics feel that more often than not the science in these texts is factually wrong, that scientists are portrayed as evil or socially apathetic, and that scientific knowledge is misused. As a result of these concerns several science advocacy organizations have developed programs in order to facilitate more scientific involvement in the production of television programs and films, including the National Academy of Sciences' Science and Entertainment Exchange, the National Science Foundation's Creative Science Studio collaboration with the University of Southern California's School of Cinematic Arts, and the Sloan Foundation's Film Development granting program.

These organizations' concerns are not trivial given the amount of science found in film and television and its generally negative depiction. The overwhelming picture that academic studies paint is a televisual and cinematic history expressing deep-rooted fears of science and scientific research.[3] Empirical evidence also demonstrates that fictional portrayals of science have an impact on public attitudes toward science.[4] Indeed, examples of how cinematic representations impact public discourse about science and scientific culture are found throughout this book. It is clear that images of science matter, especially images that come to us through popular entertainment media. The question still remains, however: Why do fictional depictions influence our perceptions of and attitudes toward science? What I find is that, like that *Jurassic Park* Thermos bottle, it is popular films' realistic appearance combined with a veneer of scientific authenticity that gives cinema its rhetorical power.

Seeing Is Believing: Cinema as a Virtual Witnessing Technology

One of the central lines of inquiry in the study of science is determining the role that science in public plays in the establishment of technoscientific knowledge. Paleontologist Stephen Jay Gould believes that the need for direct witnessing is what separates scientific practice from religious faith and he uses the figure of "doubting Thomas" to support this contention. In this biblical story, Thomas the Apostle refuses to believe in the

resurrection of Jesus until he is able to see him with his own eyes. For Gould, Thomas's need to see the evidence for himself perfectly encapsulate the primacy of witnessing in scientific thought: "A skeptical attitude toward appeals based only on authority, combined with a demand for direct evidence . . . represents the first commandment of proper scientific procedure."[5] What Gould forgets, however, is that only a few members of the scientific community working in laboratories have the capacity for gathering this "direct evidence." Individual scientists witness their own work but even scientists working in the same lab do not directly witness the experiments of their colleagues. As a scientist himself, Gould is assuming that everyone else—including other scientists—should believe these privileged scientists' pronouncements about the natural world. This is because the scientific process has developed in such a way that the *indirect* witnessing of scientific evidence is seen as sufficient for the acceptance of facts into the body of scientific knowledge.

Steven Shapin and Simon Schaffer first put forth the importance of indirect witnessing to the establishment of public knowledge in their seminal work *Leviathan and the Air-Pump: Hobbes, Boyle, and the Experimental Life.*[6] According to Shapin and Schaffer, Robert Boyle believed that the establishment of "matters of fact" rested upon the premise that all members of the scientific community were able to witness the experiments that generated the matters of fact. Of course, it would have been impossible for every member of the scientific community to witness Boyle's experiments directly. Therefore, according to Shapin and Schaffer, Boyle employed the "literary technology" of "virtual witnessing" to convince others who were not present of the validity of the matters of fact. As they defined it, "the technology of virtual witnessing involves the production in a *reader's* [sic] mind of such an image of an experimental scene as obviates the necessity for either direct witness or replication" (original emphasis).[7] The aim of Boyle's lengthy descriptions and engravings was to convince other scientific investigators of the validity of his experiments without the need for them to have actually witnessed the experiments with their own eyes.

While Shapin and Schaffer centered on the establishment of virtual witnessing as a literary technology in seventeenth-century Europe, their work establishes the significance of *witnessing*, either directly or virtually, to the public acceptance of scientific knowledge. Shapin points out that witnessing could be extended beyond a limited number of scientific schol-

ars saying that "what Boyle was proposing, and what the Royal Society was endorsing, was a crucially important *move towards* [sic] the public constitution and validation of knowledge" (original emphasis).[8] By the nineteenth century, public scientific demonstrations were not limited to the laboratories of Boyle's fellow gentlemen-scientists. The Royal Institution in Britain, for example, had established itself as a popular space where scientific demonstrations and lectures could be seen and heard including those by prominent scientists such as Michael Faraday. In his discussion of Faraday's use of the public theater, David Gooding elaborates upon the crucial role of public witnessing in knowledge production, by arguing, "demonstration— the witnessing of a phenomenon—is essential to its acceptance into the body of natural knowledge."[9] Gooding extends Shapin and Schaffer's concept of virtual witnessing beyond the confines of a small group of scholars to the wider public arena. The validation of scientific facts no longer rested only in the hands of investigators; access to scientific demonstrations allowed the public to verify knowledge for themselves.

Roving public lecturers and demonstrations in the nineteenth century allowed those outside of the scientific community to witness science, but these audiences were still spatially and temporally localized. The number of people who could directly witness an experiment or phenomenon was limited to those in attendance. Many thousands more were able to *indirectly* witness these experiments, however, by reading about them in periodicals and newspapers. Mass media like newspapers function as "virtual witnessing technologies" by allowing individuals to indirectly or virtually witness phenomena, demonstrations, and scientific events they are unable to witness directly. Those at the demonstration directly witnessed Faraday's science, while those reading about it in periodicals and newspapers virtually witnessed it. Even more than textual descriptions, visual representations play a crucial role in the concept of virtual witnessing. No matter how long and descriptive Boyle's writings, they still depended heavily on representations.

The twentieth century saw the development of far-reaching visual mass media that now allow enormous audiences to witness science they would otherwise be unable to see. Television and cinema are particularly powerful virtual witnessing technologies because they depict natural phenomena and events in such a way as to convince the audience that these representations accurately reflect the natural world. This expansive use of the term

virtual witnessing differs from Shapin and Schaffer's original conception, but it is in line with other historians and sociologists who appropriated the concept, and broadened its definition to include any attempts to persuade others that they have witnessed a "natural" phenomenon without the need for them to actually witness the phenomenon directly. The concept of virtual witnessing effectively captures the significance of visualization and representation in scientific practice and the notion that witnessing need not be direct to convince people that phenomena or events match natural law. Only two men walked on the Moon in 1969, but every person on Earth had the chance to witness this event on television.

Science, cinema, and witnessing were intertwined in the earliest films of the twentieth century. Film scholar Tom Gunning describes early cinema's fascination with images as the "cinema of attractions."[10] According to Gunning, early filmmakers were still discovering cinema's capabilities, focusing on what they could show instead of what they could tell. What better way to generate spectacle then by introducing audiences to images that were previously only available to scientists? Cinema was an ideal technology for transforming phenomena that were invisible to the naked eye into spectacular visions. Louis Lumière patented his cinematograph in 1895, which was the same year that William Roentgen discovered x-rays. It did not take long for filmmakers to exploit these mysterious x-rays in films such as *X-Rays* (1897). Charles Urban produced some of the most successful early films by attaching a camera to a microscope. His "Unseen World" series, which included pioneering microphotographer F. Martin Duncan's classic 1903 film *The Cheese Mites*, revealed a hidden natural world that audiences were unaware of and had never before had the chance to see. Urban and Duncan's scientific revelations were *too* revealing for some; the British cheese industry had the film censored because they were afraid it would negatively impact the public's perceptions of their product.[11]

Fiction enhances cinema's capacity to display science. Fictional narratives impose truth claims on scientific depictions out of necessity. Ambiguity hinders plausibility. Consequently, popular cinema strips uncertainty from its scientific representations. Popular cinema is particularly effective as a virtual witnessing technology because the intent of its construction is to blur the distinction between virtual witnessing and direct witnessing.

This blurring is especially evident for natural phenomena that have never been directly witnessed (e.g., dinosaurs). In the framework of popular cinema science *always* represents the truth of natural law because this need to present certainty is required for plots to move forward. Filmmakers could not get dinosaur-fueled mayhem in *Jurassic Park* (1993) if the uncertainty of their scientific dinosaur construction was evident on the screen.

Naturalizing Cinematic Science: Film Realism and Perceptual Reality

This notion that mass media are virtual witnessing technologies—and thus are effective channels of communication—is readily accepted when looking at nonfictional mass media like science documentaries or natural history films. Science documentaries serve as virtual witnessing technologies because, like photographs, they appear to be referentially realistic. That is, to the audience the images and activities on the screen are "referents" to real entities and situations in the natural world. Gregg Mitman shows how the purported referential reality of documentaries was historically important to the scientific community whose nature films allowed the public, and other scientists, to witness nature in action.[12] As Mitman points out, both scientists and filmmakers benefited if audiences accepted as true that they were indirectly witnessing natural reality in a scientific documentary. The perception of authenticity allowed scientists to assert objectivity for their new research tool, while filmmakers claiming legitimacy enhanced their ability to draw in audiences. Despite the scientific community's insistence on the authenticity of nature films, Mitman shows that documentaries were as thoroughly constructed as fictional films. Mitman found that while scientists and filmmakers wanted to convince both the public and other scientists that they were revealing natural reality, documentaries were, in fact, substantially edited and dramatized to enhance their entertainment value.

In spite of the highly stylized nature of documentaries, scientists and lay audiences understand how nonfictional entertainment media, and news media, disseminate scientific ideas to both the scientific community and the public. Popular films, however, are overtly fictional, making their status as virtual witnessing technologies less obvious. Popular films act as virtual witnessing technologies and channels of communication because the images on the screen appear "realistic" within narratives designed to

highlight this realism. Film theorists have recently grappled with the idea of realism in regard to new special effects technologies and have revised old theoretical models to accommodate the rise of computer-aided digital imaging.

According to film theorist Julia Hallam, the rise of the blockbuster "spectacle" film in the 1980s and 1990s resulted in a renewed emphasis on film realism.[13] She argues that rather than being "unrealistic," films that heavily rely on special effects actually embody realist filmmaking in that they must make unreal images appear "real." As stated by Noel Carroll, contemporary film theorists now "agree that in its standard uses, film imparts a *realistic effect* [sic] to its viewers" (original emphasis).[14] Joel Black refers to film's ability to "mimic" reality as the "reality effect." Black believes that the reality effect is disturbing because it has made film "a key role in determining 'reality' itself"; a concern confirmed by how many survivors of the attacks on the World Trade Center on September 11, 2001, claimed that what they saw and experienced that day was "like out of a movie."[15] Visual mass media's reality effect is a double-edged sword as it allows people to virtually witness science but it can also lead to a questioning of what is real. Television may have allowed people to witness the Apollo Moon landing, but the event's mediated nature also allowed some to question its legitimacy.[16] This makes for interesting interactions where media can make fiction more real while at the same time rendering reality more like fiction.

Stephen Prince has argued effectively that the key to cinema's reality effect is not to consider filmic images as conforming to referential reality but, rather, to regard these images as *perceptually* realistic. Prince uses correspondence theory to describe how images can be referentially unreal, but perceptually realistic:

A perceptually realistic image is one which structurally corresponds to the viewer's audiovisual experience of three-dimensional space. Perceptually realistic images correspond to this experience because film-makers build them so. Such images display a nested hierarchy of cues which organize the display of light, color, texture, movement, and sound in ways that correspond with the viewer's own understanding of these phenomenon in daily life. Perceptual realism, therefore, designates a relationship between the image or film and the spectator, and it encompasses both unreal images and those which are referentially realistic. Because of this, unreal images may be referentially fictional but perceptually realistic.[17]

In other words, filmmakers design images, even unreal images, to correspond to "cues" with which viewers normally interact. Familiarity with these cues compels the audience to perceive unreal images as realistic. Prince uses *Jurassic Park* as an example of how filmmakers create perceptually realistic images using digital technology:

No one has seen a living dinosaur. Even paleontologists can only hazard guesses about how such creatures might have moved and how swiftly. Yet the dinosaurs created at ILM [Industrial Light and Magic] have a palpable reality about them, and this is due to the extremely detailed texture mapping, motion animation, and integration with live action carried out via digital imaging. Indexicality cannot furnish us with the basis for understanding this apparent photographic realism, but a correspondence-based approach can. Because the computer generated images have been rendered with such attention to 3D spatial information, they acquire a very powerful perceptual realism, despite the obvious ontological problems in calling them 'realistic.' These are falsified correspondences, yet because the perceptual information they contain is valid, the dinosaurs acquire a remarkable degree of photographic realism.[18]

Because of digital technology's accuracy we see unreal animals (e.g., dinosaurs) that match the movement, appearance, and sounds of animals with which we have interacted, such as elephants and ostriches (figure 2.2). Therefore, we perceive these images as realistic even though they are not

Figure 2.2
Special effects technicians designed *Jurassic Park*'s dinosaurs to correspond to existing animals' movement and sounds.

actually real. This is true even though most people's experience with these creatures is through other mass media such as documentaries, news, or the Internet. Film scholar Robert Baird believes that the mediated nature of *Jurassic Park*'s dinosaurs actually contributes to their animalization because those who live in big cities predominantly experience large animals (e.g., elephants) through mass media.[19] What this means is that the mediated nature of film images actually contributes to the reality effect specifically *because* audiences' experience with corresponding creatures and objects comes through other media forms.

Although the development of digital imaging increased attention to film realism among film theorists, filmmakers' ability to create perceptually realistic images preceded this technology. As Prince points out, "The tension between perceptual realism and referential artifice clearly predates digital imaging."[20] Moreover, the relationship between mediated experience and perceptual reality holds as well for older films as it does for recent films dependent on computer-generated imagery (CGI). For instance, filmmakers repeatedly designed rocket takeoff scenes in science fiction films of the 1950s and 1960s to correspond to news footage of V-2 rockets. Robert A. Heinlein, the science consultant for *Destination Moon* (1950), understood that the audience's belief in the filmic rocket's takeoff would greatly depend on their familiarity with newsreels of V-2 rockets. In a letter to the film's editor Duke Goldstone, Heinlein suggested that the "soundtrack of V-2 rockets be obtained" to be used during takeoff.[21] Likewise, in his notes for the final script Heinlein emphasized the importance of these newsreel movies in the film's construction: "We see flame burst from the tail of the rocket, splash the ground, the rocket lifts, slowly at first, then with gathering speed until it is a round ball of flame disappearing in the sky, a second sun. If we hold this pick-up we will see vapor trails in the high stratosphere crawling snakily across the sky. This take-off will look like movies of a V-2 take-off and the odd appearance in timing must be preserved."[22]

Heinlein expected filmmakers to balk at his recommendations and he reminded them that the "odd" takeoff he suggested for the fictional rocket corresponded to real-life V-2 rockets, which do not go straight up (figure 2.3). If they chose not to follow his recommendations they risked confusing audiences already familiar with the V-2's takeoff from newsreels. In fact, however, audiences' familiarity with V-2 rockets in 1950 would only have come through the movie screen since their primary visual experience

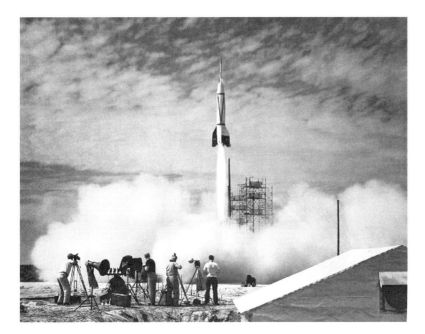

(a)

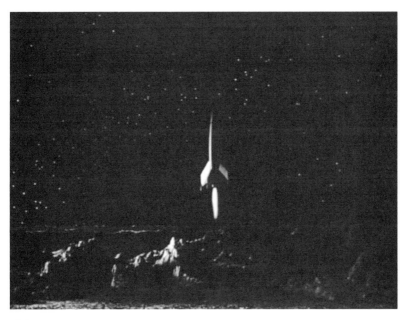

(b)

Figure 2.3
Photo of V-2 rocket takeoff (a) and the takeoff scene from *Destination Moon* (b).
Source: (a) courtesy of NASA.

with rockets would have been newsreels shown before feature films, not television. This blending of news and fiction in the theater space reinforced cinema's reality effect.

For special effects technicians, the blurring of the line between effect and reality represents the ultimate goal of their craft. Senior visual effects supervisor Ken Ralston states this explicitly in regard to *Contact* (1997): "We hope to be crossing the line where you're never sure what's an effect and what isn't an effect."[23] There are, in fact, scores of anecdotes concerning cinema viewers' inability to distinguish whether images were the result of special effects or were real objects. A scene in *Contact*, for example, depicts fictional astronomer Ellie Arroway sitting in front of a collection of large radio telescopes (figure 2.4). The radio telescopes in the film actually exist and Warner Brothers filmed the scene on site at the National Radio Astronomy Observatory's Very Large Array in New Mexico with the help of radio astronomer Bryan Butler. According to astrophysicist Philip Plait, when the scene appeared on the screen the person in front of him in the audience thought the image was computer generated and uttered to his companion, "What a great effect!"[24] Plait's response to this viewer's confusion was, "How cool is it that we astronomers have instruments so impressive that people think they aren't real?" What this actually demonstrates is that film images have become so perceptually realistic that audiences are unable to determine their veracity.

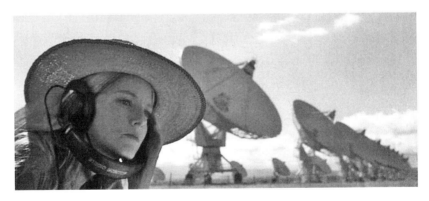

Figure 2.4
This scene in *Contact* caused confusion for some audience members as to whether the radio telescopes in the background were special effects or real objects.

Certainly the dinosaurs in *Jurassic Park* looked realistic because of the groundbreaking CGI effects and their correspondence to the movement, texture, and color of familiar animals, but cinema's reality effect is imparted through the totality of the cinematic apparatus including an aural component, lighting, editing, set design, character dialogue, and a narrative framework designed to highlight the representation's "reality" and to make opaque its construction. As Martin Barker explains, "Special effects have to be both narratively integrated and convincing representations of a realistic fictional world for the audience to believe in them sufficiently, and so to engage with the resulting dilemmas posed for the film's characters."[25] The presence of a narrative storyline, in particular, contributes to the perceptual realism of images and scenarios by providing audiences with explanations and rationales for why events are unfolding on the screen. Equally important, characters in these fictional worlds treat every object on the screen—even unreal images—as a "natural" aspect of the landscape. In essence, the construction of popular film *naturalizes* images and depictions embedded within their narratives.

Plausibility and the Reality Effect: Popular Films as Speculative Modeling Spaces

Communication researchers have addressed the issue of the perceived reality of entertainment media in terms of audience reception. According to Michael Shapiro and Makana Chock there are two ways of considering perceptual reality.[26] "Absolute" perceptual reality is the degree of perceived similarity between mediated images and situations and real-life objects and situations. "Relative" perceptual reality is more appropriate for considering the depiction of science in fictional media because it involves judgments about how realistic images and situations are if those sorts of images were to actually exist or those situations were to actually occur. Martin Barker and Kate Brooks's audience reception work on the film *Judge Dredd* (1995) supports this notion of relative perceptual reality as being the means by which audiences judge unreal images.[27] They interviewed filmgoers about their perceptions of the future world depicted in the film and found that audiences make judgments about what is plausible within the film's world, not about what seems "real" when compared to our own world. In regard to the science in the film, for example, the cloning

technology depicted in *Judge Dredd* appeared logical in the context of the film's fictional futuristic world, even though this technology does not exist in the real world.

Plausibility, then, is as crucial in cinema's reality effect as is the quality of its special effects. We accept the realism of both the trolls in a fantasy film like *The Lord of the Rings: The Fellowship of the Ring* (2001) and the dinosaurs in *Jurassic Park* because they look realistic and they plausibly fit within each film's narrative. Realism in *Jurassic Park*, however, extends beyond the illusion that the dinosaurs looked, acted, and sounded like familiar animals. Their correspondence to real-world animals made them seem natural, but "natural" is not the same thing as "authentic." The reality effect in *Jurassic Park* depended not only on the fact that the dinosaurs moved like real *animals*, but also that audiences believed they looked and acted like authentic *dinosaurs*. Plausibility in cases of science in cinema is dependent on a sense that these images and scenarios have a scientific grounding. The cinematic dinosaurs' authenticity comes from a reconstruction based on current scientific data about dinosaur physiology, ecology, and behavior. Thus, the perceptual realism of *Jurassic Park*'s dinosaurs flows from both their naturalism (visual realism) and from their authenticity (scientific realism).

Most filmmakers do not envision perceptually realistic images as an end in themselves. Film is a visual medium and its overarching narrative (dramatic realism) hinges upon the believability of its images. In order to maintain the interest of audiences, films must be sufficiently credible within the context of their own internal narrative logic. Filmmakers bring scientific experts into the filmmaking process to provide this credibility and, thus, avoid audience disenchantment. This cinematic realism in turn contributes to the plausibility of the scientific concepts themselves by acting as a virtual witnessing technology. So what we see, then, is a circular relationship among science, plausibility, and film realism where science enhances cinematic plausibility, which can then reinforce scientific explanations.

That plausibility leads to the perception of reality is important, because, as paleontologist Kevin Padian has shown, the role of popular images in the acceptance of scientific concepts depends not on their correspondence to natural law, but rather on their plausibility. According to Padian, picto-

rial representation is a "powerful determinant of perception" that "need only be plausible, not accurate, to become fixed in the mind's eye."[28] In his historical study of the taxonomic reconstructions of pterosaurs, Padian found that popular images supplanted even scientific evidence in scientific reconstructions, saying that "the popular reconstruction of pterosaurs assumed an important role in establishing the acceptance of the bat-winged image, in spite of the lack of evidence then or now for it."[29] In the end, Padian concludes, "a picture is not only worth a thousand words; however inaccurate, it may be worth a wealth of documented evidence to the contrary."[30]

Films act as virtual witnessing technologies and communicative vehicles for science, because filmmakers are asking science consultants to help them develop realistic models of the natural world. The use of film as a modeling device is not a novel concept within scientific practice. In many cases, scientists use "animated" films as simulation tools to allow them to theoretically model a system without having to set up an experiment, or to examine a phenomenon without having to actually see it; computer-generated animation models have long been routine equipment in seismology, molecular biology, and astronomy. Popular films can even improve on the visualization of these models since their technologies are of a higher quality than most scientists have access to. Bruce Lewenstein and Steven Allison-Bunnell show, for example, that researchers from the Jet Propulsion Laboratory in Pasadena, California, were able to better visualize their data on Venus and Mars by being involved in the construction of an IMAX film, which displays images of far greater size and resolution than conventional film formats. According to Lewenstein and Allison-Bunnell, "the need of the IMAX film for dramatic moving images provided researchers with the funds and the opportunity to create new ways of viewing their scientific data, leading them to new appreciations of the complexity and richness of the two planets."[31]

In this same way, popular fictional films also serve as modeling tools that allow science consultants to represent systems and phenomena with a very sophisticated visualizing technology. Paleontologist Jack Horner of the Museum of the Rockies in Bozeman, Montana, appreciated how the visual effects for *Jurassic Park III* (2001) allowed him to view a computer-generated simulation of *Spinosaurus*, which is only known from a few

partial fossils. "For me, [modeling] was really the idea of the *Spinosaurus*. I was curious to see what it would look like," he said.[32] Because these modeling tools are used in a fictional context, science consultants feel unrestricted in designing models. According to Stephen Hilgartner, the scientific community views popularization as a "simplification" process, and as such, they are more willing to discuss speculative interpretations than they would be able to in "serious" scientific publications.[33] As Massimiano Bucchi describes it: "The popular stage can in this sense provide an open space where stimuli, ideas and information are merged and exchanged among different actors and across disciplinary fields, in the absence of the constraints and conventions which bind scientific work and communication at the specialist level."[34]

Many consultants on popular films regard movies as an open, "free" space to put forward their conceptualizations. A lack of constraints allows them to be more speculative, which is the creative and fun part of science. If they are wrong in their speculation there is no harm since "it's only fiction." Marvin Minsky of the Massachusetts Institute of Technology, who consulted on *2001: A Space Odyssey* (1968), considers science fiction a good way to work out some theoretical problems. As Minsky says, "I thought that science fiction was a good venue for exploring the implications of AI [artificial intelligence]. It helps you to be clearer about the implications of your work."[35] Richard Terrile of the Jet Propulsion Laboratory realized while working on *2001*'s sequel *2010* (1984) that filmmakers' need for detailed depictions necessitated a more speculative approach to scientific knowledge than was normally acceptable in scientific practice. As he put it, "A filmmaker would ask you questions that you do not normally get to think about in science. We were designing the elements on the Galilean satellite Europa and they will ask you 'what does it look like on the surface?' So, you have to extrapolate from the little we knew at the time all the way down to what it would look like if you were standing on one of these bodies" (figure 2.5). This freedom to explore in fictional spaces means that science consultants are often providing extrapolative speculations about scientific phenomena, which can help scientists see novel connections and provide new interpretations that are then conveyed to audiences.

The conception of film as a modeling space is why many films in retrospect seem "ahead of their time" when science consultants are involved

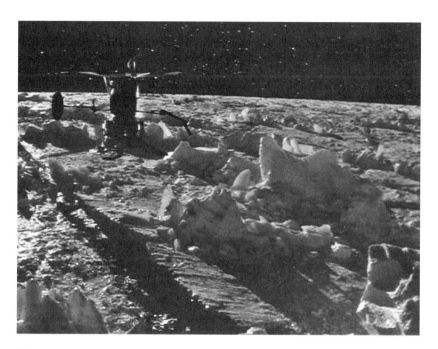

Figure 2.5
The Galilean satellite Europa's surface in *2010*.

in the production. Film critics often point to the groundbreaking German space film *Frau Im Mond* [*Woman in the Moon*] (1929), for example, as a "prophetic" film.[36] Indeed, many of the scientific ideas used in the film have come to pass. NASA has used the mobile launch vehicle depicted in the film on every launch since Apollo, the Saturn rocket's booster design was identical to the one represented in the film, and NASA decided in 1981 to rest the Space Shuttle in a pool of water during takeoff just as the rocket in the film was put in a pool of water to protect its "delicate parts."[37] The primary consultant for the film was pioneering rocket scientist Hermann Oberth. Willy Ley—another of the film's consultants—notes that because of "a dramatic requirement—the director [Fritz Lang] wanted a full Moon in the sky during takeoff—the flight path that Oberth calculated turned out to be the figure-8 flight path actually taken by Apollo 8."[38] This is not to say that NASA scientists calculated their trajectory for Apollo 8 based on *Woman in the Moon*. Rather, Oberth was speculating on a trajectory as if he actually was planning a rocket trip to the Moon, and other scientists

later accepted his speculative trajectory as accurate. Oberth's ideas for what a Moon flight should entail were central to the film's depiction of space flight, ideas that he also promoted in venues other than the film, including technical publications. Scientists decided his ideas were a correct path for their own research or experiments. Thus, the film merely seems prophetic because a scientist designed it based on his own theoretical and speculative ideas.

Another way to think about the idea of fictional films as scientific modeling tools is to examine an upcoming film for which a science consultant is simulating phenomena that have yet to be verified by close visual inspection. Theoretical astrophysicist Kip Thorne of the California Institute of Technology wrote the script treatment for the upcoming *Interstellar* (2013) and will be heavily involved in the design of the film's gravity fields and wormholes. Currently, wormholes are only theoretical entities within the astronomical community; there is no direct evidence for their existence. Thorne is essentially designing these entities—as well as the scientifically based notion of traversable wormholes—based entirely on his theoretical models. When, and if, we are able to confirm that wormholes exist, they may indeed behave as in this film or they may look and behave completely differently. Nevertheless, being a consultant on this film allows Thorne the filmic space to develop, visualize, and experiment with his conceptual models.

The Power of Images: Science, Cinema, and Public Discourse

While science consultants increase the amount of accurate science in a film they certainly are not able to render all the scientific depictions factual. This means that the science emanating from fictional films is as likely to represent "bad" science as it is to be "good" science. As I have shown in this chapter, the construction of fictional films "naturalizes" the images and depictions embedded within their narratives. Filmmakers construct fictional films so that the film's content appears to be natural and normal, and therefore, perceptually realistic. The representation of natural phenomena, scientists at work, and research spaces, whether they represent accurate science or not, are all rendered realistic within the cinematic framework. Studios add to cinema's naturalizing effect by using scientists

in their publicity material to claim scientific legitimacy for their films. They lead audiences into thinking that their scientific representations are not only plausible but also match up with the natural world. This problem is complicated by the fact that "accuracy" is an ambiguous concept in cinema. Although consultants can help filmmakers to portray more plausible science, this is not the same thing as creating scientific representations that correspond to natural law.

Cinema's naturalizing effect, in fact, makes it incredibly difficult for lay audiences to determine which depictions are correct and which result from filmmaking constraints or creative decisions. It may well be cinema's naturalizing effect, and not scientific errors specifically, that motivates the scientific community's numerous critiques of science in entertainment media. In addition, cinema adds legitimacy to pseudoscience concepts like ESP and other paranormal phenomena. Audience reception work on the 2004 film *The Day After Tomorrow* in Britain supports the notion that audiences can confuse fact and fiction in cinema. In this study researchers asked focus groups about their concerns over global warming before and after viewing the film, as well as their perceptions about the factualness of the science in the film. What they found was that audiences were unable to determine the accuracy of the science in the film:

The realistic way in which phenomena were depicted in the film (through the use of high quality special effects) created difficulties for respondents in determining where the accepted scientific evidence ended and the fiction began. That said, the film's special effects do appear to have aided the visualisation of scientific data and information for some and, for many participants, the force of this imagery was sufficient to heighten their concern about the potential impacts of climate change after seeing the film.[39]

The researchers' study points directly to cinema's power as a virtual witnessing technology. Whether audiences could tell what was accurate or not, the film's realistically depicted disaster scenario induced them care more about the effects of global climate change.

When I was writing this book people often asked me why I chose film over other popular science outlets like television, novels, or museums exhibits. My love of film certainly played a role in this decision. However, the uniqueness of cinema's immersive environment was the primary reason for choosing film as a topic of study. Hollywood cinema with its

perceptually realistic images and linear narrative structures contextualizes science in a manner that can establish our primary cultural meanings of science more than any other media. Said another way, film's visually and emotionally immersive environment enables it to dominate our techno-scientific imaginary, which shapes meanings in other media forms. Cinema's virtual witnessing capacity, then, has the potential to significantly impact—positively or negatively—our perceptions of the natural world and science as a cultural endeavor.

3 Valuing Expertise: The Entertainment Industry's and Scientific Community's Motivations in the Science Consulting Relationship

In January 1951 astrophysicist Samuel Herrick received a phone message that producer Julian Blaustein wanted to hire him as science consultant for *The Day the Earth Stood Still* (1951).[1] Herrick was the world's leading authority on celestial mechanics who founded the Institute of Navigation and taught the first university course on astronautics. Blaustein and director Robert Wise wanted to tap into the astrophysicist's expertise to craft a realistic interstellar spaceship as well as feature him in their publicity material. For his part, Herrick saw the film as an opportunity to promote rocketry. His research on astronavigation was not particularly practical in the early 1950s given the absence of space travel. He also used the film and its publicity to push his own ideas on the importance of the "three-body problem" in celestial navigation.[2]

These reasons, however, were not sufficient for Herrick to immediately agree to work on the film. He was not going to accept Blaustein's offer unless it was clear to him that Blaustein, Wise, and 20th Century Fox respected the value of his expertise. Before phoning back, Herrick made a list of reasons he could provide for turning down the position. Prominent on this list was a concern for adequate payment. What he termed appropriate "remuneration" for his work would indicate that 20th Century Fox valued his uniqueness, while "insufficiency" would indicate "a lack of appreciation."[3] Herrick understood that he was the "only person in the country for [this] part of it" and strongly felt that 20th Century Fox must provide "adequate compensation for specialized knowledge." He also produced counterarguments against hiring two other scientists who may have appeared to be appropriate. He conceded that famous space artist Chesley Bonestell was "good for planets" but that he had "no knowledge on design whatsoever." Likewise, Herrick contrasted his knowledge of

celestial mechanics with that of astronomer Robert S. Richardson of the Mount Wilson Observatory as "20 years vs. big talk."[4]

His notes from the phone conversation itself further emphasize his belief that financial compensation was a recognition of his expertise, writing "I know I have special something [film] needs but unwilling to participate unless 20th Century also knows." In the end 20th Century Fox paid him what he demanded; $75 a day, which was considered a sizeable fee in 1951. Meeting Herrick's financial demands suggested 20th Century Fox believed they could not obtain this expertise from anyone else. Despite Herrick's claims that he had other work "more important to myself and my future" he took up the studio's offer once the filmmakers agreed to pay him an amount he believed his expertise warranted.

Herrick's case with regard to *The Day the Earth Stood Still* makes explicit the role that expertise plays in the valuation of science consulting on the part of both the scientific and entertainment communities. Much of this book is devoted to discussing *what* advice filmmakers want from their science experts and analyzing *how* filmmakers act upon this advice. In this chapter, I explore *why* filmmakers select specific experts and, in return, *why* scientists and scientific organizations become involved in fictional enterprises. Not every consultant has Herrick's conviction that value is tied to financial compensation and scientists' motivations for working on popular films reveal a conflict between a valuation of their expertise and their belief that scientific information should be a public resource.

Hiring an Expert: General Characteristics of Science Consultants

Consultants may not be hired at all if filmmakers do not recognize the need for science advisors in the first place. Unfortunately for Daniel Kubat he learned this after starting his now-defunct consulting business, Fact of Matter: "There is no place for a science advisor in the filmmaking hierarchy based on the entire history of cinema. It's really a fluke that there are science advisors ever. The only reason it happens is because there's somebody in a position of power who really cares about not only telling their story but that the story has a plausible reality."[5] Hiring a science consultant is a conscious *choice* on filmmakers' part and not a standard operating procedure. Some filmmakers like James Cameron, Steven Spielberg, and Ron Howard consider science consultants an essential position from the

outset. Most, however, hire a science consultant only after recognizing the need for expert advice, which could occur very late in the production schedule.

Once the consultant is on board there is no standardized method of integrating him or her. Science consulting can range from brief informal discussions with screenwriters all the way to daily involvement in a production (figure 3.1). While there is no traditional approach to filmmaker/ scientist interactions, I have identified five basic types of science consultants: (1) informal consultation, (2) consultant think tank, (3) specialist consultation, (4) on-set advisor, and (5) boundary spanner. Informal consultations include any one-off conversation with filmmakers before a film is greenlit for production, or during preproduction before the script has reached a filmable stage. In these preliminary stages scriptwriters and producers are searching for science that can ground their script ideas or asking scientists to fact check scripts. It is difficult to judge the frequency of these

Figure 3.1
Production photo from *Jurassic Park III* showing (from the left) paleontologist Jack Horner, producer Kathleen Kennedy, actress Téa Leoni, and actor Sam Neill.

informal consultations since most scripts never even make it into production. For those that do these conversations are so casual they are rarely documented or rarely noted in archives. Discussions with my informants indicate, however, that it is clearly the most common form of science consulting.

Consultant think tanks are a means by which studios can obtain a wide variety of advice before beginning production work. Futurist Peter Schwartz of Global Business Network (GBN) organized a two-day workshop for *Minority Report*'s (2001) director Steven Spielberg and his creative team. GBN convened a group of twenty-three prominent experts from a wide variety of disciplines including physics (Neil Gershenfeld), urban planning (Peter Calthorpe), architecture (William J. Mitchell), literature (Douglas Coupland), engineering (Harald Belker), and computer science (Jaron Lanier). This think tank provided the means by which filmmakers could acquire a broad range of information in a short time span. As production designer Alex McDowell remembers it, this event took place before there was a script: "We sat around in a room and talked through the aspects of how society would be affected over the future. What would change, what the trends were, and where they would logically end up."[6] There was also a one-day think tank convened for *Deep Impact* (1998) in April 1997, when a room full of filmmakers asked questions of the film's six science consultants: former astronaut David Walker, former NASA mission controller Gerald Griffin, astronomers Eugene and Carolyn Shoemaker, astrophysicist Chris Luchini, and astronomer Josh Colwell.[7] The think tank approach is becoming more common as the National Academy of Sciences (NAS) expands its consulting activities through its Science & Entertainment Exchange program.[8] The NAS prefers this consulting mode and has created think tank teams for *Watchmen* (2009), *TRON 2.0* (2010), *Iron Man 2* (2010), *Thor* (2011), and *The Forever War* (2011).

Since filmmakers predominantly hire consultants on an ad hoc basis, they often look for specialist consultations to address unique situations. This means that production companies often bring in several different experts over the course of a production to solve specific scientific problems. The experts may not even know that other consultants are working on a film. On *Contact* (1997), for example, the producers brought in radio astronomer Tom Kuiper, mathematician Linda Wald, astronomical artists Jon Lomberg and Don Davis, astronomer Carolyn Porco, astronomers Seth Shostak and Jill Tartar of the SETI Institute, physicist Kip Thorne, and

former director of NASA's Johnson Space Center Gerry Griffin to address scientific issues including basic astronomical questions, designs for the alien transport device, set design of scientific spaces, and astronomers' behavior. Most of these scientists did not know the others were working on the film. In addition to these specialist consultations, the filmmakers also hired radio astronomer Bryan Butler to serve as their on-set advisor. Butler's duties as on-set advisor included advising actors, suggesting dialogue, helping set designers, and answering all scientific questions—even those outside of his specialization. It is often the case that filmmakers ask scientists they have encountered through informal consultations, think tanks, or specialist consultations to stay on as on-set advisors once they realize the need for a full-time advisor—as was the case for John Underkoffler on *Minority Report* and Jim Kakalios on *Watchmen*.[9]

There are certainly factors outside of scientific expertise that come into play when deciding upon a suitable science consultant, such as availability and personality. Previous experience with the entertainment community is certainly an advantage for scientists who have consulted on multiple films, such as Richard Terrile of the Jet Propulsion Laboratory (JPL) or John Underkoffler. The benefits of familiarity with entertainment culture have led to the development of a recent type of science consultant that I refer to as boundary spanners.[10] Boundary spanners are individuals with some scientific training who also develop extensive experience within the entertainment world. The boundary spanners' methodology involves their own consultation with appropriate specialists from whom they obtain and synthesize scientific information that they translate into the language of cinema. Donna Cline—who has consulted on over a dozen major Hollywood films including *Outbreak* (1995), *Deep Blue Sea* (1999), and *The Shaggy Dog* (2006)—is a prototypical boundary spanner. Cline earned a master's degree in biomedical illustration and trained as a forensic artist then worked as a storyboard artist and illustrator before engaging in science consulting work. Boundary spanners provide advantages because they readily move between the social worlds of science and entertainment. While there are currently few boundary spanners, it is a category that is certain to grow as members of the scientific community gain experience working in Hollywood.

While there are no established filmmaking rules for seeking out consultants, there are some general demographic patterns. Not surprisingly, consultants most frequently come from organizations that engage in scientific

research such as universities and research institutions. Being located in the Los Angeles area is another common feature. Filmmakers prefer consultants from the Los Angeles area because it is easier to schedule face-to-face meetings and phone calls, and it is more convenient for bringing experts on the set. Being the expert nearby when filmmakers are on location also accounts for the hiring of scientists from more difficult-to-reach locations such as epidemiologist David Morens of the University of Hawaii who consulted during the filming of *Outbreak* in Hawaii.[11]

The ability to be on set can be a crucial condition in hiring a consultant. Film production can be a lengthy process. Filmmakers cannot predict when they will require an expert's advice, so an on-set advisor is expected to work long days over several weeks. This presents a difficulty for established scientists who usually cannot spare that much time away from their institutional commitments. Producer Ian Bryce's requirement of a three-month commitment for *Twister* (1995) could not be met by many scientists and he asked six scientists before obtaining the services of meteorologist Vince Miller, who had recently left the Weather Channel.[12] Comparative anatomist Stuart Sumida of California State University at San Bernardino—who has consulted on many films including *Hollow Man* (2000) and *Stuart Little 2* (2002)—sums up the difficulty of balancing his university duties with entertainment work: "All consulting *must* be secondary to [one's] primary job of teaching, research, and administration at the university; so, much is done over holiday breaks, summers, weekends, and evenings" [emphasis in original].[13] Even Wayne Grody's location in Los Angeles could not guarantee enough time on the set for several projects. "Any technical advisor who has a day job cannot be there all the time," he said. In one instance Grody noticed an obvious inaccuracy in the rough cut of the television film *Condition: Critical* (1992). When he brought this to the director's attention he received a sarcastic reply, indicating that this error was Grody's fault for not being on set the day the scene was filmed.

To get around these time constraints filmmakers may turn to less senior researchers. Bryan Butler was a postdoctoral researcher at the National Radio Astronomy Observatory in New Mexico when he served as *Contact's* on-location advisor and was also flown out to Los Angeles to work as their on-set consultant for a month.[14] When I asked Butler if he would consider working as a consultant again he was not sure it would be possible: "I don't know if I could do it again at this point in my personal life and career. I

don't know if I could take five weeks off and just go and do that. At that point I could go on vacation from work and my [girlfriend, who is now my wife]. We were living together then and we didn't have any kids so I could just go off. . . . Now I have two kids and for my work it would be much harder to get a whole month away." Butler admitted that if the same opportunity arose today he would recommend that the filmmakers hire one of his postdocs instead. During their postdoctoral studies scientists have no supervisory commitments and are only responsible to themselves and their supervisor. Because postdocs tend to be younger they are also less likely to be hindered by family obligations. In addition, the conditions of film production are strenuous and energetic postdocs have the stamina needed to handle the rigors of production schedules.

Once filmmakers recognize the need for a consultant they are not necessarily capable of identifying what constitutes an appropriate expert. Scientific expertise is complex and layered, and scientists cannot be experts on every scientific topic even if it falls within their broader discipline. 2010's (1985) initial director Peter Hyams, for example, called JPL's Public Information Office simply requesting a "scientist" even though he was specifically asking about the telemetric power of the Arecibo Observatory. A narrow definition of scientific expertise suits filmmakers' purposes when they are looking for advice on very specific scientific topics. Their requirements are different, however, when they look for consultants to serve as a general science consultant. Few people in the world would be considered experts in comet topography, but every scientist has an expertise in the culture and process of science—although they may vary in their ability to articulate this! For some filmmakers this is sufficient and they hire the first scientist who is in a relevant research area. Finding Nemo's (2004) director hired marine biologist postdoc Adam Summers as a consultant based merely on the recommendation of Summers's landlady.[15]

Familiarity with science's generalities, however, does not mean that expert knowledge extends to every facet of science. There is a widespread public perception—fuelled to a large extent by media stereotypes—that equates "science" with universal knowledge. Consultants, then, are often treated like the "Professor" on the television show Gilligan's Island. The Professor is a stereotypical scientist who knows everything about everything. According to sociologist Helga Nowotny this conception of scientists as "universal" experts creates problems when scientists serve as advisors

outside the scientific community, because "Experts have to synthesise all available knowledge and of necessity transgress the boundaries of their discipline as well as the constraints of their own limits of knowledge."[16] This succinctly sums up the challenges faced by scientists who serve as entertainment consultants. Their particular expertise may only be appropriate for a single cinematic element, but to be effective over the entire production they need to answer questions far outside their research field and apply their expertise to fantastical situations.

Publicity and the Superstar Consultant

One of the most important factors production companies take into account in hiring scientists is their potential contribution to a film's publicity campaign. Studios encourage scientists to speak with the press about their film work; scientists also often attend press conferences surrounding the films. Physicist Brian Cox of the University of Manchester, for example, featured heavily in *Sunshine*'s (2007) publicity material and on their promotional tour.[17] Publicist Warren Betts of Warren Betts Communication, in fact, has turned this promotional strategy into a thriving PR business.[18]

A scientist's publicity value can often exceed his or her value as a consultant. By using scientists in their publicity, filmmakers claim legitimacy for their scientific visions. According to Matt Golombek of JPL his primary role as science consultant on *Mission to Mars* (2000) was not to provide filmmakers advice but to publicly legitimate their version of Mars: "Mostly, what they used me for were media relations to the science part of the media. So they had a big media day up at the shooting site in Vancouver and they invited me up to see the site and to talk to the media about the movie."[19] In the jargon of Chris Toumey filmmakers are "conjuring science" by using science consultants as promotional devices.[20] By bringing on scientists, studios can borrow their scientific authority to claim that their films adhere to a sense of scientific realism. The construction of science, then, becomes a promotional strategy where "realism" is highlighted as an entertainment value.

Viewing consultants as publicity investments explains the hiring of high-profile researchers or scientists who are widely known through their popularizing endeavors. Prominent examples include gene therapy pioneer French Anderson on *GATTACA* (1997), early AIDS researcher Donald

Francis on *Outbreak*, and string theory progenitor Brian Greene on *Frequency* (2000) and *Déjà Vu* (2006). One of the appeals of NAS's science consulting program is that it provides filmmakers with access to its prestigious members. For earlier films a consultant's prominence was also a crucial factor in hiring. Meteorologist Fritz Loewe and glaciologist Ernst Sorge, for example, were hired as consultants on the German film *S.O.S. Iceberg* (1933) based on their involvement in Alfred Wegener's ill-fated and well-publicized 1930 research expedition to Greenland. Likewise, microbiologist Paul de Kruif was hired to work on *Arrowsmith* (1931) based on the popularity of his 1926 book *Microbe Hunters*. Film studios have also historically sought out the endorsement of prominent research institutions such as NASA and JPL. *Armageddon*'s (1998) director Michael Bay, for example, felt that NASA's cooperation was crucial to the film's success, "Our biggest challenge was to get NASA's approval. . . . If we didn't get it, this movie would not have worked."[21] The advice of NASA scientists and engineers and access to its research spaces may have enhanced the authenticity of Bay's film, but the major benefit of NASA's involvement was the ability to say "NASA approved" in film publicity and press materials.

Unlike postdocs such as Bryan Butler and Andy Summers, distinguished scientists do not have the time required to act as on-set consultants. They may read a film's script and spend a day or two on the set at most. Filmmakers, however, are not hiring a scientist like Brian Greene to have him devote weeks fixing scientific details. They are primarily hiring Greene because his bestselling 1999 book *The Elegant Universe: Superstrings, Hidden Dimensions, and the Quest for the Ultimate Theory* was a finalist for the Pulitzer Prize in nonfiction in 2000 and he has been favorably compared to Carl Sagan because of his good looks and easy manner on television. I am not suggesting that these scientists are incapable of putting in the time necessary for a full-time science consultant. Some, like paleontologist Jack Horner on *Jurassic Park* (1993), have spent a great deal of time working with filmmakers. What I am arguing is that these scientists' primary value rests on their scientific expertise transferring to a film through their "celebrity endorsement." Just as the endorsement of a celebrity like Nicole Kidman conveys to a product her sophistication and beauty, the film endorsement of a prominent scientist like Brian Greene conveys his scientific expertise. Postdocs may be more effective as consultants, but a postdoc's name will have little recognition value outside of a very small research

community. The perception of scientific realism is often more important for a film's box office than the actual achievement of authenticity. The endorsement of a high-profile scientist is an expedient means by which to feed this perception.

Politics of the Look: Shaping Institutional Identity through Cinema

In his study of network television, Todd Gitlin argues that corporate, political, and nonprofit institutions have recognized visual mass media's impact on their public images and, therefore, attempt to control these media depictions during production: "In an age of image, every social group practices the politics of the look."[22] The need to cultivate the "politics of the look" motivates a large number of scientific institutions to assist film productions and allow filmmaking teams access to their research spaces. Scientific institutions have historically embraced the opportunity to collaborate with filmmakers and other entertainment media producers. Cooperation between scientific institutions and fictional filmmakers can be traced all the way back to 1916 when the Selig Zoo in Los Angeles allowed filmmakers to use its animals for the film *Thou Shalt Not Yet Covet*. Image is especially important for publicly funded scientific institutions, which need to display their utility to the public. When scientists and scientific organizations are involved in a production they can help craft narratives that promote their research fields, their scientific institutions, and their own scientific work. Involvement in film productions is also the best means of avoiding a reactionary position to filmic representations.

The scientific community has a long-standing tradition of using mass media as promotional tools. Jan Golinski shows how chemists in nineteenth-century Britain convinced the public of their discipline's value through newspaper advertisements, posters displayed at lecture halls, accounts of lectures in popular magazines, and editorial cartoons.[23] Scientific promotion through the mass media gains further traction through visual mass media. Cinema provides an ideal format for shaping institutional identity because of its virtual witnessing capacity. Narrative, visuals, and character actions can all support a particular vision of a scientific institution and its scientists—positive or negative. Whether these depictions are true or not, films can then impact what an institution *means* to people. What better way for Carl Sagan to promote the value of the

controversial SETI Institute than by creating an entire movie in which SETI actually succeeds in discovering an alien radio signal? Likewise, any financial or material resources NASA spent while helping the producers of *Armageddon* and *Dante's Peak* (1997) are insignificant in light of the publicity value the organization gained from flattering depictions including dialogue such as "Thank you NASA! Thank you NASA! Thank you NASA!"[24]

Film studios receive significant benefits from collaborations with prominent scientific organizations including access to institutional personnel, research and exhibit spaces, material objects, and institutional prestige for use in publicity material. These benefits are significant enough to provide institutions with the leverage to influence cinematic depictions in a manner that is equivalent to "source dependence" in newspaper coverage.[25] It is a symbiotic relationship between studios and scientific organizations where studios get expert advice and a scientific stamp of approval while scientific organizations have the opportunity to shape their cultural image through popular films and television. Television medical dramas, for example, routinely granted the American Medical Association (AMA) veto power over scripts so that they could feature the AMA's stamp of approval at the end of each episode. As Joseph Turow details, the AMA ensured that these programs presented an exclusively positive image of doctors.[26] Similarly, Nathan Reingold found that Manhattan Project scientists exhibited substantial control over the final version of *The Beginning or the End* (1947), having the power to veto any portion of the script they disagreed with.[27] NASA has developed a similar reciprocal relationship with the entertainment industry. According to executive producer Sam Mercer, consultation with NASA for *Mission to Mars* was in the best interest of both parties: "They want a piece of material that speaks strongly to what NASA and a man-in-space mission are all about. . . . The first process was technical assistance from NASA in terms of developing the screenplay and then the research. And the final process was to see if everything we wanted to do was in line with what NASA is doing and if the story makes a positive statement. Then it would get their seal of approval—which we received."[28] The "NASA-real" aesthetic that Mercer desired ultimately came at the cost of making sure NASA looked good on screen.

Most scientific organizations do not chase Hollywood exposure unless the opportunity presents itself. But when the opportunity comes along

they are not shy about promoting their "brand" in cinema, including the National Severe Storms Laboratory (NSSL) in *Twister* (1995) and the U.S. Geological Survey (USGS) in *Dante's Peak*. Science consultants representing these organizations were able to exert plot changes in these films, which enhanced the depiction of their institutions. After NSSL consultants for *Twister*, for example, read the initial script they convinced filmmakers to change the NSSL's depiction:

We [the National Severe Storms Laboratory] were supposed to be the corporate, evil . . . the bad guys. We were supposed to be them. And in terms of well-funded, all the latest equipment, you know, that was supposed to be the Severe Storms Lab. As we—when we sat down and talked to them ahead of time, and this is to the credit of [producer] Kathleen Kennedy, when she came down and talked to us and said, you know "what do you think? Can you help us out?" and we said we had seen part of the script and this portrays us incorrectly; let us walk you around. We showed her how our stuff is held together with wire wrap and duct tape, and we said, you know, this is a seat-of-the-pants, scrape-money-together operation, and so she, right then on the spot, said "we will change that" and so she did. And we ended up being, in the movie, more of an advisory capacity group, which was really quite a change from the original portrayal of the NSSL.[29]

Being involved in the process gave NSSL scientists the opportunity—and the leverage—to change their depiction from being well-funded, governmental bad guys to being the under-funded, individualist heroes—a depiction that would surely help in the funding cycle (figure 3.2a). The USGS's involvement in *Dante's Peak* also allowed the organization to influence the depiction of its scientific work, including script changes that reflected the uncertainty of USGS scientists' predictions of volcanic eruptions (figure 3.2b).[30] While such a depiction might not seem to be in the best interest of the USGS it actually met institutional objectives for tempering public expectations about the scientists' ability to unfailingly predict eruptions.

Some prominent research institutions have set up divisions devoted to seeking out relationships with the entertainment industry. The ever-image-conscious NASA has interacted with the entertainment community since the 1960s when it formed its Entertainment Industry Liaison.[31] NASA cultivated these relationships specifically for its own publicity purposes with space travel films of the 1960s and 1970s such as *Marooned* (1969). Constance Penley argues that NASA's Hollywood relationship, especially with the *Star Trek* franchise, helped it maintain a positive public profile after

(a)

(b)

Figure 3.2
NSSL's participation in *Twister*'s production led to a more positive depiction of the organization (a) as did the USGS's participation on *Dante's Peak* (b).

the *Challenger* disaster in 1986.[32] NASA scientists have been intricately involved in the production of numerous films, including *Apollo 13* (1995), *Armageddon*, *Mission to Mars*, and *Space Cowboys* (2000); each of these films is essentially one long "product plug" for NASA. NASA provided technical advice, access to its scientists, script analysis, and the use of facilities and equipment including the Vehicle Assembly Building and the launch pad and landing facilities in the Kennedy Space Center. NASA even authorized the use of its logo in *Mission to Mars* and *Space Cowboys* (figure 3.3).[33] As Matt Golombek says, "Hollywood does a much better job of talking about what NASA does than NASA does itself."[34]

(a)

(b)

Figure 3.3
NASA's logo is prominently displayed throughout *Space Cowboys* (a) and *Mission to Mars* (b).

Since the government prevents federal agencies from profiting from outside collaborations, producers sign NASA's Space Act Agreement. While NASA scientists do not receive financial benefits for their assistance, the agency views their work on popular films as an excellent vehicle for promoting NASA missions and scientific projects. According to Warren Betts, who was *Deep Impact*'s director of marketing, NASA leaders were "eager" to work on the film when he approached them.[35] In an interview with *Mail & Guardian Online* Bobbie Faye Ferguson, a NASA spokesperson, explained NASA's reasoning for why it seeks involvement in fictional enterprises:

One of the things we do is try to increase awareness of space and spatial exploration. . . . Right now there is a lot of interest in a manned mission to Mars. There is no official manned mission listed, but that's not saying there's not a lot of people who aren't very excited about it. I certainly think that participating in films that reach a large number of people, and that are feasibly fictional, increases the awareness of space and the future.[36]

Warren Betts was blunter in his assessment, "Hollywood is one of the most powerful marketing forces in the world. . . . The movies are critical in helping NASA excite the public about what they do, which may get them more support from Congress."[37]

Despite its belief that movies are good publicity, NASA does have limitations on its willingness to become involved in fictional productions. For example, NASA would not participate in *Red Planet's* (2000) production. NASA officials balked at a scene in *Red Planet's* script in which one astronaut accidently kills another astronaut by knocking him off a cliff (figure 3.4).[38] NASA leaders felt the scene would damage its image and asked the filmmakers to remove it before the agency would provide assistance. Unlike many other filmmakers, director Antony Hoffman was not willing to compromise his creative vision in order to obtain NASA's approval. As he explained to the *Los Angeles Times*, "NASA couldn't get their heads around that [scene]. The system breaks down. They didn't want that. And while I really wanted NASA's approval, I said, 'It's more important dramatically to get what I need than it is to get the little logos on the ships.'"[39] For

Figure 3.4
NASA refused to work on *Red Planet* because of this scene where one astronaut inadvertently kills another astronaut.

NASA's part, the price of those "little logos" was a guarantee that the agency and its personnel be portrayed in a flattering light. Instead, Hoffman clearly prioritized his own expertise as a filmmaker over the need for public legitimization from this well-known agency.

While NASA had problems with a film that questioned the integrity of its astronauts, it did approve the script for *Mission to Mars* even though the film features the pseudoscience "Face on Mars," which is a geographic feature that NASA has repeatedly denied. From NASA's perspective as long as a film promotes space travel by portraying the agency's technology, personnel, and scientific mission in a positive light it is acceptable, no matter how problematic the rest of the film's science may be. There are drawbacks to such an approach, however. NASA's decision to allow the Face did prove to be problematic from a PR angle as the movie became fuel for Face proponents who used NASA's tacit approval of the script as evidence that even NASA believed the Face was legitimate.[40]

Compensation: What Is Expertise Worth?

There can be risks for scientists who become involved in fictional enter-prises. In her classic investigation of "visible scientists," Rae Goodell docu-ments the negative impact that media popularization had on the careers of several scientists including Paul Ehrlich and Carl Sagan.[41] If association with "legitimate" media endeavors like documentaries could hinder a sci-entist's reputation within the scientific community, then connections with fictional media should be even more problematic. This was certainly true for some scientists who worked within the entertainment field. Plant geneticist Bob Goldberg of UCLA was worried about having his name associated with the horror film *Warning Sign* (1985): "No, I wasn't involved in publicity. I didn't want to do any of that stuff anyway. I wanted to keep as low a profile as possible. In fact, I was even reluctant to have my name in the credits."[42] According to a *Los Angeles Times* interview, molecular biologist Raul Cano—whose work on ancient DNA in amber came out just before *Jurassic Park*'s release—became disenchanted with his agreement to help promote *Jurassic Park* because of his colleagues' negative reactions: "[Cano] also seemed unsettled by sniping from some scientific quarters, questions about ethics and priorities. There's a line between seizing the

moment and forfeiting professional dignity, and Cano could only hope he had not crossed it."[43] Mere association with a fictional text is generally not enough to harm a scientist's reputation. Fictional endeavors can become a problem for scientists, however, if the scientific community finds the end product particularly problematic in terms of its science. For instance, after reading the script for *Volcano* (1997), California Institute of Technology seismologist Egill Hauksson advised Caltech's lawyers to send a letter to the production company demanding that Caltech's name not be used in the movie for fear that association with the film's incredibly inaccurate science would tarnish the institution's reputation.[44]

Given Goodell's findings it was surprising how little the consultants I interviewed—outside of Goldberg—considered the possibility that their consulting work could negatively impact their reputations. Scientific culture has changed since Goldberg's experience twenty-five years ago and other scientists no longer view cooperation with the media so negatively. In fact, consulting work on popular films was more likely to have a positive impact on my informants' careers by raising their profile than it was to hinder them. Generally, colleagues were either jealous at a scientist's opportunity to work in Hollywood or respected them for trying to raise the level of scientific accuracy in fictional texts. Any negative reaction was usually through good-natured teasing. The rise of celebrity culture and reality television throughout the 1990s has made association with popular media desirable.[45]

The novelty of working with entertainment producers and the prospect of fun were, in fact, two of the major reasons my informants cited for consulting. There are, however, a multitude of other motivations— fame, science advocacy, promotion of ideas, and popularization of a research field being a few. Still, most consultants expect some form of compensation for their expertise. Of course, the most straightforward method of compensation is financial. Stuart Sumida, for example, charges a consulting fee of between $100 and $200 per hour.[46] Similarly, The Dinosaur Society recommends that paleontologists charge up to $4,000 per week for advising work on entertainment products.[47] Most of my informants also received financial payment for their consulting work on films that went into production. Director Martha Coolidge ensured that physicist Martin Gunderson of USC was compensated well enough for his

work on *Real Genius* (1985) that he could afford to "get a new swimming pool."[48]

Although many consultants received direct payment for their services, there are numerous examples where science consultants accepted alternative forms of monetary payment—such as grants to support their research—in lieu of direct financial payment. Paleontologist and artist Douglas Henderson, who acted as a consultant on *Jurassic Park* and *Dinosaur* (2000), views this work as a form of research funding, claiming that his motivation for working on these films was to get "very well paid" in order to "free me later to take the time to do the work I want."[49] In essence he is using his salary from these jobs to support his paleontological research and art. Jack Horner received generous research grants from Universal Studios and director Steven Spielberg in addition to his consulting salary: "Steven or Universal would give me a donation to my research after the movies came out. It came to my museum and Universal is my largest single donor." In this way their work on fictional films provided them with the funds they needed to support their work in paleontology—a notoriously difficult field in which to obtain research funding. For Bob Goldberg acceptance of the laboratory supplies used on the set of *Warning Sign* was preferable to financial payment: "I wouldn't take any money but they gave us all the equipment when they were done," he explained. "All the chemicals. They just said, 'Here, have it.' We had chemicals for two years, which saved us thousands of dollars basically from buying stuff. That was a big deal as far as we were concerned at the time because money was not in plentiful supply."

In another instance, filmmakers sought out sonoluminescence researcher Ken Suslick to help them on their film *Chain Reaction* (1996). Instead of receiving direct financial payment, Suslick's department within the University of Illinois received a grant from 20th Century Fox as compensation for his advice and for the use of old laboratory equipment.[50] For Wayne Grody the decision to forego personal salary in favor of research money was imposed upon him by his institution. UCLA's Medical School considers his expertise to be their intellectual property and he is barred from accepting money for his consulting work; instead studios "have to make the check out to Regents of the University of California, not to me."

A number of consultants felt it was their duty as a scientist to impart knowledge to an uneducated public, including filmmakers, and that it

would have been unethical for them to take money for this activity. Two of the consultants for the 1922 Lon Chaney Sr. horror film *A Blind Bargain* (1922), for example, felt that it would be "disreputable" for "medical researchers" to accept payment and they even requested their names not be included in publicity material.[51] While all of the military advisors on the MGM atomic bomb docudrama *The Beginning or the End?* received monetary rewards, none of the Manhattan Project scientists accepted financial compensation.[52] Eminent Princeton physicist John Wheeler asked MGM to contribute $500 to his university in lieu of any financial payment. In a more recent example, Donald Francis, who cofounded the biopharmaceutical company VaxGen in 1995, refused financial payment for his work as consultant for *Outbreak*; accepting as compensation "only that his 17-year-old son, Oli, be allowed to observe the filming."[53]

Francis's example underscores the conflict that science consultants face. Even in an era when academic-industry boundaries are blurred there remains a strong conviction in the scientific community that popularization and outreach activities are a mandatory form of public service. On one hand, consultants believe that as scientists they should give scientific advice freely to anyone who seeks knowledge, a belief reinforced after the growth of the "Public Understanding of Science" movement in the 1980s and 1990s.[54] On the other hand, these scientists provide a specialized service for filmmakers and believe they should receive compensation of some type.

To resolve this tension, consultants have come up with other forms of compensation that do not involve direct financial payment. Consultants who accept research funds rather than salary or consultation fees perceive that this action does not compromise their ethics because the money will not go into their pockets but will go toward the production of new knowledge. In other cases, consultants devise novel means to balance the value of their expertise with their belief that knowledge is a public commodity. For example, epidemiologist Frederick Murphy provided his Ebola micrographs to *Outbreak*'s filmmakers in exchange for "tickets to the premiere in Sacramento."[55] Screen credits, minor acting roles, and invitations to film premieres are compensation for scientists' contributions that avoid the potential problems of monetary exchange.

Every person has their own conception of what constitutes adequate compensation for their expertise. The problem is that rewards like film

tickets cost studios very little. Donald Francis would never consider making VaxGen's proprietary scientific work public, yet he basically worked for free on a film that made hundreds of millions of dollars for other people. Studios know that many scientists are satisfied merely to be associated with the "glamour" of Hollywood. Studios also take for granted scientists' reluctance to take pay for their services as well as scientists' desire to perform a public service by fixing cinematic science. Physicist Jim Kakalios, for example, did not initially ask for any compensation for his phone conversations, personal meetings, and on-set work with the filmmakers of *Watchmen*. He was undertaking this work out of a strong desire for science outreach and for fun. At some point he felt he had fulfilled his outreach duty and wanted financial compensation. "Ultimately it was like, well if I am going to be spending a lot of time then we have to start negotiating some sort of compensation or something," he said. "At that point they were like, 'look we basically have what we need so thanks a lot.' I don't mean thanks in a dismissive way but you know." Kakalios was certainly happy with the outreach opportunities that emerged from his association with the film, but it is clear that the studio profited from his commitment to the public understanding of science.

For their part, most scientists are ignorant of what would represent adequate financial compensation for their consulting work. I met a physicist on one occasion who had started consulting for a new television program. He knew of my writing on this topic and the first question he asked me was "Am I getting paid enough?" Filmmakers can get scientific expertise very cheaply and it is clear that scientists are selling their expertise short in this relationship. Not only did Raul Cano's publicity work on *Jurassic Park* alienate his colleagues, he also realized that he was being underpaid for his services. At the end of this publicity tour he spoke in a revealing way to the *Los Angeles Times*:

More than anything, [Cano] had come to realize that his relationship with the Hollywood promotional juggernaut was not symbiotic. Spielberg was going to make many, many millions off the movie, helped in part—as even he admits—by a suggestion of scientific plausibility created by the work of Cano and a few others. All Cano could count on, meanwhile, was a case of laryngitis. "I got the fame," he told a well-wisher in the lobby, "but not the fortune." In private, he put it more bluntly: "I got short changed, and I also got burned. Why? Because I am naive." Well, professor, that's show business.[56]

Several of my informants also recognized after the fact that they had severely underestimated their expertise's value to the studios. Bryan Butler, for example, was thrilled with the amount he was paid for working on *Contact* until he spoke with another consultant on the set. "They were not paying me that much," he found. "It was pretty good for a post-doc at the time! I was like, 'Wow you want to pay me that much?' Then when I told one of the other consultants, who was there consulting on the seeing-eye dog, how much I was getting paid they said, 'Oh God! You should have bartered for more! They would have paid you a lot more than that.'"

Butler's contributions can be felt throughout *Contact*, while the seeing-eye dog expert was only relevant for a single scene. Yet, Warner Brothers paid Butler far less for his expertise. Should not Butler's scientific knowledge be worth at least as much as the seeing-eye dog expert? From Butler's perspective, however, he felt he was fortunate that they had paid him anything since there were other scientists who would consult for even less. Chris Luchini came to the same conclusion after his consulting experience on *Deep Impact*: "They figure that since you are a scientist you will do it for free."[57]

This willingness of scientists to offer their expertise for free has prevented several consulting companies from establishing fee-based businesses. Daniel Kubat disbanded his company Fact of Matter when he was unable to get enough paying opportunities to support himself. Joan Horvath of Takeoff Technologies was also unable to sustain her consulting business because of the ready availability of cheaper alternative experts:

Here's why we have never done a lot of science consulting: Scientists will work for free. Most scientists are thrilled to go on a movie and they will work for free. The point at which a scriptwriter needs advice is very early when it's 'spec.' So, there is no money in the project yet. They can't pay you. We've tried to get people to pay us some smallish amount, to separate out the flaky spec from the people who think they are going to get a contract. People won't pay it. They will start calling universities until they find someone who will do it for free. That has been the problem.[58]

The success of NAS's Science and Entertainment Exchange program shows the appeal the fee-free model making it more difficult for other organizations to charge for their consulting services. The NAS has the capacity—and a strong desire—to offer their services for free. Their program runs out of

a financially stable organization that sees this service as part of their mandate to improve the public understanding of science. Therefore, their only concern is maximizing the number of entertainment professionals receiving scientific advice including any who might be turned off by a fee.

Horvath points to an additional problem for science consulting businesses: a good deal of consulting work occurs well before films are greenlit. While early conversations may lead to later paid consulting work, advice given to writers over the phone is rarely compensated. This is a major dilemma for scientists. The earlier they get involved, the more impact they can have on a film. Yet, the earlier they get involved, the less likely they will be compensated for their advice. This dilemma has made Wayne Grody, for one, a little disappointed with his consulting work:

I am very receptive, probably too much so. I'll talk to anyone. . . . I give the writer story ideas. In a way that part bothers me. I feel that I am selling myself a little too cheap. Because it's one thing to get a completed script and make some corrections. That doesn't take much work. I shouldn't get paid or screen credit for that. On the other hand, if I am giving them the whole premise, well that's potentially worth a lot of money and yet you get nothing. If you're the technical advisor you get paid for that but you are not considered one of the writers. The contracts, believe me, spell that out in great detail. That you have no claim to being a writer of this. No matter how many ideas you gave. Because they don't want you suing them later that they stole your ideas.

Like Butler, Grody undervalues the worth of his expertise. He believes that fixing script errors is not worth much because it does not take *him* much time, never mind how much work it would take for the screenwriter to fix the script. Still, he recognizes that his advice could potentially be providing filmmakers with the central concept for a movie that could make millions of dollars. It is also clear that studios recognize this possibility as well and they take measures to protect their profits.

As subsequent chapters will demonstrate, hiring a scientist is worth the expense for studios. Scientific expertise compliments filmmaking expertise in a way that contributes entertainment value to cinematic texts. A consultant's impact on a film can be immeasurable. Yet, Grody and many other scientists provide their expertise to the entertainment industry for very little. Scientists are giving these ideas away for free because they are caught between union laws, industry precedent, university regulations,

and, most significantly, a strong sense of public duty. In the context of entertainment culture, scientific expertise is a commodity. The involvement of organizations like the NAS and NSF has certainly increased the level of scientists' involvement within the entertainment industry. The next challenge for these organizations is to find a means by which the expertise of their members and grantees is not only utilized but also appropriately compensated.

4 Scientists on Screen: Being a Scientist, Looking Like a Lab

Contact (1997) was partly filmed on location at the Very Large Array (VLA) in New Mexico, which is a component of the National Radio Astronomy Observatory (NRAO). Filmmakers hired radio astronomer Bryan Butler to control the radio telescopes during filming and to serve as on-site science consultant. Butler also worked with them in Los Angeles while they filmed scenes at a mockup of the VLA's control center. Filmmakers asked him to review script pages and to contribute unique dialogue.

In one instance, on the spur of the moment director Robert Zemeckis needed to know: What would *Contact*'s star Jodie Foster's character and her colleagues say when they are verifying the alien radio signal's authenticity? Essentially, he was asking his scientific expert to put words into the mouth of an actor so that she spoke with authority. Butler quickly wrote some dialogue that the director approved and gave to the actors. I start with this story because it seems like a fairly standard use of a science consultant's expertise. Filmmakers need dialogue for a radio astronomer character so they ask a radio astronomer to write this dialogue. This story, however, is not as straightforward or as simple as it appears. Is Bryan Butler's "expertise" really in writing film dialogue?

Although Zemeckis was satisfied with the dialogue provided by Butler, not every filmmaker had cause to be happy. By writing dialogue the science consultant was actually veering into the screenwriter's area of expertise. According to Butler, providing dialogue was a tricky proposition:

They had to be a bit careful about having me make dialogue changes because the writer, of course, didn't like to not be involved in these things. Some of the changes had to go through the writer. Some of these changes happened right when they were filming and could not go through the writer. Zemeckis would just say "This is the change," because the director is in charge of everything basically. The writer he

was pretty good about these things and was fine as long as he had a little advanced notice. But things happen so quickly that sometimes you didn't have time to give him notice.

Butler was not the only consultant who indicated to me their concern that screenwriters would find out they were creating dialogue. Another of my informants was proud that "a very significant portion of the technical dialogue in [the movie] is directly what I wrote," but asked me not to attribute this quote for fear of upsetting the screenwriter. As professional science consultant Donna Cline tells it, scriptwriters are very protective of their work and so when she recommends dialogue she does it carefully, "with tea and scones."

Technically neither the director nor any other member of the filmmaking crew has the legal right to make script changes without the screenwriter's consent. The Screenwriters Federation of America has very specific rules about when, how, and who can alter a screenwriter's creation. The director may have ultimate power on the set, but the union's job is to protect the screenwriter's intellectual property. Allowing anyone to change scripts without the writer's knowledge or consent devalues their members' expertise. In addition, a science consultant who writes dialogue has a legal claim to royalties as an author of the film. This opens the film's production company up to potential lawsuits. This is aside from the fact that screenwriters take professional pride in their work, and they resent outsiders coming in and telling them their dialogue is wrong.

Daniel Kubat pointed out to me that the screenwriter is just the most obvious filmmaking professional who may feel a science consultant encroaching on their area of expertise. In reality, a science consultant intrudes into someone else's area of expertise with every piece of advice. Kubat, for example, has an undergraduate engineering degree from MIT, yet he was forbidden from ever making drawings for any of the film crew because that would go against the rules of the Illustrators and Matte Artists of the Motion Picture and Amusement Industries Union. He had to describe his ideas to a union artist who would then make the drawing for him. Throughout this book I refer to "filmmakers" as a general category for practical reasons. In actuality, production crews represent an incredibly diverse group of experts, each heavily protected by unions.[1] Not only did Bryan Butler help write dialogue for *Contact*, he also gave advice to the actors, helped conceive the set designs, and assisted in the filming of the

radio telescopes. In part, he was telling the actors, set designers, and cinematographer in specific contexts how to perform their jobs.

Despite the dangers that he might alienate his screenwriter, call down the wrath of the screenwriters' union, or open the production company to a lawsuit from a savvy science consultant, Robert Zemeckis valued Bryan Butler's advice enough to bend the rules and asked him to write dialogue for the film. Clearly there is something unique in the nature of a science consultant's expertise worth this risk. It is still an open question, however, as to what exactly is the nature of the expertise these consultants are providing in the context of fictional Hollywood films.

Acting Like a Scientist

I took Errol Flynn to see the dailies with me. Had a nice talk with him and he absolutely agrees with you. He also believes that the shirt is lousy and makes him look like an actor and not a doctor—which he is supposed to portray. He will switch the shirt in the next sequence and will start to wear home-spuns and tweeds.

—From a memo from producer Henry Blanke to executive producer Hal Wallis concerning *Green Light* (1937)[2]

Stereotypes recur in cinema because they possess utility. For Errol Flynn and the makers of the film *Green Light*, "home-spuns and tweeds" was a quick visual cue that Flynn's character was a "scientist." Cinematic scientist stereotypes, however, are no longer the norm. The prevailing portrayal of scientists has changed over the last fifteen years.[3] Audiences have become more sophisticated and they no longer accept obvious caricatures so willingly. To maintain a high level of realism, studios frequently call in science consultants to help actors portray "scientists." Clearly, the thinking among filmmakers is that if a scientist has any sort of expertise, it certainly would be in how to act like a scientist.

The presence of science consultants on a film minimally prevents the depiction of scientists as one-dimensional stereotypes. Consultants pore over scripts and are quick to point out any characterizations of scientist characters that veer toward stereotypical portrayals. The consultants for *Deep Impact* (1998) complained to filmmakers about the inclusion of an eccentric astronomer who ran around nude at an observatory in an early script. According to Chris Luchini, the nude astronomer was "thrown out

immediately" after he and the other consultants objected.[4] Similarly, Seth Shostak "tried to wean the filmmakers from the cliché image of scientists as clipboard carrying, labcoat-wearing ciphers" while working on *The Day the Earth Stood Still* (2008).[5] Like Luchini and Shostak, most science consultants balk at depictions they feel will convey to the audience the problematic stereotype of scientists as "mad" or as "absent-minded professors."

Consultants can remove obvious stereotypes, but that still leaves the question of what exactly constitutes a "realistic" scientist in cinema? Unique to scientists are their physical actions within scientific spaces, which are an important means of conveying a sense of scientific authenticity. This is particularly true for minor characters. Lab technicians, field assistants, and other behind-the-scenes scientific workers need to appear as if they are actually doing the work of science. For Wayne Grody, this meant teaching minor actors and extras on *The Nutty Professor* (1996) how to engage in molecular biology procedures, such as operating a pipette, in order to create a sense that the fictional "lab" appeared to be doing legitimate scientific research.

Consultants also need to provide filmmakers with the motivations behind these actions. *Contact*'s filmmakers, for example, wanted help choreographing the action of background characters during the alien signal discovery scenes. This mainly entailed "moving actors from one side of the room to the other" and answering questions like "why would they want to go over there?" Butler essentially provided justifications for characters' on-screen activities:

We had a lot of paper shuffling. We would have people go back and forth to the printer. Go back and forth to get books. We typically did a lot of that ten years ago. Ten years ago [in 1997] there was a lot more paperwork involved so you would be checking books and printouts and things as the observations went on. So I would tell the director, "This person could get over there by just going over to the printer and they would tear off a sheet and walk back to where they were and then have them go to look at a particular computer screen. This is the reason they have to walk over there."

To a scientist this may not seem the best use of Butler's expertise. In this instance, however, they needed to tap into expertise built upon Butler's experiences as a radio astronomer. Of the people on the set that day, only Bryan Butler was an expert on when to have the actors shuffle

papers, when they should go to the printer, and when they should grab a book.

Even though scientific actions on screen are not meant to produce anything tangible, it is still a difficult task teaching actors how to carry out these procedures. In his study of experimental replication, Harry Collins shows how difficult it is to transfer "tacit knowledge" between scientists.[6] While information is easily articulated, practical knowledge embodies skills that are not so easily communicated. Therefore, the easiest way to make sure background characters act like "scientists" is to get real scientists to perform these actions.

Several consultants reported to me that they frequently request that actual scientists handle scenes calling for real-life scientific activity. Donna Cline strongly believes that scientists' involvement adds to a film's realism and she recommends that filmmakers use real scientists whenever possible because their actions will look "gesturally correct." Dave Bayer served as "hand double" for actor Russell Crowe on *A Beautiful Mind* (2001) so that the writing of the equations had a natural flow (figure 4.1). Along these same lines, Seth Shostak wrote out the math equations featured in *The Day the Earth Stood Still* in pencil. Actor Keanu Reeves then traced over them in chalk during filming and editing techniques were used to make it look

Figure 4.1
Mathematician Dave Bayer wrote equations as the "hand double" in *A Beautiful Mind*.

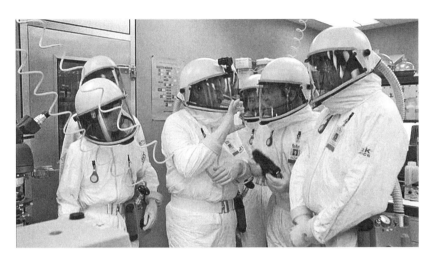

Figure 4.2
Many of the "actors" within these suits in *Warning Sign* are postdoctoral researchers.

like he was writing faster than he was. Bob Goldberg said that there were two reasons for suggesting that his postdoctoral and graduate students perform all the scientific actions in *Warning Sign* (1985). First, these activities would appear more realistic if carried out by people who undertake them in the course of their daily work, and second, he felt it would take too long to teach the actors how to do them correctly (figure 4.2). Goldberg's experience as a scientist told him that the transfer of tacit knowledge is a frustrating endeavor. If you have people on the set who already possess these skills, why not let them do it for themselves?

Allowing scientists to appear as background characters is acceptable, but filmmakers cannot replace Jodie Foster, Pierce Brosnan, or Dennis Quaid with scientists. These are Hollywood stars and studios are banking on them for box office appeal. These actors expect scientists to advise them on how a scientist would look, behave, and talk in any given situation. As Donna Cline pointed out to me, actors are the ones in front of the camera and on the screen. It is their reputation and financial future that are on the line if their portrayal does not ring true. Therefore, it is imperative that the actors look like they know what they are doing both in their physical actions and their characterizations. Acting was so important to *Sunshine*'s

(2007) director Danny Boyle that he set up a scientific "boot camp" for actors run by physicist Brian Cox.

It is common for science consultants to arrange visits to research facilities to allow actors to watch professionals in action. Morgan Freeman and Keanu Reeves met with staff at Argonne National Laboratory to prepare for their roles in *Chain Reaction* (1996).[7] To help them prepare for their roles in *Hulk* (2003), John Underkoffler took Jennifer Connelly, Eric Bana, and Nick Nolte to Steve Mayo's laboratory at the California Institute of Technology. Connelly, Bana, and Nolte worked with scientists on learning scientific actions: "They put on the lab coats, they put on the gloves, they did a little titration, and prepared some samples" (figure 4.3).

Learning appropriate actions is important to the actors, but the real value in these trips is that they allow actors to watch scientists in their "natural" habitat. Actors want to find out "what makes a scientist tick," so they can give authentic portrayals. In addition to lab visits, actors will "shadow" individual scientists to try and absorb their persona and daily experiences. According to Jack Horner, Sam Neill "hung out with me so he could see what a paleontologist is like" for his performance in *Jurassic Park* (1993). Cillian Murphy spent a week watching Brian Cox

Figure 4.3
Actor Eric Bana spent time with biological researchers in order to learn how to operate scientific equipment for his role in *Hulk*.

work. Dustin Hoffman prepared for his role as an epidemiologist in *Outbreak* (1995) by spending time with Donald Francis, who recalls his interactions with Hoffman in a *Minneapolis Star Tribune* interview: "We ended up going down [to Los Angeles] for 12-hour script sessions on weekends. He wanted to make sure everything was exactly right." At times, recalls Francis, Hoffman's attention to detail reached weird extremes. "There we were, driving down the freeway, and while he's driving he's also watching me intently, soaking up my gestures like a sponge, barking at his assistant in the back seat: 'Watch that! Write that down!'"[8] By following Francis around and taking detailed notes of his actions, Hoffman hoped to get an essence of what it was to be a scientist. In addition, the film's primary science consultant Donna Cline provided Hoffman an "actor-friendly" notebook containing a detailed "psychological profile" of epidemiologists. Cline maintains that these notebooks are popular among actors because they are searching for any means of making their performance authentic.

Portraying an authentic scientist is not the same as creating portrayals that correspond to "real" scientists. Actors are looking for some specific, but generalized, behaviors in the actions of a scientist that would help them to convey to audiences that they are indeed viewing a realistic scientist. Did Dustin Hoffman's intensive watching of Donald Francis provide him with some insight that allowed him to portray the "reality" of a scientist? Did Hoffman, Reeves, Bana, or any other actor find something unique about scientists and their motivations that would connote "scientist" to the audience versus "stock broker" or "waitress?" Essentially, audiences are seeing a particular actor's interpretation of the category "scientist" with modifications to make the on-screen scientist heroic or evil as the case may be; such portrayals are also influenced by previous entertainment texts. Actress Hilary Swank may have spent time with astronaut Susan Helms preparing for her role in *The Core* (2003), but she essentially pulled out characteristics that matched the depiction of astronauts from previous films.

Actors are hoping to find something unique about scientists and ultimately are disappointed when they find out that scientists are basically just like everyone else except for their career choice. Actor Aaron Eckhart interacted with several geologists preparing for his role in *The Core*. He appeared shocked to discover that scientists are "just as concerned as you

or I about everyday things."[9] Michael Brett-Surman of the Smithsonian Institution provided advice to filmmakers early in *Jurassic Park*'s preproduction process. Given he is a leading expert on duck-billed dinosaurs, he assumed the questions would be related to dinosaurs. Instead, they wanted to know how a paleontologist would react to various situations: "They interviewed me for three hours. And at no time did they want to know what dinosaurs looked like, how they moved, anything biological," Brett-Surman recalled. "What they wanted to know was, 'If you dug this up, what would you think? If you came around the corner and had this situation with a dinosaur what would you think? How would you react to this?' That's all they were interested in."[10] For Brett-Surman this focus on his "feelings" seemed to be a strange use of his expertise, especially for the implication that a paleontologist would react differently to these situations than a regular person would. If Brett-Surman, as a paleontologist, walked around the corner and saw a *Tyrannosaurus rex*, he said he would react the same way anyone else would: "I'd load my pants and faint."

Scientists, in fact, are concerned that this perception that they are somehow "different" is what perpetuates caricatures of their profession in popular culture. The scientists I spoke with welcomed plot elements indicating flaws in scientist characters. Pablo Hagemeyer of The Dox consulting firm in Munich, Germany, feels that these elements are important in humanizing scientists.[11] In one script he reviewed, the scientist character was having an extramarital affair. Not only was Hagemeyer okay with this plot element, he also felt it would present a more realistic portrayal since "we know that, of course, scientists have affairs." After a hundred years of movie caricatures, science consultants hope to help actors create cinematic scientist portrayals that match more closely to the experiences of real scientists: that they are just like everyone else.

However, although they have the same daily concerns as everyone else—family, bills, housework, and so on—scientists are different from other people in one key respect: they are motivated to do science. Scientists have chosen a career in which they spend tedious months working in ignorance; they live most of their lives not knowing. Brian Cox tried to articulate scientists' underlying psychological motivations to the makers of *Sunshine*. Although the cast, and Cillian Murphy in particular, mimicked his specific actions and behaviors he tried to convey to them that acting like a scientist is not about these small details. Instead, the essence of being

a scientist is to understand why scientists spend their lives seeking to understand the laws governing our universe. Cox's job was to help the director, screenwriter, and actors understand, in this case, "What would motivate a scientist to go on this suicidal mission to the Sun?" According to Cox, the filmmakers would have been motivated by a sense of religious belief. But if Cox, as representative of the scientific community, was not motivated by religion, then what would motivate him? Among many things, Cox told the filmmakers that he was motivated by a desire to understand how the natural world operates. It was then up to the actors to use their own skills in conveying this to the audience.

The Language of Science

One element unique to scientists' behavior is the use of scientific jargon. The arcane nature of scientific language adds legitimacy to a film's images and plot. In her seminal work on the science fiction genre of film, Vivian Sobchack maintains that scientific jargon's incomprehensibility renders it dull, but that its dullness is an asset; for a "dull and routine language by remaining dull and routine may very well authenticate the fiction in the films' premises or images."[12] For Chris Toumey, the importance of scientific language is that it connotes "scientific knowledge" and knowledge is what gives science its authority.[13] The interconnection of language, knowledge, and power helps to explain the use of pseudoscientific gibberish in many earlier science fiction films. Characters that spout esoteric words demonstrate to the audience that they have powerful scientific knowledge that others do not possess. By this logic, the more obscure the words, the more powerful the knowledge should be.

Filmmakers have to come to understand, however, that false "technospeak" may do more harm than good. Technospeak that does not ring true with an audience is likely to put them off a film's scientific underpinnings. The rewards of including authentic jargon far outweigh the risks of including impressive-sounding but fabricated technospeak. Rather than sounding silly or boring, legitimate volcanology phrases such as "pyroclastic clouds" and "glowing avalanche" added a sense of dread to the disaster film *Dante's Peak* (1995). In contrast to Sobchack's assertion about the dullness of scientific language, actual scientific jargon in cinema projects an image of

science that is progressive, cutting edge, and exciting. This is especially the case when real scientific language is tied to high-tech gadgetry that conjures up a James Bond/*Mission Impossible* sense of "action" and "adventure."

Every consultant I spoke with helped filmmakers to develop technical dialogue. Much of this work occurs during the script development stage as filmmakers send consultants numerous script revisions for review. Looking over copies of these script revisions it is obvious that consultants go over them with a fine-tooth comb, looking for any dialogue that does not ring true either for technical terms or the way a scientist would speak. Astronomer Josh Colwell of the University of Central Florida understood that most of his script changes for *Deep Impact* were "trivial" including correcting the names of stars the characters see in the sky.[14] For Wayne Grody, dialogue was the only thing he could make sure was completely accurate in the comedy *The Nutty Professor*. Although Grody was working on a comedy, a genre not known for its scientific accuracy, he expresses a key rationale for why consultants pay close attention to scripts. Dialogue may be the only cinematic element for which a consultant can guarantee accuracy. As will be evident throughout this book, much of a science consultant's filmmaking experience consists of compromises or deference to the filmmakers. Dialogue, however, is the one area where scientists rarely have to defer to a filmmaker's expertise. Dialogue changes do not cost any money or take extra time to achieve nor do they change a film's plot (although there are significant exceptions as discussed in this book). So when Josh Colwell made sure the names of the stars in the sky were appropriate or when Wayne Grody made notations changing the phrase "DNA strand" to "DNA sequence" they knew these changes would be made without a struggle.

Many actors greet even legitimate scientific terms as if they are a foreign language. An article in the *Los Angeles Times* catalogues the reactions of several actresses from films in the late 1990s, including *Jurassic Park: The Lost World* (1997), *Contact*, and *Volcano* (1996) on having to learning how to technospeak.[15] An executive producer on *Volcano* called scientific nomenclature "gobbledygook," while one actress called scientific terminology "techno-babble," comparing it to learning Japanese. Josh Colwell relates one instance where he had to convince actors that the word *outgas-*

sing was a legitimate term in planetary science and was not a joke he was playing on them. Colwell's anecdote is telling because it clearly shows how actors and filmmakers must take it on faith that the consultants are providing them with appropriate technical terms. If it all sounds like gobbledygook, how could you know if *outgassing* was a made-up word?

Science consultants also assist actors with the pronunciation of these unfamiliar words. Actor Morgan Freeman had difficulty pronouncing the phrase *Ariane missiles*, so Josh Colwell convinced *Deep Impact*'s filmmakers to switch to the easier-to-say phrase *Titan missiles*. On *Outbreak* Dustin Hoffman and his fellow actors needed help with pronunciation of words specific to molecular immunology like *gamma globulin* and *aerosolized*. For the *Jurassic Park* films (1993, 1997, 2001) actors needed to pronounce complex dinosaur names such as *Pachycephalosaurus* and *Compsognathus*. One strategy for consultants is to write out the words phonetically for the actors, an approach used by Donna Cline and Jack Horner on *Outbreak* and *Jurassic Park* respectively.

Actors are trying to convey to the audience that they are scientific experts in the fictional world. Scientific jargon's authority is not in the words themselves but in suggesting that the person saying them actually knows what the words mean. An actor who struggles with a word or phrase will not convince anyone that his character knows the jargon's meaning. An actor who can pronounce the appropriate words gives his character power within the fictional world. These characters know things that other characters do not.

Ultimately, actors and directors are tapping into a scientist's experiences in being a scientist. Experiential expertise is, in fact, the most basic type of expertise expected from science consultants. In this respect, scientists are no different from other occupational consultants working on popular films such as military consultants, police advisors, political consultants, or even astrological consultants. All of these consultants know through experience the actions, psychological motivations, movements, behaviors, lingo, and interpersonal interactions needed to convey their occupation. What separates science from other professions—with the exception of historical consultants—is that scientists' actions and behaviors are in the service of a knowledge-producing activity. Authenticity comes from not only looking like you can hold a pipette properly, but that your actions will lead to knowledge production.

The Look of Science

Josh Colwell was not the first consultant hired to work on *Deep Impact*. When Colwell asked his brother, the film's first assistant director, about becoming involved he was told that the production already had two science consultants. Yet, his brother kept calling him with filmmakers' scientific questions. At some point director Mimi Leder realized that it would be useful to have an astronomer on hand since their film revolved around cometary science. If Leder needed to bring in Colwell as a scientific expert, what were the two science consultants already on their staff doing? According to Colwell, these other consultants were brought in to help with the film's visuals, not its scientific underpinnings. "As it turns out the consultants they had on board were not astronomers," he explained. "They were a former NASA mission controller, Gerry Griffin, and a former astronaut, Dave Walker. So their areas of expertise were limited to the spaceships and the NASA control room sets. They didn't have anybody who knew about comets or celestial mechanics or impacts themselves. At that point I had given a lot of informal advice to them through my brother, so they decided to officially bring on board some astronomer consultants." Colwell's story underscores the point that visual elements are filmmakers' primary concern, not the accuracy of scientific information. Filmmakers will often seek advice concerning visual aspects before they even think about help on other scientific elements.

Not surprisingly, several consultants' initial involvement on a film came through the art department or the production designer. Donna Cline on *Deep Blue Sea* (1999), *Hollow Man* (2000), and *The Shaggy Dog* (2006); John Underkoffler on *Minority Report* (2001); Wayne Grody on *The Nutty Professor*; Daniel Kubat on *K19: The Widowmaker* (2002); and Jim Kakailos on *Watchmen* (2009) were all brought in to help with visuals before their consulting roles expanded. Every consultant mentioned to me how they were shocked at the level of detail and the amount of work that went into making the laboratory sets look realistic. According to Bryan Butler, NRAO rules prevented *Contact*'s filmmakers from filming inside the control room of the VLA so they created an exact replica next door to the actual control room and a second one on a set in Los Angeles. The filmmakers even went so far as to take paint scrapings from the walls to make sure the paint colors matched up exactly with the paint in the real control room. Ironically, it

was difficult for Butler and other members of the scientific community to accept that another professional culture could be as detail oriented as scientists. This at least partially explains the scientific community's concern about scientific accuracy in cinema: scientists cannot accept that filmmakers will pay attention to the small details that are at the heart of science.

Certainly a dominant component in the look of science is the design of scientists' workspaces. Research spaces incorporate visual elements that convey to audiences that "science" is on display. Science consultants must answer questions, such as: What does a dinosaur excavation site look like? What equipment would a biolevel 4 laboratory include? What kinds of instruments do volcanologists use? Verisimilitude does not necessitate a move away from audience expectations of scientific spaces as foreign and secretive. Lab scenes do not have to be set in remote castles to provide a sense that esoteric research is taking place. Scientific spaces, with their strange symbol-laden notebooks, exotic equipment, and liquid-filled beakers, are alien enough to signify science as an arcane intellectual pursuit.

The Symbols of Science: Lab Notebooks, Mathematics, and Computer Screens

The visual equivalents of scientific jargon are the impenetrable symbols and graphical inscriptions prominently displayed on blackboards, in lab notebooks, on test tubes, and on computer screens. Scientific symbols lead us to an intellectual treasure but only a few people have the keys to break this code. Laboratory notebooks are vaguely recognizable to audiences. They can grasp that notebooks are logs of scientific activity detailing what scientists have tried, what has worked and what has failed, but notebooks are still densely packed with obscure notations like "TAE" and enigmatic genetic names like "L-anatoxin gene." John Underkoffler took advantage of this play between the familiar and the mysterious when he turned the opening credits of *Hulk* into an extended look at the scientist character David Banner's lab notebook. The notebooks provided important back-story information with recognizable phrases like "I intend to achieve human regeneration" and "hints of genetic modification." These recogniz-

able phrases, however, were juxtaposed with unrecognizable symbolic phrases like "α-β-γ complex" and "fragment β-ENH-17." This juxtaposition has the effect of informing audiences of Banner's goals while obscuring his methods and adding a veil of mystery. The symbol-laden notebooks, combined with a sinister music score and intercut with shots of dismembered starfish and gassed monkeys, tell the audience that David Banner may be searching for "knowledge" but that this may be "forbidden knowledge."

The exact meaning of the symbols in these cinematic lab notebooks is not important for them to function as visual cues of science's impenetrable nature. In fact, the notebooks often bear no relationship to the experiments on screen since these experiments can be fantastical or about imaginary creatures (see chapter 7). Underkoffler invented *Hulk*'s symbolic phrases or borrowed them from work on other organisms. Scientists do not possess any concrete knowledge about dinosaur genetics so UCLA laboratory technician Ron Rogge used *Drosophila* genetics for his notebooks in *Jurassic Park*. These literal "scientific symbols" are the easiest means by which to, in Chris Toumey's terms, "conjure science."[16] For most audiences it makes no difference whether the symbols refer to dinosaur DNA or *Drosophila* DNA, these images are recognizable only in that they convey the notion of "science."

Michael Lynch illustrates how "mathematization" is an important process in science.[17] By mathematizaton Lynch means that scientists create symbolic representations that bring nature inside the scope of mathematics. Mathematization has the dual effect of making scientific explanations seem both "natural" and mystifying. Mathematical equations in movies convey this duality of the known and unknown. There have been several specialist "mathematics consultants," including Harry Pinkham for *The Mirror has Two Faces* (1997), Patrick O'Donnell for *Good Will Hunting* (1997); Linda Wald for *Contact*; and Seth Shostak, Marco Peloso, William Hisock, and Hector Calderon for *The Day the Earth Stood Still*. Director Ron Howard's main concern for *A Beautiful Mind* was to make sure the math was visually interesting. In an article in *Nature*, Howard's consultant Dave Bayer contended that reality was the key to math being visually interesting because "audiences can tell when the mathematics is real."[18] It is not clear, however, whether lay audiences would be able to distinguish between

actual and fictional mathematical equations. Bayer contradicts himself later in the article by acknowledging that most equations are on screen for so little time that audiences "barely have time to recognize it's a problem in de Rham cohomology." It is a good wager that even if the entire two-hour film were focused on this equation only a handful of people in the world would recognize it.

Still, filmmakers hire math consultants to help them with their equations because they also believe that audiences can spot fictional mathematics, even if they themselves do not understand any of the equations. Filmmakers also want genuine mathematics because math's inherent complexity is a visual indication that any characters grappling with these equations must be doing something extraordinary. Filmmakers on the original version of *The Day the Earth Stood Still* (1951) hired Samuel Herrick to develop an equation, expressed both visually and orally, that would convey to audiences that the alien Klaatu was extremely intelligent, from an advanced race, and peaceful. Herrick reasoned that an equation related to celestial mechanics would be most appropriate, specifically an equation related to his own work on the "three body problem" in astronavigation (figure 4.4).[19] The equation itself was so complex that Herrick provided the director with a list of "confusable symbols" (figure 4.5).[20] Note in figure 4.4 the presence of signs saying "Don't Erase" and "Don't Touch." Once Herrick left that set there was no one who could put it back together outside of a scientist (or an alien intelligence).

Computers are a standard feature of any modern research space. Unlike static background equipment like centrifuges and refrigerators, computers require extra visual graphics for their screens. Special effects technicians routinely bring in scientists to help them generate graphs, data streams, and computer screens. Roger Silverstone refers to these types of mass media representations as semiomorphic images, and they are the literal visualization of the products of scientific work.[21] The special effects company Banned From the Ranch specializes in the representation of scientific computer screens in cinema and worked with scientists on projects including *Dante's Peak*, *Twister* (1996), and *The Relic* (1997).

Visual effects supervisor Stephen Rosenbaum brought in Ian Kelly of the computer effects company Kelly's Eye to generate the computer screens in *Contact* because "virtually every scene in the film, [includes] computer screens, video or television monitors of some kind."[22] Kelly, in turn, hired

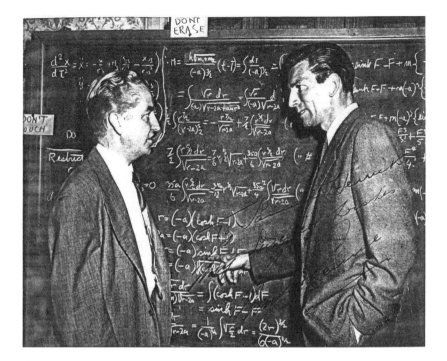

Figure 4.4
UCLA astrophysicist Samuel Herrick and actor Michael Rennie on the set of *The Day the Earth Stood Still*, standing next to a blackboard filled with Herrick's mathematical notations.
Source: Samuel Herrick Papers (Ms1978-002), Special Collections, University Libraries, Virginia Polytechnic Institute and State University.

Figure 4.5
Herrick provided filmmakers with a list of "confusable symbols" to help actors on *The Day the Earth Stood Still*.
Source: Samuel Herrick Papers (Ms1978-002), Special Collections, University Libraries, Virginia Polytechnic Institute and State University.

(a)

(b)

Figure 4.6
Data generated by Tom Kuiper and Linda Wald for *Contact*'s computer screens.
Source: (a) courtesy of T. B. H. Kuiper, PhD, scientific consultant to *Contact*; (b)
courtesy of Linda Wald, PhD, scientific consultant to *Contact*.

Tom Kuiper and Linda Wald to help his team develop appropriate graphics
for the computer displays (figure 4.6).[23] Kuiper and Wald assumed that
they would generate graphical displays based on standard radio astronomy
equations and Kelly would simply upload these legitimate scientific graph-
ics. The process turned out to be more complex. Kuiper and Wald gener-
ated data that Kelly modified for aesthetic reasons before a computer effects
specialist built the displays. As Kuiper says, "All the computer screens in
the film were generated rather painstakingly by somebody at Kelly's Eye.
Basically, frame-by-frame implementing our ideas and our inputs which

Figure 4.7
Special effects technicians modified real scientific data so that it would appear more dynamic in *Contact*.

Ian had supplemented." In this case, scientific authenticity was an easier and cheaper option, but when it comes to visuals filmmakers demand control over everything that will appear on the screen (figure 4.7). In essence, Kelly and his technicians were reasserting their expertise as graphic designers.

Filmmakers also utilize computer screens to visualize scientific phenomena that cannot be seen with the naked eye. Meteorologists from the National Severe Storms Laboratory helped Banned From the Ranch create the Doppler radar display interfaces for the film *Twister* in order to show the audience tornadoes both "seen and unseen."[24] Molecular biologists also helped Banned From the Ranch develop computer screens visualizing DNA sequences for *The Relic*.[25] DNA, in fact, is an interesting scientific object because it is visually interesting and it is a powerful cultural icon—the "stuff of life."[26] The problem for science consultants is that DNA is not a visible object. After Wayne Grody informed the makers of *The Nutty Professor* that molecular biologists never directly see DNA, they still insisted that DNA be a part of the film's visuals. Ultimately, Grody suggested that they show DNA unwinding on a computer screen. Not only did they get DNA visuals, his suggestion also helped them minimize dialogue by including pertinent information on the computer screen like "mutations found." In this case, Grody's scientific expertise helped filmmakers utilize their own visual and storytelling expertise.

The Spaces of Science: Laboratories, Field Sites, and Research Equipment

At the very least, scientists can ensure that research spaces do not resemble the gothic, dungeon labs in old horror films. This is, of course, unless filmmakers require the caricature of a secretive laboratory. *Hollow Man*, for example, was about a mad scientist undertaking clandestine weapons research, a factor Donna Cline kept in mind when she helped design the underground lab spaces with winding corridors and security stations. Even this mysterious research lab, however, had to look authentic and contain appropriate-looking equipment for biomedical research.

For filmmakers, the easiest, but not necessarily cheapest, way to achieve verisimilitude for cinematic research spaces is to film inside scientific research facilities. Scientific research institutions have a long history of allowing production companies to film inside their facilities. Argonne National Laboratories, for instance, allowed 20th Century Fox to use its facilities, including their Zero-Gradient Synchrotron ring room and Continuous Wave Deuterium Demonstrator laboratory, while filming *Chain Reaction*. Argonne received financial reimbursement and garnered substantial publicity as several newspapers wrote about its involvement in the film.[27] In addition, the presence of the production company increased worker morale as scientists were given a glimpse of Hollywood and large numbers of employees appeared as extras.[28] 20th Century Fox utilized several other scientific institutions while filming *Chain Reaction* including the Field Museum in Chicago, the Museum of Science and Industry in Chicago, and Yerkes Observatory in Wisconsin.

Filming inside a research facility may generate publicity, and funds, for a research institution but in many cases film production work necessitates a disruption of scientific activities. Media relations officer Catherine Foster had to convince Argonnne's upper management and the Department of Energy that the benefits would outweigh the possible disruption to scientific work before they would allow the studio to film their facilities.[29] According to Bryan Butler, Warner Brothers' large financial payment allowed them to bypass the time allocation committee of the NRAO and the National Science Foundation for gaining "dish control" time at the VLA while filming *Contact,* which meant the displacement of legitimate scientific projects. The NRAO, however, did take steps to minimize the scientific disruption. Filmmakers could only film during daytime hours

when the radio telescopes were in less demand by astronomers. Warner Brothers was also limited to a strict five-day window for filming. Even still, the production crew's presence was a significant disruption at the VLA. Ultimately, the NRAO decided the benefits of Hollywood funds and publicity was worth the costs to their research activities.

It is not always possible, or desirable, to film in actual research locations. *Jurassic Park*'s filmmakers had to design two distinct research spaces, a paleontological dig site, and a molecular biology laboratory. While the filmmakers hoped to make their site truly authentic by building the set in Montana's Badlands, for budgetary reasons they had to "settle" for filming in the Mojave Desert. Jack Horner was on hand to make sure that the research site conformed to his experiences. He also made sure that small touches were added to make the site authentic like the presence of tin foil for wrapping delicate fossils (figure 4.8a). Horner did have reservations about the depiction of the site. A full skeleton is very rare and the prevalence of loosely covered fossils is highly unusual, but he understood filmmakers' reasons for these inaccuracies and he acceded to their expertise in visuals and storytelling.

For the molecular biology lab the filmmakers relied on laboratory technician Ron Rogge.[30] Rogge's mandate was to make the lab look as much like a modern-day molecular biology lab as possible and then the set designers would modify it as they saw fit. First, he prepared laboratory notebooks and labeled beakers with the names of common reagents used in molecular biology labs (e.g., TAE buffer). Then, to make the lab appear authentic Rogge ordered research equipment both large and small. Laboratory equipment and other high-tech apparatus are what Roger Silverstone refers to as technomorphic images in visual mass media.[31] According to Silverstone these images fit "our culture's general enthusiasm for the biggest, the newest, and the most expensive" high-tech gadgets. The biggest, newest, and most expensive were what *Jurassic Park*'s filmmakers were after and Rogge, like several of my informants, was given carte blanche to order whatever was necessary from the equipment catalogues of supply houses like Fisher Scientific.

Many geneticists applauded the verisimilitude of the molecular biology lab setup. One scientist, for example, noted the inclusion of boxes of dust-free tissues, known as Kimwipes, in his film review (figure 4.8b). For this scientist, the presence of the easily identifiable green-and-white boxes,

(a)

(b)

Figure 4.8
Jurassic Park's paleontological field site (a) and molecular biology lab (b).

found in every molecular biology lab, told him that the filmmakers "knew what they were doing."[32] In reality, the presence of the Kimwipes was due entirely to the fact that Rogge, a laboratory technician, designed the labs. In this case, the filmmakers were actually better served by having the "invisible technician" assist them rather than a senior scientist.[33] Many consultants are senior-level scientific researchers who may not have done lab work for years. Their expertise lies more in current scientific thinking in their field, grant writing, publishing scientific papers, and managing people. A laboratory technician, on the other hand, would be intimately familiar with all the minute details of a laboratory. This is borne out by some of my informants, such as Wayne Grody on *The Nutty Professor* films and Bob Goldberg on *Warning Sign*, who intentionally brought their graduate students and postdocs along to help them design laboratory sets.

Dozens of companies specialize in scientific equipment prop rental, including Technical Props and Morgue Prop Rentals in Los Angeles and Scientific Props in Vancouver. Individual scientists have also provided filmmakers with material objects. The plot of *Chain Reaction* centers on an alternative, low-cost, pollution-free fuel source involving sonolumines- cence—the conversion of sound energy to light energy. Set designer Gene Serdena sought out Ken Suslick for advice on building a "realistic" looking ultrasound lab.[34] Serdena spent hours talking with Suslick while examining and recording his lab setups. Suslick also donated old laboratory equip- ment (figure 4.9). Scientific publishing companies can also lend their products to film production companies, as was the case when Elsevier and Macmillan Magazines donated books and journals for use in the lab scenes of *The Fountain* (2006).

Scientific supply companies also lend or donate equipment for reasons of product placement. Several supply companies donated equipment for *Jurassic Park*, for example, including Fisher Scientific and Precision Scien- tific.[35] Likewise, Perkin Elmer worked out a product placement arrange- ment with Paramount Pictures for their use of DNA sequence analyzers in the horror film *The Relic*.[36] It does seem odd for biotechnology companies to want their products associated with films with such obvious antibio- technology messages. Like any product placement, however, these biotech- nology companies believed they would be reaching their primary customer base: molecular biologists. Scientists do pay attention to science-based

Figure 4.9
Chemist Ken Suslick donated the sonoluminescence equipment used in this film still from *Chain Reaction*.

cinema, especially if a film features their research field. For laboratory supply companies, donating equipment to film productions becomes a cheap but effective form of advertising. In a culture that worships celebrity, appearance in a Hollywood film also brings with it a cultural capital that raises a company's status within its industry, which is something supply companies can boast about in annual stockholder meetings and brag about at industry-wide conventions.

Professional science consultant Donna Cline has a register of companies that donate equipment to her productions. To maintain a good relationship with her sources Cline must protect each product's image. In one case she persuaded the director and screenwriter to change dialogue that reflected unfavorably on a piece of equipment. "I promote this beautiful piece of machinery donated by my contact," she explained. "Then I look at the new script pages and they have a line with a character cracking on the machine. It's a throwaway line and it's not critical to the story so I said 'Hey I think we ought to pay attention to this.' Luckily they changed it. They did. Because they could see that we have the use of this beautiful machine and we are going to criticize it? No. Because it wasn't necessary." Cline understands that these supply companies save filmmakers up to $500,000 in production costs, which is what it would cost to outfit a brand

new molecular biology lab. Most members of the production crew, however, do not regard donated scientific equipment as product placements in the same way they view consumer products like a can of Coca-Cola or a Lexus car. They themselves will never buy a thermocycler or an ultracentrifuge so they treat these pieces of equipment as just more props. It takes an expert to tell them the value of this unfamiliar machinery.

Prioritizing Expertise to Make Functional Fictions

In spite of their consultants' expertise, their use of authentic equipment, and their attention to detail, my research shows that filmmakers' desire for high-quality visuals, requirement for narrative control, and need to meet audience expectations guarantee that cinematic labs will invariably be inaccurate. *Chain Reaction* was filmed in an official Argonne research laboratory and the set included equipment from both Argonne and sono-luminescence researcher Ken Suslick. Yet, the lab sets were far from accurate. For one, Argonne was not chosen as a filming location because it was a functioning scientific space. Rather, the director and the location scout picked Argonne because it had an unused laboratory with a gothic and secretive feel to it, and many winding steam-filled tunnels that could accommodate the film's numerous chase scenes.[37] In addition, while the equipment Suslick donated had been used for sonoluminescence research, it was also old, outmoded, and useless at the time of the filming.[38] The set reflected a sonoluminescence research lab at least ten years older than ones at the time of filming, a point that did not concern the filmmakers. Their goal was not to make a working laboratory, but to give the sets enough sense of authenticity that audiences would believe that high-tech and secret corporate research was taking place in the space.

Likewise, the help of technician Ron Rogge in designing *Jurassic Park*'s molecular biology lab should have rendered it as accurate as if the audience had stepped into a typical lab on UCLA's campus. *Jurassic Park*'s lab, however, was far from a typical molecular biology lab. Unlike the outdated lab space in *Chain Reaction*, *Jurassic Park*'s lab equipment was too advanced. According to Rogge he "always tried to pick equipment which was the most expensive, that looked the nicest," picking a specific microscope because it "was a lavish, expensive, top-of-the-line scope."[39] Giving advisors like Rogge free rein to order from the Fisher Scientific catalogue

guarantees that lab sets are filled with the newest, most expensive-looking equipment.

Wayne Grody was aware of this tendency to outfit labs with too much expensive equipment in his work on *The Nutty Professor*. He tried to convince the art director and director to shrink the size of Professor Klump's laboratory. According to Grody they disregarded his pleas for a more modest laboratory: "I mean this guy was supposed to be at this little Liberal Arts College in the Department of Biology and it's not like being at UCLA Medical Center," he recalled. "I just said, 'Someone like that is not going to have the state of the art, million dollar lab!' I told them to make it a little more hokey if they could. But they didn't care. They wanted it that way. So, the thing was huge and littered with expensive equipment. It must have taken up 20,000 square feet." In the battle between visuals and verisimilitude, visuals will always win. From a design perspective, a large, expensive, visually dynamic lab space is much more interesting on screen than a real but bland functioning research laboratory.

Filmmakers are quick to make changes they feel are necessary to match audience expectations for scientific spaces. In essence, filmmakers are prioritizing their expertise over those of their science consultants. Wayne Grody and his PhD students spent days making sure the lab set for *The Nutty Professor* looked authentic. According to Grody this attention to detail went for naught when accuracy fell victim to perceived audience expectations:

> We tried to make it as realistic as we could, none of this dry ice steaming and bubbling colored water. So what does the director do the day before shooting? He goes in there and says "I want red and green solutions bubbling and boiling." Just like [the movie] Frankenstein. So I got in there on the day of shooting and the thing had totally been redone and there were all these crazy things. You know, what Hollywood thinks the public expects of a scientist. That was a lesson to me that the director has ultimate authority and he can change things at the last minute. No matter how much time you spent on it.

Ron Rogge had to make similar concessions to *Jurassic Park*'s set decorators. He altered his lab setup for narrative reasons such as placing a dinosaur hatchery in the middle of a molecular biology lab. Like Grody, Rogge also had to incorporate beakers filled with bubbling, colored liquids. Filmmakers make these demands because bubbling, colored liquids look more

interesting and audiences expect them. The use of bubbling liquids on scientific sets, in particular, emerged from the early days of cinema where filmmakers required a means by which to visually convey lab activity. These early depictions created public perceptions that then led to audience expectations of a "legitimate" lab containing colored, bubbling liquids. This creates a circular relationship as new film productions catering to this expectation reinforce this perception.

What this means is that audiences see cinematic labs that are at once both accurate and inaccurate, labs that can contain representational extremes in the same spaces. *Chain Reaction* included authentic equipment filmed in an actual laboratory, but this same equipment and location were long obsolete at the time of filming. *Jurassic Park* and *The Nutty Professor* both featured high-end molecular biology equipment and authentic lab notebooks next to beakers filled with bubbling, colored liquids. The simultaneous presence of accurate and inaccurate representations means that filmmakers can claim authenticity for their lab spaces even as scientists throw up their hands in frustration. For filmmakers, real equipment equals authenticity no matter how inaccurate everything else on the set may be.

Filmmakers' expertise in creating sleek, fantastic-looking designs can also provide value for scientific institutions. The case of wardrobe specialist Chris Gilman perfectly illustrates how a filmmaker's visual expertise can be adapted into the scientific world. With the help of NASA consultants Gilman designed space suits for several high-profile space-themed films including *Deep Impact*, *Armageddon*, *Space Cowboys*, and *Zathura: A Space Adventure* (2005) as well as for the television miniseries *From Earth to the Moon* (1998) (figure 4.10). NASA itself was so excited by his cinematic space suits that they purchased one for over $24,000 to analyze its design.[40] The space agency subsequently hired Gilman to design and manufacture a prototype External-Vehicular-Activity space suit to be used for real space walks.

It is possible that NASA hired Gilman as a means of creating "sexier" space suits for image purposes. As discussed in chapter 3, NASA is an incredibly image-conscious institution that has dipped into the Hollywood pool on numerous occasions for publicity reasons. In this case, however, NASA hired Gilman because agency leaders believed his design expertise

(a)

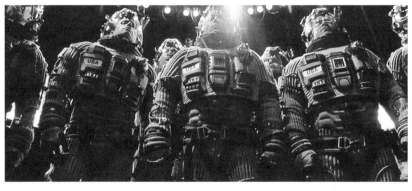

(b)

Figure 4.10
Space suits designed by special wardrobe designer Chris Gilman for (a) *Deep Impact* and (b) *Armageddon* based on NASA designs.

with cinematic space suits would actually help them improve the efficiency of their real-life suits. Gilman's prototype featured several elements that increased space suit functionality including a shoulder flap to add mobility, a new helmet for improved visibility, and an inflatable bladder to increase comfort. Of course, it should be remembered that it was NASA consultants in the first place who helped Gilman design the space suits for the films that impressed NASA so much. His costumes were based on potential designs that NASA was already working on, such as their Mark III prototype.[41] He took their existent suits and gave them a Hollywood veneer, and in the process rendered them inaccurate but it was these

changes based on his ability in crafting a practical looking fictional object that made NASA want to hire him to design real-world scientific objects. Hollywood cinema is not about combining style with substance. It is about providing enough style to make objects appear as if they embody significant substance. Hollywood specializes in making the visual look practical, which is why filmmakers will always prioritize their expertise over their science consultants' expertise.

5 Cinematic Fact Checking: Negotiating Scientific Facts within Filmmaking Culture

They pay you to give them advice, not for them to take it.
—Chris Luchini, consultant on *Deep Impact* (1998)

It is no surprise that film studios bring in scientific experts to fact check. The makers of *Dante's Peak* (1996) had questions about portraying a volcano nearing eruption so they called volcanologists John Lockwood and Norman Macleod, and seismologist David Harlow. To visualize the Antarctic's geological features in *Whiteout* (2009), the filmmakers contacted geologist Bill Coughran, the National Science Foundation's manager for McMurdo Station. To make sure their depiction of string theory was correct, *Déjà Vu's* (2006) filmmakers turned to theoretician Brian Greene who is one of string theory's progenitors. Filmmakers require facts ranging from specific subjects, such as the morphology of a "death's head" moth in *The Silence of the Lambs* (1991), to broad topics, such as generalized dinosaur behavior in *Jurassic Park* (1993).

A large proportion of fact checking involves scientific knowledge for which a strong consensus exists as to what represents natural law. The generalized termite social structure needed for *Mimic* (1997) or the level of light reflected off of a comet's surface needed for *Deep Impact* (1998) are scientific facts about which there is little or no disagreement within the scientific community. This category of scientific knowledge corresponds to what philosopher Ludwik Fleck calls "textbook science."[1] Textbook science represents scientific knowledge about which there are no major disputes among scientists and for which the science is as settled as it ever can be. Textbook science approximates what Bruno Latour categorizes as a "black box."[2] The metaphor of the black box symbolizes scientific ideas or technologies upon which there is general agreement and, so, what it

comprises—its underlying assumptions and process of construction—is not challenged or questioned. Black boxes are then seen as accurate and useful elements in the stock of scientific knowledge. It would be counterproductive, for example, for any biologist to open the black box that says that DNA is a double helix.

Textbook science does *not* represent esoteric knowledge accessible only to those immersed in scientific research. Rather, it represents science's institutionalized knowledge. What was once arcane knowledge has now become readily accessible information and anyone with access to a library or Internet sites like Wikipedia can fact check textbook science.[3] If textbook science is so readily accessible, why are there so many obvious scientific errors in films? Chris Luchini's quote opening the chapter underscores the situation that scientists face when consulting: you are paid to give advice and filmmakers choose whether or not to follow it. For example, it is well established that comets are very dark celestial bodies. Luchini told the filmmakers that a comet is black like a "dirty snowball." Yet, the comet in *Deep Impact* is not black but a grayish-white. Luchini gave them his advice, but he could not force them to take it. This puts filmmakers in the awkward position of knowingly rejecting information that has been scientifically certified as factual.

Errors in textbook science rile up expert viewers, and form the basis of "Real Science of" style books and, increasingly, Internet blogs devoted to scientific inaccuracies in fiction.[4] Expert viewers generally put inaccuracies down to willful ignorance on filmmakers' part or the need for "dramatic license." That filmmakers cannot accommodate every scientific fact is obvious. But dramatic license is far too nebulous a phrase to capture the complexity of the negotiations between scientist/filmmaker and science/fiction. The makers of *Deep Impact* did not reject Luchini's advice on the darkness of comets out of indifference to science or some need to add more "drama." Filmmakers' inability to accommodate this fact was forced upon them by cinema's technological limitations: it is not possible to film a black object before a black background.

Textbook science represents the biggest challenge for filmmakers with the least reward for hewing close to accuracy. No matter how much they strive to accommodate established scientific facts, critics will not focus as much on a film's accuracy as they will on its inaccuracies. Still, filmmakers' efforts at overcoming or bending filmmaking constraints can ultimately

help them at the box office if they imbue the film with a sufficient level of scientific veracity to satisfy audience demands. An example from early cinema will begin to clarify the complexity of dealing with textbook science in cinema.

Expertise in Conflict: Facts versus Filmmaking

Fritz Lang, director of the classic *Metropolis* (1926), was adamant that his 1929 film *Frau im Mond* [*Woman in the Moon*] would be more scientifically accurate than previous space flight films such as *Das Himmelskibet* [*The Sky Ship*] (1918) and *Aelita* (1924).[5] To this end, Lang hired several science consultants to help him with the rocket and astronomical details. Since screenwriter Thea von Harbou had cited Romanian rocket scientist Hermann Oberth's 1923 book *The Rocket into Space* as a scientific source it seemed natural to turn to him as consultant. Lang also hired popular science writer Willy Ley who helped found the famous *Verien für Raumschiffahrt* (VfR), more popularly called the German Rocket Society. Several members of the VfR also helped on the set including a young Werner Von Braun.

Despite access to these experts it would have been clear to any astronomically literate audience in 1929 that Lang fell far short of achieving scientific verisimilitude. Most glaringly the film features characters walking on the Moon without space suits (figure 5.1). There was certainly a scientific consensus well before 1929 that the Moon lacked an atmosphere. According to Ley, he and Oberth consistently pointed out astronomical inaccuracies and they constantly battled Lang over how to portray the Moon. The lack of an atmosphere was of particular concern to Oberth and he considered turning down the consulting work if this error was not rectified in production.[6]

Lang's decision not to heed his consultants' advice concerning an atmosphereless Moon was not arbitrary. He had legitimate dramatic, artistic, and technical reasons for portraying the Moon in a manner contrary to accepted scientific thought. Lang drew on his own expertise as a filmmaker to decide if scientific accuracy overrode filmmaking constraints; while scientifically accurate, a Moon without an atmosphere was cinematically impractical. First, he emphasized to Ley and Oberth that box office concerns dictated that the film was first and foremost a love story. As Lang

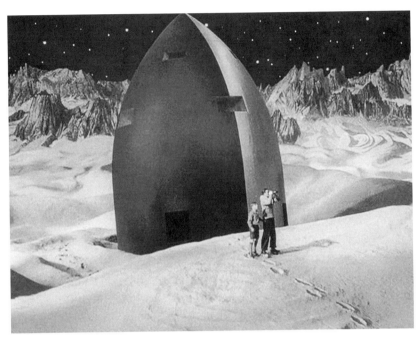

Figure 5.1
Characters from Fritz Lang's *Woman on the Moon* brave the Moon's lack of an atmosphere without space suits.

told Ley, space suits would seriously hamper this aspect of the drama: "I cannot have whole scenes played in diving suits."[7] As a silent film it was also essential for audiences to see actors' facial expressions. Space suits would have obscured actors' faces and prevented audiences from understanding characters' emotional states.

Even with these valid filmmaking reasons Lang still tried to justify his inclusion of an atmosphere on scientific grounds. He resurrected an 1856 hypothesis by Danish astronomer Peter Andreas Hansen to argue that the far side of the Moon *could* have an atmosphere. In fact, he forced Oberth to calculate the timing of the rocket's takeoff, trajectory, and landing site to accommodate this theory. In essence, Lang used a loophole to maintain his belief that the film was scientifically accurate. According to Ley, this transparent post hoc justification also allowed the scientists to distance themselves from the film's inaccuracies. They had given Lang their advice and he chose instead to rely on the work of a long-dead scientist.

Not All Textbook Science Is Created Equal: Expert Science and Public Science

The alien radio signal was particularly problematic for *Contact*'s (1997) filmmakers. Being an *alien* signal they had no basis for determining the transmission's structure. As discussed in chapter 4, computer and video supervisor Ian Kelly hired Tom Kuiper and Linda Wald to develop the computer displays and audio for the radio signal. While an alien radio signal might sound fantastical, the science is actually mundane. Rather than facing infinite possibilities there is only a single option based on mathematics as long as the aliens live in the same universe as us. According to Kuiper it was fairly easy to determine the signal's form, strength, and audio, because "It's radio engineering of a pretty straightforward kind. It's what radio astronomers do all the time." Kuiper and Wald knew the precise distance from the Vega star system to Earth and that the signal would be a string of prime numbers housing an embedded television signal. So, to determine the radio signal's characteristics they plugged the numbers into well-established equations.

In some ways, the filmmakers received more certainty than they desired. Kuiper and Wald presented one answer instead of multiple options. The filmmakers mostly adopted Kuiper and Wald's recommendations with little modification. The filmmakers did, however, find the signal's sound to be problematic and they modified the correct sound to suit their needs. This move away from accuracy disappointed Kuiper:

One thing did not turn out as we wished. I urged Ian to explain to the sound people how the pulsed audio signal should sound, basically a pure tone (whistles a pure tone). Ian says, "Uhm, I don't think that the sound editor is going to like that" (laughs). I said, "Well look we have this fancy software here and we'll simulate it. We'll produce the signal on the basis of our model." Of course it came out (whistles the pure tone again). Ian says, "Oh no, the sound editor isn't going to like that at all." So Ian was not successful in convincing them of that because such a sound is not very interesting. So, for the prime number sequences, we ended up with the sound of a giant [who is] munching corn flakes (makes sound like whomph whomph).

Bryan Butler made the exact same objection to the sound editor while serving as a consultant on the set. He received the same reply Kuiper received—a pure tone is not cinematically interesting. Even with two scientists independently telling him what was scientifically accurate,

the sound editor made a decision that a pure tone was dramatically unacceptable. The main character Ellie Arroway's discovery of the alien signal is a very powerful scene that is crucial to establishing the film's atmosphere. The sound ultimately used effectively conveys a combination of exhilaration and foreboding. After watching the film it is easy to understand why the sound editor rejected Kuiper's and Butler's advice and went with a dynamic sound. Sometimes scientifically accurate is cinematically boring.

A move away from scientific accuracy in this case did not mean that filmmakers were willing to alter every aspect of the alien signal to fit their dramatic needs. It is Arroway's realization that the signal is coming as a numbered sequence that tells her that the signal is not random noise. In this case, the signal is a simple repeating prime number sequence: 2, 3, 5, 7, 11, 13, and so on. When Wald saw that they were planning to include the number one she informed them that one is not a prime number. From a filmmaking perspective, however, the scene is much more exciting if the prime number sequence includes one. The first sound is suggestive without being conclusive. The next two sounds in rapid order give a sense of something extraordinary and the next three sounds together would confirm that it is indeed a nonrandom sequence. Wald understood the filmmakers' desire to make one a prime but knew that mathematical law was as solid as scientific facts come. "It certainly would have sounded better for them to come out with a good solid 'thunk' at the first sound," she said, "but there's not much they can do about one." In this instance, scientific accuracy won out over dramatic needs.

Why was Wald able to convince filmmakers to maintain scientific accuracy while Kuiper and Butler could not in the case of the pure tone? This question gets to the heart of filmmakers' decision making regarding textbook science. We have a clear instance of two facts each having a solid consensus among scientists, each imposing on the film's dramatic potential, yet only one fact is preserved. This disparity, of course, is not isolated to *Contact* or these particular facts. Textbook science needs to be refined to account for the differences in the treatment of facts by those outside the scientific community. I propose that textbook science consists of three categories distinguished by the public's familiarity with a scientific fact. Facts that are likely to be known by a majority of the public fall into the

category of "public science." Facts that are agreed upon by scientists as true but are relatively unknown outside the expert community (which includes lay experts) compose the category of "expert science."[8] The third category, which will be discussed in the next section, is "folk science." Folk science refers to incorrect science that is nonetheless widely accepted by the public as true.

Of course, there is variability within these categories as to how well known something may or may not be. Still, the subdivision of textbook science into these categories helps explain the differential treatment film-makers give to scientific facts. Especially, if we take into account that film-makers' division of facts into these categories is predicated upon their *perception* of an audience's scientific literacy. They are more likely to modify or ignore facts that they perceive as expert science. The fact that the radio signal would be a pure tone, for example, is something scientists take as true but is unlikely to be known to anyone other than radio astronomers. Unless filmmakers can easily accommodate expert science they are liable to overlook accuracy in these instances. Since the signal's sound was pivotal in establishing the ambiguous intentions of the alien transmitters it made sense for *Contact's* sound designer to risk the wrath of radio astronomers in order to satisfy dramatic needs, considering the vast major-ity of the audience would not notice.

Inaccuracies regarding public science, on the other hand, are more dif-ficult to ignore or alter without repercussions at the box office. It is risky for filmmakers to ignore public science unless filmmaking constraints are overwhelmingly difficult to overcome. According to Jack Horner, scientific inaccuracies were only crucial on *Jurassic Park* if they meant that director Steven Spielberg "would get nasty letters from 6th graders." Gerry Griffin, one of *Deep Impact's* consultants, sums up filmmakers' concerns with vio-lating public science another way: "None of [the filmmakers] wanted to look stupid."[9] In the case of the prime number sequence in *Contact*, film-makers were contemplating a basic mathematics fact strongly entrenched as a piece of public science. As Wald says, it was "grade school math."[10] Their reasons for wanting one as a prime number had to do with adding drama to the discovery scene. The scene was important enough that film-makers kept calling her and asking her if it was true. As Wald says, "They asked me whether one was a prime several times. They wanted one to be

a prime so badly." Clearly, a single first ominous sound would have added significant drama, but not enough to justify disregarding such a well-known piece of public science.

Although filmmakers are more inclined to modify or disregard obscure scientific information, there can be serious economic drawbacks in taking too lenient an approach to expert science. Filmmakers have to judge for themselves how damaging negative publicity from scientific attacks will be, especially if they are planning on incorporating scientific accuracy as a theme within their publicity campaign. If the inevitable "Real Science of" articles focus on small or inconsequential errors the damage is likely small. The crucial part is anticipating how strongly the scientific community will feel about an inaccuracy. Marine biologist Mike Graham, for example, was giving a lecture to *Finding Nemo*'s (2004) animators when the director asked him "if there was one thing that the film might get wrong that would really disturb him."[11] An account of this meeting in *Nature* shows how Graham's answer created a predicament for the animators: "Quick as a flash, Graham said the most intolerable outrage would be to see kelp—a type of seaweed that only grows in cold waters—depicted in a coral reef. There was an uncomfortable shuffling in the audience. Then a voice from the back called out: 'Better not go see the movie then.' But if you check out your video or DVD, you'll see there is no kelp. After Graham raised his objections, every frond was carefully removed from each scene, at considerable cost" (figure 5.2).

The animators were not being altruistic by correcting this error. They understood that if this mistake was "intolerable" to this scientist it was likely to be problematic for every marine biologist. They had already used significant resources ensuring as much scientific accuracy as possible. Realism in regard to the animation and the scientific depictions was a major selling point. They were not going to risk the potential box office boost engendered by the scientific community's goodwill by including an error that would undercut the film's other scientific accuracies. Expert science may only be recognizable to specialized scientists, but if they feel strongly enough about a scientific flaw their public complaints may be enough to diminish box office potential.

Expert science and public science are fixed at a given time, but facts shift from expert science to public science over time. In 1929, Lang considered an atmosphereless Moon to be expert science only scientists would

Figure 5.2
Animators removed all traces of kelp from *Finding Nemo* before the film's release.

care about. By 1950, filmmakers faced decisions about the Moon's atmosphere during the making of *Destination Moon*. The film's science consultant, science fiction author Robert A. Heinlein, foresaw himself facing the same battle as Oberth and Ley and he explicitly warned co-screenwriter Rip Van Ronkel to be prepared for fights over depicting the Moon without an atmosphere: "So that when a producer says, 'Why doesn't the moon have an atmosphere?' You can tell him."[12] Heinlein's concerns proved unfounded as producer George Pal realized this fact was well known. In 1929 the Moon's lack of an atmosphere was known only to experts, but by 1950 it was midway between expert science and public science. Today this fact is so widely known that such a blatant error would be box office suicide.

Give the Audience What It Wants: Audience Expectations and Folk Science

Matt Golombek, chairman of the Mars Pathfinder Project Science Group at JPL, served as "look-of-Mars expert" for *Mission to Mars* (2000).[13] Despite this explicit title his impact on the depiction of the Martian set was minimal. "My involvement on the film was actually fairly slim," he said.

"It involved reviewing the script in an early phase and commenting on things that were unrealistic from a science aspect." The set designers and special effects technicians did not need an expert to tell them what Mars looked like since they found detailed pictures of the planet on JPL's public Pathfinder Web site, a site that was made famous through extensive news coverage and record-breaking Web traffic (figure 5.3).[14] According to Golombek, his primary role was not to provide filmmakers advice but to publicly legitimate their version of Mars: "Mostly, what they used me for were media relations to the science part of the media. So they had a big

(a)

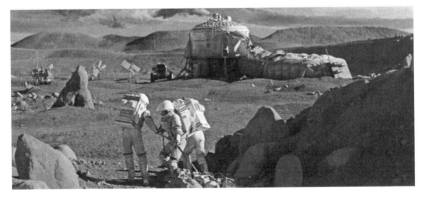

(b)

Figure 5.3
Filmmakers used images from the Mars Pathfinder (a) to design sets and special effects for *Mission to Mars* (b).
Source: (a) courtesy of NASA/JPL-Caltech.

media day up at the shooting site in Vancouver and they invited me up to see the site and to talk to the media about the movie."

Of course, Golombek's public statements did not mean that he considered the film's depiction a completely accurate representation of Mars. In fact, he encountered an unusual reason for subverting scientific accuracy: what was scientifically accurate was contrary to what filmmakers believed audiences would find to be a credible representation. According to Golombek, filmmakers believed that audiences would only consider Mars realistic if they depicted the planet as having a red tinge rather than its true color of yellow-brown. Undoubtedly, a large portion of the public in 2000 would have been familiar with Mars's surface, given that the popularity of Pathfinder's Web site drove Touchstone Pictures' initial decision to produce the movie.[15] Yet, filmmakers insisted on filming scenes through a red lens filter. They felt that deviations from this fictional fact would undercut the film's believability more than any real scientific inaccuracy. Rather than complain Golombek actually endorsed their incorporation of this enduring cultural belief: "It's the red planet, it's not the yellow-brown planet! So who cares what reality is. You can't fault them for that."

If Mars's color were merely expert science the filmmakers could have ignored, modified, or accommodated the fact as was done in the various examples I have analyzed in this chapter. If it were public science the filmmakers would have struggled with possible negative repercussions from deviating from a well-known fact. It fits neither of these categories. Instead it falls into the category of folk science. Knowledge within folk science is considered well-established truth that appears to be common sense. It is difficult to challenge long-standing cultural beliefs, which makes folk science just as problematic for filmmakers as public science. In the case of folk science filmmakers are not displacing truth for fiction, rather, they are willingly accepting the fictional as truth. With folk science, scientific reality actually *undercuts* a film's authenticity in the eyes of the audience. This also sets up a circular system in which entertainment texts create conceptions of science that become so ingrained in the public's mind that subsequent texts need to incorporate them or be seen as inaccurate, which then reinforces these same misconceptions.

For the lay public, a deviation from folk science would appear the same as a deviation from public science. The difference between the two categories, however, is that it is possible to challenge folk science in a way that

is impossible for public science in cinema. It takes a tremendous amount of effort and screen time, however, to challenge audience expectations. The appeal of *Jurassic Park*, for example, is entirely predicated upon breaking people's ingrained beliefs of dinosaurs as slow, lumbering, and dull beasts. To achieve this, though, they had to create a film where the plot, dialogue, character interactions, special effects, and sound effects—as well as a high-profile PR campaign utilizing their science consultant Jack Horner and other famous paleontologists—all conveyed the idea that agile, smart dinosaurs were natural. For this movie, challenging deeply held cultural beliefs provided far greater box office rewards than giving the public what they expected dinosaurs to be.

Fudging Science: Navigating Textbook Science through Cinematic Constraints

It is important to reiterate that when conflicts arise between science consultants and filmmakers it is the filmmakers who make the ultimate decisions about what science appears on the screen—especially those higher up in the filmmaking hierarchy such as directors or producers. The importance of a consultant's role, therefore, is not so much in telling filmmakers what represents natural reality but in convincing them that maintaining accuracy has significant consequences for box office potential or in helping them find the means by which they can maintain accuracy despite filmmaking constraints.

Sometimes adherence to accuracy is relatively straightforward, such as simple dialogue changes. In most instances, however, the decision to preserve or reject scientific accuracy is not so straightforward. Filmmakers make decisions based on their perception of audiences recognizing a fact (expert, public, or folk science) and filmmaking constraints including budgetary, visual, dramatic, and technical. If this combination hits a certain threshold where realism outweighs the constraints then filmmakers are willing to accommodate accuracy. If constraints outweigh accuracy then they must either incorporate inaccuracies or find some other means around their constraints. Of course, each director or producer will have a different threshold for making this decision.

By far, budgetary concerns are the most limiting constraints. Robert Heinlein summed up this overriding constraint: "Realism is confoundedly

expensive."[16] Budget becomes even more of a limitation the closer a fact comes to being considered expert science. This is not always the case, however. For one piece of expert science, *Deep Impact*'s filmmakers decided it was worth the resources required for scientific accuracy. During the *Deep Impact* think tank process discussed in chapter 3, several filmmakers were initially irritated to learn that rather than having a low but significant amount of gravity like the Moon, a comet's gravity is negligible.[17] The illusion of near-zero gravity requires significant wirework, which is expensive and time consuming. Josh Colwell's brother served as first assistant director and was reluctant to accommodate this fact knowing the difficulties involved for him. Josh Colwell acknowledged that this fact was not widely known among the public and that the filmmakers "could have easily swept it under the rug." Instead, despite Colwell's brother's reluctance, director Mimi Leder and producer Walter Parkes decided that authenticity in this case was worth the expenditure of time, energy, and money.

Computer-generated imagery (CGI) technology has made it easier to incorporate facts that may have at one time been problematic from a budgetary or technical aspect. Filmmakers in the 1950s and 1960s, for example, had to rely on propane tanks to mimic the exhaust coming off a rocket in space. When gas leaves the tank it "curls" as the atmosphere causes it to form vortices. In a vacuum gas does not behave in this manner, so these films were inaccurate in this respect. During production for *Deep Impact*, Chris Luchini explained this to the propmakers regarding the rocket exhaust as well as the comet's outgassing. Liquid nitrogen helped them get around this problem for the rocket exhaust, but for safety reasons they were unable to utilize this for outgassing jets. When Luchini saw a rough cut of the film he noticed the curling of the gas off these jets. He mentioned this error to a special effects technician who used a CGI wipe effect to remove the curling days before the film's premiere. Such a fix would have been impossible prior to the development of CGI technologies. Although CGI work can be expensive and difficult, it is often easier and cheaper to fix scientific inaccuracies during postproduction than it would be to struggle with them during production. In this case, they were able to rectify an error days before the release of the film.

It is important to bear in mind that not every factual error is due to budgetary or technical reasons. At one stage during the *Deep Impact* think

tank, several filmmakers asked consultants to clarify an appropriate timing between the splitting of the comet in two (the failure to destroy the comet) and the successful destruction of the larger piece, which saves the earth. One filmmaker wondered whether the fictional astronauts could destroy the larger piece near Earth's atmosphere. He was emphatically told no, because the pieces resulting from the comet's destruction would carry the same force as the intact comet. This information clearly did not fit in with Leder and Parkes's vision for the film's ending, with Leder telling scientists "That is a problem" and Parkes emphasizing to them "That's our light show." Parkes made it explicit to the scientists that this explosion was essential for visual and storytelling reasons: "The final piece which our astronauts take out, we want that to be close to earth to give a meteor shower. . . . We are following the story and it blows up. We need to look up in the sky and see that they were successful." Ultimately, visual requirements and a need to convey plot information outweighed a desire for realism and the filmmakers went with a near-Earth explosion (figure 5.4).

Not every choice is a binary choice between "accurate" and "inaccurate." Variability in the natural world provides filmmakers with plenty of room for interpretive flexibility. In their public statements scientists often convey an idealized description of scientific phenomena that overlooks natural variation since variability and uncertainty are easily conflated.[18] Natural variability, however, provides filmmakers leeway in their cinematic depictions. A depiction that falls within the accepted range for what is

Figure 5.4
Deep Impact's filmmakers required a meteor shower "light show" finale.

possible is still an accurate depiction, even if it exists at the extreme end of this range. This was borne out in *Deep Impact*'s think tank as consultants consistently referred to "typical" values. When the subject of a comet's rotation time came up, for example, Gene Shoemaker continually answered that a "typical" rotation is ten hours, despite filmmakers' desire for a much shorter, more dramatic four-hour rotation time. Most science consultants quickly realize that natural variability is crucial in Hollywood science because it extends the range for what is considered "accurate." Professional consultant Donna Cline sums up the importance of variability to filmmakers, stating, "I want to make sure [a scientific fact] is in the ballpark. It could be behind third base but it is in the ballpark." The consultants on *Deep Impact* eventually agreed rotation periods among comets range from three to twelve hours; so even if four hours was toward the tail end of the distribution it was still "in the ballpark."

The threshold at which filmmaking constraints outweigh scientific realism is highly filmmaker dependent. For Michael Bay, the director of *Armageddon* (1998), the accuracy of the movie asteroid's size and the timing between discovery and impact was irrelevant. *Armageddon* came under heavy scientific criticism for its unlikely scenario that an asteroid the "size of Texas" would go undetected until eighteen days before impact. *Armageddon*'s consultant Ivan Bekey encouraged filmmakers to rectify these problems: "I tried to get them to make it smaller, and I tried to get them to give more time before interception. It was no go."[19] From Bay's perspective the short time frame was essential in heightening the film's dramatic potential. He also felt the outlandish size created a greater feeling of danger, "We didn't think the audience would believe something five or six miles long could kill the earth."[20] Bay considered Near-Earth Objects (NEOs) to be expert science so he did not worry about his severely exaggerated scenario. He also did not show a deep commitment to accuracy as evidenced by his continual reminders to Bekey that "we were making a movie, we could fudge it a little." Bay's threshold for rejecting accurate science was very low, so "fudging the science" left him with a highly improbable scenario.

Unlike her directing counterpart on *Armageddon*, Mimi Leder made sure that the comet's size and the timing between discovery and impact was near accurate for *Deep Impact*. Like Bay, she also had significant dramatic, visual, and technical reasons for incorporating a specific scenario. The

difference is that *Deep Impact*'s filmmakers worked with their consultants to make this predetermined depiction accurate, while *Armageddon*'s filmmakers simply defended their predetermined depiction as a need to "fudge." While filmmaking limitations can hinder scientific depictions, inaccuracies can also result from filmmakers not recognizing that scientists' expertise extends beyond simple fact checking.

For the timing between discovery and impact *Deep Impact*'s filmmakers were facing a constraint opposite to that on *Armageddon*. Instead of manufacturing drama primarily through action scenes as in *Armageddon*, *Deep Impact*'s filmmakers were creating a psychological drama where personal relationships evolved in light of impending catastrophe. Therefore, they required at least eighteen months for these issues to play out in a realistic fashion. The problem is that there is no way to accurately predict whether a comet that far away is actually on a collision course with the earth. It requires time after a comet's discovery to map its trajectory before generating any reasonable predictions. As several consultants mentioned in the think tank, certainty of collision may not be possible until one or two weeks ahead of time. In addition, secrecy was an important plot element as the first third of the movie revolves around a news reporter's uncovering knowledge of the imminent impact. Keeping the comet secret over an eighteen-month time period is not very realistic, however. As Josh Colwell told them, "If the comet is detectable with a small telescope by [the character of] Leo, then observers all over the world will independently discover it."

Rather than accepting their depiction as inaccurate they asked their consultants to suggest dialogue or plot changes to explain this time frame. Colwell suggested a scene in which an astronomer plots the comet's trajectory by examining older photos of the sky taken when astronomers were not looking for comets. This solution was doubly pleasing to Walter Parkes because it solved the filmmakers' accuracy issue and provided them a dramatic moment that was missing from earlier scripts. "This is an interesting point because it is where verisimilitude and drama intersect," he said. "In other words, I do not think in the script right now there is a sense of 'Oh, my God!'" Colwell's suggestion also solved the issue of secrecy. The astronomer dies in a car crash before he tells anyone about his finding and is discovered by governmental officials, giving them exclusive knowledge of the comet's trajectory. Instead of bypassing their consultants, they received

a reasonable solution that allowed them to justify their eighteen-month time frame.

Although Colwell's suggestion solved the accuracy problem for the comet's discovery it also required filmmakers to include entirely new scenes with additional plot twists, which is not always a practical solution. Another potential avenue for filmmakers who are unable to find the means to incorporate accurate textbook science is for them to compromise with accuracy by including representations that are halfway to reality. At one point during the think tank consultants David Walker and Gerry Griffin mentioned that constraints due to the speed of light dictate a twenty-minute communication delay between the spaceship and Earth, with Griffin emphasizing that "most people, I am talking about the audience, know you have longer delays in communication at planetary distances." This fact clearly displeased Leder who bluntly told them "I do not like the delay." She explained the necessity of instantaneous communication: "I was thinking of the moment when [newscaster] Jenny announces to the world that the mission has failed. If that is a twenty minute delay that takes the tension out of the movie." Just as with the timing before impact, they could have incorporated a scenario explaining and utilizing the communications delay. In fact, they spent several minutes in the think tank discussing this possibility. The final film shows that they came to a compromise solution. They acknowledge a communications delay in a line of dialogue but severely reduce its duration from twenty minutes down to twenty seconds. Leder is clearly fudging the science, just as Michael Bay did on *Armageddon*, but she is fudging in a manner that at least gestures toward accuracy.

It is important to note that these "half-truths" do not represent negotiations or compromises between the filmmakers and the scientists. These are compromises the filmmakers make between accuracy and inaccuracy. While such compromises may be unacceptable to expert viewers they are better than the alternative. Whether compromised or not, any observance of factual science in cinema is only by filmmakers' consent. Brian Cox tells of an experience on *Sunshine* where he convinced filmmakers to change the mass of the nuclear bomb being taken to the sun, but then was dissatisfied with the new mass:

Well when I read the script it said the bomb was the mass of the Moon. And I said, "Well come on, imagine putting rockets on the back of the Moon, think about how

big the rockets are going to have to be?" So he said, "No it's smaller.' Well I said, "It doesn't matter. F=MA" and he said "Ah shit." So they changed it to the mass of Manhattan. And I said, "Well how deep? I mean what do you mean the mass of Manhattan?" [They replied] "Fuck off, you've had your way, it's not the mass of the Moon anymore." [laughs]

Essentially they were telling Cox to be satisfied with the efforts they already made toward accuracy. They made the bomb smaller than what they had wanted, but it was never going to be accurate or "sciencey" enough to satisfy Cox the scientist. In the end, Cox was thankful that they made any attempt to overcome their filmmaking constraints in the name of accuracy.

Keeping It Real: The Significance of Scientific Accuracy in Cinema

Unlike scientists, audiences do not require accuracy for the sake of accuracy. Audiences want realism only if it enhances a film's entertainment value. Filmmakers' major concern is to identify those elements of scientific accuracy that significantly enhance enjoyment or impact plausibility. Matt Golombek felt that most scientific facts were inessential for audiences to enjoy *Mission to Mars*. "In reality very little of what they did plus or minus with respect to science really had any impact on whether it was a good film or not," he said. "Certainly most of the populous couldn't tell whether something was realistic or not." The same, in fact, can be said for most films. Scientific accuracy can be crucial in establishing plausibility, but some facts are more important than others in conveying a sense of believability. Making textbook science as accurate as possible will certainly contribute to an overall sense of realism, but filmmakers need to pay special attention to the accuracy of scientific facts that can significantly impact plausibility.

For the scientific community the more important question is not which inaccuracies impact plausibility, but how cinematic inaccuracies impact public perceptions of science. Cinematic science *can* play a crucial role in influencing public discourse about science, but only if we focus on those depictions that potentially shape cultural meanings of science and not on issues of science literacy. By focusing on the cultural meanings of science we find that most cinematic inaccuracies do not impact public perceptions of science. Of all the facts I discussed in this chapter, few would hinder

the cultural meanings of science whether they were accurate or not. Did the lack of a pure tone in *Contact* impact the public's perception of whether or not SETI is a worthwhile activity, or the meaning of radio astronomy as a scientific pursuit? Were audiences less disposed to support NEO research because the comet in *Deep Impact* was depicted as grayish rather than black? Does Mars's inaccurate red color in *Mission to Mars* change people's perspective on astronomy or support for travel to Mars? Even the common complaint about the lack of sound in space, which emerged again in scientific reviews of *Sunshine*, has little bearing on public attitudes toward space travel or the depiction of science as a noble enterprise, which is what Brian Cox wanted for *Sunshine*.

Even though Golombek felt that most inaccuracies were not worth worrying about in *Mission to Mars*, there was one inaccurate depiction that distressed him a great deal. When the astronauts reach Mars they discover that the pseudoscientific "Face on Mars" actually exists and was created by an ancient Martian race, as noted in chapter 3 (figure 5.5). For Golombek this inaccuracy was unacceptable because it had real-world implications:

The thing I hated the most about the film was not any of the factual inaccuracies. It was that they took a pseudoscience item, namely this "Face on Mars," and they made it real. So what they effectively did is they legitimatised this pseudoscience thing. All these people screaming about this "Face on Mars" being some kind of real feature. It's just absurd. It's ridiculous. And if anything the film made it acceptable to even think that. That was the thing I responded to with the greatest vehemence.

Figure 5.5
The pseudoscience "Face on Mars" in *Mission to Mars*.

All the other scientific inaccuracies I could forgive. But that one bothered me the most because it bordered on irresponsibility.

What irked him the most was not that they legitimized the notion of an ancient Martian civilization—that is part of the fictional enterprise—but that they used a piece of misinformation that scientists have been campaigning against for years when that *specific* misconception was unnecessary. The script required evidence of a structure from an ancient Martian civilization—but that could have been any structure like a pyramid or a black obelisk as a nod to *2001: A Space Odyssey* (1968).[21] According to Golombek the filmmakers chose the "Face" because of its recognition with the public and, to his dismay, "they never considered what impact that would have."

Daniel Kubat had a similar experience on *K-19: The Widowmaker* (2002). The film recounts the story of the first Soviet nuclear submarine to carry ballistic nuclear missiles on its disastrous initial mission during the heart of Cold War tensions in 1961. Despite his significant influence on the film's reactor scenes, Kubat's inability to change a few lines of inaccurate dialogue left him feeling as if he had minimal impact on the science. During the film, a reactor develops a leak in its coolant system while the sub is near the American coastline (figure 5.6). The nuclear officer, Vadim Radtchinko, explains the danger of this leak saying, "It could start a chain reaction. There would be radiation leakage. The core would melt through the reactor and start a thermonuclear explosion." In a subsequent scene

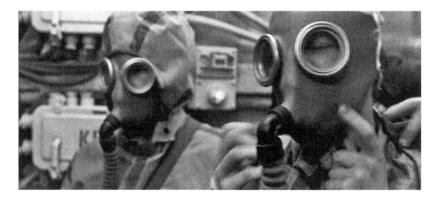

Figure 5.6
Russian sailors prepare to fix a nuclear reactor leak in *K-19: The Widowmaker.*

Radtchinko claims the magnitude of the explosion would be "Hiroshima. 1.4 megatons if we factor in the two reactors and the warheads. Only Hiroshima was less. It was a lot less."

Any nuclear experts hearing this dialogue would be scratching their heads in puzzlement. Thermonuclear explosion? Hiroshima? Radtchinko's concern that a core meltdown will lead to a nuclear explosion does not make sense in terms of nuclear engineering. The submarine crew's biggest concern from the meltdown was massive radiation exposure, not a nuclear explosion. Kubat was brought in during production, so he understood his potential impact was limited. Still, he told me that he tried as hard as he could to convince the filmmakers to change those lines. They refused to correct something that would have been easy to change because a potential nuclear explosion near the American coast *could* start World War III.

While Kubat understood their reasoning, he was unhappy with their decision because he felt it had real-world ramifications for debates about nuclear energy's safety:

This was born out of the writer's misconceptions of science, his misconception of the way that nuclear reactors work. It's born out of the fears that people have of nuclear reactors. . . . I believe this misconception has terrible consequences to the public at large. The public sees this movie, a true story about a Russian nuclear reactor, and it enters into their consciousness that nuclear reactors can explode like nuclear bombs and that's dangerous. That, I think, was perhaps my biggest failing. Not being able to convince them to change that. I didn't get involved early enough to make that fundamental change, the really important change. I got to play around with the details, but ultimately, those things mattered less.

He also argued that the accurate dialogue enhanced the film's drama because it kept the narrative focus on the crew's efforts to survive, rather than diluting the drama by adding global catastrophe. Importantly, Kubat did not blame filmmakers and took responsibility for this error. He felt that it was *his* failing as a consultant that he could not convince them that accuracy would serve the film's plot better. Kubat was correct in his assumption that audiences would accept this misinformation as true. Many critics cited the possibility of an explosion as one of the film's most dramatic aspects. Most of the other details of *K-19* were correct, but these likely had little impact on the public's attitude toward nuclear energy.

Every consultant I spoke with conveyed anecdotes about scientific facts that filmmakers could not or would not accommodate. Rarely did the

scientists become agitated about these cinematic mistakes. Only in the case of egregious errors that could impact the cultural meanings of science did they regret their inability to convince filmmakers to incorporate more accurate depictions, especially for films that could potentially impact public health decisions. For Golombek and Kubat even these meaningful errors were not enough for them to quit their respective projects. They were merely disappointed that dramatic potential overrode such easily corrected mistakes, especially when they had provided filmmakers with perfectly viable alternatives.

For a few consultants I interviewed, a movie's potential damage to public perceptions of science was enough to make them pull out of a project. For Jack Horner, his experiences taught him that scientific inaccuracies are an inevitable part of consulting in Hollywood. He readily accepted the need to subvert accuracy in the *Jurassic Park* series. He had the same attitude when he began consulting on the Disney animated film *Dinosaur* (2000), but when studio executives insisted upon talking dinosaurs halfway through production[22] he walked away. "It is a kids' thing so the idea of a dinosaur and mammal hanging out is fine," Horner explained. "I worked with them on and off until the dinosaurs started talking. Until they had front teeth and were starting to talk. There was obviously nothing more I could do," he concluded, laughing.

This glaring factual error was not going to undermine scientific literacy, but could shape the cultural image of dinosaurs. Horner felt that talking dinosaurs were no longer prehistoric animals; they had become anthropomorphized "cartoon characters." Once *Dinosaur*'s filmmakers ignored the one scientific fact that truly mattered for the cultural meaning of dinosaurs, he realized that ensuring other accuracies was not worth the effort.

The scientific community's focus on the minute details of cinematic science in their critiques may ultimately be more harmful than helpful. Rather than improving science literacy, continual complaints about scientific inaccuracies lead people to believe that science is too rigid, uncreative, and boring. The title of an "article" from the satirical newspaper *The Onion* cleverly illustrates the problems the scientific community faces from constant criticisms of fictional science: "Man Vows Never to Watch Another Sci-Fi Movie with Physicist Friend." As with the "Man" in this satirical story, the public becomes tired of hearing about what is "wrong" with

fictional science when they merely want escapist adventures, unless they find reading these scientific critiques entertaining in and of themselves.

I am not arguing that the effort filmmakers and scientists put into scientific accuracy is pointless. On the contrary, I believe consultants should help filmmakers find the means to create as much accurate science as possible—especially since it is true that for the detail-oriented entertainment community realism *is* in the minor details. What I am arguing is that a focus on scientific literacy through cinema is severely misguided. Cinematic depictions of science involve the production and presentation of an *image* of science, whether or not the science has anything to do with "real" science. Cinematic images carry a cultural currency that both reflects and influences public attitudes toward the scientific enterprise. The importance of science consultants is in helping filmmakers craft images and narratives that convey the excitement of scientific research or communicate a sense of awe about the natural world. The accuracy of scientific facts in cinema can be important in shaping public discourses about science, but it is crucial for a science consultant to identify those aspects of scientific knowledge that will significantly impact the cultural meanings of science.

6 Best Guesses: Scientific Uncertainty, Flexibility, and Scientists in the Aisles

King Kong was box office champion in 1933 by a wide margin and is thought to have singlehandedly saved RKO studios from bankruptcy. The film's groundbreaking special effects not only brought the giant ape to life, but also provided audiences with visions of long-extinct animals including *Stegosaurus*, *Apatosaurus*, *Plesiosaurus*, and *Pteranodons*. One of *King Kong*'s most memorable scenes was Kong's battle with the king of the dinosaurs *Tyrannosaurus rex*. Special effects pioneer Willis O'Brien worked relentlessly to ensure that *King Kong*'s dinosaurs were as paleontologically correct as they were for his previous dinosaur films *The Ghost of Slumber Mountain* (1919), *The Lost World* (1925), and his unfinished 1931 film project *Creation*. With sculptor Marcel Delgado, O'Brien sought out advice from several paleontologists including Barnum Brown, with whom he collaborated for the *T. rex* in *The Ghost of Slumber Mountain*. Brown, famous for his reconstruction of *T. rex* for the American Museum of Natural History in New York, was certainly the leading authority on this dinosaur.

Given the meticulous research that went into this depiction, why, then, has O'Brien's *T. rex* become the king lizard of scientifically inaccurate dinosaurs? Specifically, we know that *T. rex* had only two digits on its forearm rather than the three digits depicted in *King Kong* (figure 6.1). The reason the cinematic *T. rex* had three fingers was not due to budgetary constraints or narrative demands. In fact, O'Brien and Delgado adhered closely to Brown's advice. Simply put, at the time Brown's recommendation was *not* inaccurate. In the 1920s and 1930s, the number of digits on *T. rex*'s forearms was a debatable subject. Brown vociferously maintained that *T. rex* had three digits on its forelimb as did *Allosaurus*, and his hypothesis was equally valid as that of a two-digit *T. rex* in 1933. An older film like *King Kong* shows us how scientific debates were ultimately settled

Figure 6.1
The *T. rex* in *King Kong* has three fingers.

within a historical context. In the end, Brown's conjecture has since been proven incorrect. Had O'Brien and Delgado chosen to speak with Charles Gilmore of the Smithsonian Institution, who argued that *T. rex* had two digits like *Gorgosaurus*, and implemented his advice then *King Kong*'s *T. rex* would be considered an "accurate" representation today.[1]

As discussed in chapter 5, textbook science describes scientific knowledge accepted by the scientific community as fact and whose underlying construction has become "black boxed." Knowledge about *T. rex*'s digits was not textbook science in 1933 and, in fact, remained a debatable topic until a complete *T. rex* skeleton was uncovered in 1992.[2] *King Kong*'s filmmakers were asking their consultant about a phenomenon for which several satisfactory explanations existed but none of which had a solid scientific consensus. The number of fingers on a *T. rex* in 1933 is a case of science in the making from which an agreed upon answer has yet to emerge—what I will refer to as "unsettled science." Which side of a scien-

tific debate becomes accepted as textbook science is of the utmost importance to a group of specialist scientists. Ultimately, a dominant view on a particular scientific issue is agreed upon by a majority of scientists in this peer group. These scientists then take public steps to black box this view as natural fact and marginalize those scientists who may still hold alternative views.

Distinctions between textbook and unsettled science result from analysts' categorizations of scientific knowledge. Filmmakers do not make these distinctions. For them, there is only a monolithic "Science" and they expect their experts to tell them how to make their cinematic representations accurate. Sociologist Helga Nowotny emphasizes that it is the "lure of such an 'external' certainty" that drives people to engage scientific experts in the first place.[3] Scientists, however, are well aware of the division between textbook and unsettled science even if they do not use this terminology. Scientific expertise, then, not only encompasses what we know, but more importantly, it also extends to what we know about "what we do not know." Unlike textbook science in which filmmakers can seek information in a reference book or on a Web site, filmmakers must rely on their experts to tell them what is not yet known for certain but *could* represent natural reality. In order to understand the impact unsettled science has on filmmaking decisions I will explore more recent films in which consultants grappled with scientific knowledge in flux. I will also examine how cinematic representations involving issues of scientific uncertainty feed back into the scientific community.

The Utility (and Danger) of Uncertainty in Hollywood: Cometary Science in *Deep Impact*

Deep Impact's (1998) science consultants all undertook cometary research, but with the exception of Gene and Carolyn Shoemaker they did not have a vested interest in the central questions about the physical makeup of comets.[4] Although there were several comet flybys near the Earth prior to 1998, including several by Halley's Comet in 1986, there was very little concrete knowledge about the physical characteristics of comets at the time of *Deep Impact*'s production. As discussed in chapter 5 some information was established as textbook science, such as the notion of comets as "dirty

snowballs." Other aspects were mostly unknown including the cometary surface's features. *Deep Impact*'s consultants could not answer many questions about cometary science with certainty during the think tank meeting discussed in chapter 3 but they could provide best guesses and tell the filmmakers what the answers *might* be.

The existence of outgassing geysers on a comet provides an example of how unsettled science gave filmmakers both certainty and flexibility in crafting their fictional narrative. Because of data collected during spacecraft flybys it was known that comets had geyser structures that outgassed into space due to sublimation. Such details about the natural world are what filmmakers are looking for, and those at the think tank were excited by the dramatic opportunities and striking visuals offered by this information (figure 6.2). But they still needed to know exactly what properties these geysers possess. How powerful are they? What do they look like when they vent? How many geysers would be present on a comet of this size? Does this outgassing lead to an accumulation of material on the comet's surface and/or in the comet's coma or tail? These questions led to the types of detailed conjectures only their scientific experts could provide.

Unsettled science's uncertainty provides filmmakers flexibility because they can work with a broader range of options and still technically strive for accuracy. For example, *Deep Impact*'s filmmakers wanted to know if it was plausible for a geyser to knock an astronaut off the comet. According to consultant Josh Colwell there is no evidence as to these geysers' strength,

Figure 6.2
Outgassing cometary geysers provided drama in *Deep Impact*.

but he used some theoretical models to show that it is possible. If Colwell had told the assembled filmmakers "We know exactly how strong these geysers are and knocking someone off a comet would be impossible," then the filmmakers would be in the same bind as with any case of textbook science: whether to sacrifice accuracy by keeping the unrealistic drama/ visuals or to remove the scene. Hypothetically, however, strong geysers are *possible*, which was enough for filmmakers who appreciated their visual and dramatic potential. In essence, the fact that a scientist said it was possible made it "true" for filmmakers, who can then treat unsettled science (uncertainty) like textbook science (certainty).

This question of geyser strength led to an extended discussion in the think tank about another unknown aspect of these geysers: the size and speed of the material coming out of the geyser when it outgassed. Colwell, Chris Luchini, and Gene Shoemaker each in rapid succession tried to provide an answer to this question, but their advice always included a qualifying statement that made it difficult for filmmakers to know exactly what they were being told. Luchini, for example, told the filmmakers that "depending on whose hydrodynamic calculations you believe" the size and speed of the particles could work to the filmmakers' advantage.[5] An obviously exasperated Mimi Leder, the director, stopped these planetary scientists at one point and asked the only question that interested her: "What can we do practically with this?" Carolyn Shoemaker, who had been relatively silent, provided Leder an extremely perceptive answer: "It means you are free to do quite a bit doesn't it, because we don't really know." Shoemaker's answer sums up the creative freedom that comes with unsettled science in Hollywood. Scientists may not know the answer, so filmmakers can pick whichever potential answer they find useful, knowing it is within the range of what could be true.

The degree of scientific uncertainty about comets meant that consultants occasionally argued among themselves about what represented an accurate depiction. Colwell, Luchini, and Gene Shoemaker, for example, all disagreed about the comet surface's texture (figure 6.3). Colwell mentioned at one point that he thought large surface structures were possible because "gravity is so low on the surface of the comet that really fragile structures can survive."[6] Luchini in response told filmmakers that his own research on the "terrain modeling of the surface of a comet" contradicted Colwell's contention. He felt that dust falling back to the comet would

Figure 6.3
Deep Impact's filmmakers chose a visually interesting rough and foreboding come-
tary surface.

wipe these structures out. Thus, in contrast to Colwell he considered a
smoother cometary surface to be more accurate.

At that time, either interpretation could have been correct, but film-
makers decided to go with the rougher, more menacing (and more visually
interesting) interpretation favored by Colwell. After the set designers fin-
ished the comet set Gene Shoemaker still believed that the comet's surface
looked too jagged, while Colwell believed that the surface had just the
right amount of roughness, "I thought the surface of the comet looked
very good. Gene thought it was too irregular, too jaggedy." Given the lack
of any hard evidence for one view over the other, Colwell again justified
his assessment of a rough surface on theoretical grounds that a comet's
"venting combined with the low gravity could lead to lots of fairy-castlelike
structures." Colwell believed that outgassing could theoretically lead to
stable, intricate structures, but he also acknowledged an alternative theo-
retical interpretation—one supported by Luchini and Shoemaker—that
constant bombardment may prevent these formations from occurring. Of
course, Colwell was not making any truth claims. They are speculative
guesses based on his interpretation of the data. Yet, because of cinema's
virtual witnessing capacity, they come across on the screen as truth claims,
and are thus subject to critique by those who would have a different inter-
pretation. In the end, most scientific reviewers of the film, like Kevin
Zahnle of NASA's Ames Research Center, agreed with Colwell's theoretical
interpretation, singling out the rough cometary surface as "realistic."[7]

Figure 6.4
Large fragments fly past the *Orion* spacecraft on its way through the comet's coma in *Deep Impact*.

Another area of scientific uncertainty was the particle size distribution in a comet's coma. *Deep Impact's* filmmakers had an interest in this cometary feature because their plot included a space flight through the coma. They could add significant drama to this scene *if* the particulate matter in the coma was large enough to create forbidding obstacles for the spaceship to maneuver through on its way to the comet nucleus (figure 6.4). Chris Luchini advised them that based on the latest data coming out of cometary studies he believed that there were "apartment size" pieces in the coma. Luchini defended his decision to advise on large fragments by citing studies done using radar observations of the comet Hyakutake: "There's particles everywhere from cigarette smoke sized to the size of three story apartment buildings which we have really good reason to believe [the presence of these large fragments in the coma] is true." When reporters following the production questioned John Harmon of the Arecibo Observatory, the author of the work Luchini was drawing on, about these "apartment sized" fragments, Harmon agreed that his work supported Luchini's advice because it showed that the gas jets coming off Hyakutake were so powerful they "could have blown off stuff tens of meters in size."[8] According to Luchini the inclusion of the large fragments in the debris field represented "cutting-edge science," and he was "very proud of getting it into the film."[9]

As with the surface's texture, there were disagreements among the consultants regarding what constituted an "accurate" representation of the

particle sizes in the coma based on contemporary data. For Luchini it was cutting-edge science but for Josh Colwell it was a questionable interpretation of the data—or at least he felt it was not strong enough evidence to claim it was probable. Despite his concerns, Colwell felt it would not be prudent to disagree with his colleague in front of the filmmakers:

Some of the suggestions that were made in the think tank I thought were made a little bit more strongly than our data or understanding warranted. But I actually didn't think it was important enough to say anything. I felt at the time, and still think it is the right decision, that if we started arguing amongst ourselves then they are going to say, "Well they can't even agree themselves. Why should we pay any attention to them?" So when somebody, Chris Luchini I think, said something about particle size distribution in the coma, which I didn't agree with how he said it or the particular numbers, I just decided to bite my tongue because I didn't think it really mattered. It wasn't something that was blatantly wrong or misleading. It was just not the same advice that I would have given.

Colwell had high hopes that the film would cause the public to take the idea of a killer comet seriously and he believed scientific realism was essential to this goal (see chapter 8). In their study of how scientific facts develop, Harry Collins and Trevor Pinch show in *The Golem* that scientific practice—especially in its initial stages when it is at its most unsettled—is far messier than it is presented to the public.[10] Thus, as Ulrich Beck demonstrates in *Risk Society*, when unsettled science is opened up to public scrutiny it can destabilize perceptions of scientific expertise.[11]

Colwell's colleague Luchini clearly had no compunction about airing his differences with Colwell over the presence of fragile surface structures. Colwell, however, decided not to make public in the think tank his disagreement with his fellow scientist even though such disagreements are a natural part of scientific practice. His chain of logic was that if filmmakers glimpsed the messy part of science they might call into question the validity of consultants' advice overall, such as that concerning the presence of low-level gravity, or the size and speed of the post-impact tidal wave; and if the filmmakers did not follow such advice it would hinder the film's overall realism and ultimately would not convince anyone about cometary threats. Colwell certainly appreciated the utility of unsettled science for filmmakers, but he perceived a danger that too much uncertainty would throw into question the whole notion of expertise.

Unsettled Science Settled: The Construction of Visual Evidence in *Jurassic Park*

In 1993 *Jurassic Park* sparked a dinosaur renaissance and almost single-handedly replaced previous public perceptions of dinosaurs as slow, lumbering, and dim-witted beasts with a new vision of dinosaurs as fast-moving and highly intelligent animals. *Jurassic Park*'s filmmakers put an extraordinary amount of effort into portraying accurate dinosaurs.[12] On many levels, however, the question of what represents an "accurate" dinosaur remains unclear, and the film contains conjectures about dinosaur behavior, evolution, and ecology that were at the time—and in some cases still are—open questions in the field of paleontology. *Jurassic Park*'s consultant Jack Horner had a significant stake in the depiction of contentious science in the film. In this case, cinema showed itself to be a valid method of communicating both to the public and to other scientists.

Although many of the contentious ideas in *Jurassic Park* and its two sequels (*Jurassic Park: The Lost World* of 1997 and *Jurassic Park III* of 2001) were present in the source book *Jurassic Park*, written by Michael Crichton, these ideas were initially inspired by Horner's writings or represented hypotheses he actively supported.[13] In many ways, Horner's use of *Jurassic Park* as a communicative medium was exceptional because he served as the primary science consultant on all three films, giving him a unique opportunity to suggest ways in which filmmakers could enhance or highlight key theoretical ideas. Theoretical concepts in the films that Horner endorsed include the hypotheses that dinosaurs were warm-blooded animals, that most had a communal nature, that dinosaurs vocalized for sophisticated communication, that many dinosaurs nurtured their young, and that *T. rex* was exclusively a scavenger. Although presented as "factual" in the films, none of these concepts had a complete scientific consensus and many of them were the subjects of heated debates.[14] Horner contributed to these debates by helping filmmakers design visual "evidence" demonstrating the validity of theories he supported.

The bird-dinosaur connection is a particularly interesting example. In *Jurassic Park* birds are represented as having evolved from a dinosaur ancestor rather than from another, older branch of reptiles. While most paleontologists now accept this hypothesis, it was a contentious issue in 1993

when the original film was released. Many ornithologists and developmental biologists still fiercely contest the idea.[15] Not only was Horner pleased to see the bird-dinosaur connection in the script, he also saw a golden opportunity to popularize this idea through the film. According to Horner, the dinosaur depictions in *Jurassic Park* were intended to demonstrate this connection: "The whole idea of the film was to get people to look at dinosaurs as birds, rather than as reptiles." Therefore, he helped filmmakers construct cinematic confirmation for the bird-dinosaur evolutionary connection including visuals, dialogue, character actions, animal behaviors, and entire scenes.

The bird-dinosaur theme plays a major role in the film and is portrayed as the "radical" hypothesis of Alan Grant, who is based on the real-life Jack Horner.[16] Throughout the course of the film the audience is presented with visual support for Grant's/Horner's theories. When we first meet Grant he explains to his field assistants, and to the film's audience, his conceptions of the bird-dinosaur evolutionary relationship. He backs his explanation up by pointing to a computer screen that visualizes a complete *Velociraptor* (raptor) fossil (figure 6.5):

Grant: Look at the half-moon shaped bones on the wrists. No wonder these guys learned how to fly. (The field assistants laugh at him.) Seriously. Well maybe dino-

Figure 6.5
A "raptor fossil" in *Jurassic Park* provides visual "evidence" supporting the idea that birds evolved from theropod dinosaurs.

saurs had more in common with present day birds than they do with reptiles. (Pointing at a computer image of a *Velociraptor* fossil.) Look at the pubic bone turned backward, just like a bird. Look at the vertebrae full of air sacs and hollows just like a bird. And even the word raptor means "bird of prey."

With the guidance of Horner, the filmmakers created a computer-generated image of a "*Velociraptor* fossil" that Grant used as a visual device to explain the theory of bird evolution favored by Horner. There are several other scenes that present with observational "demonstrations" that birds evolved from dinosaurs. In a scene where a pack of *Gallimimus* run away from a *T. rex*, Grant exclaims that the *Gallimimus* move with "uniform direction changes, just like a flock of birds evading a predator." Of course, the audience sees this "flocking" just as Grant does and Grant's dialogue encourages the audience to "witness" his interpretation of these actions as well.

Jack Horner rejected any element in the script or in the production that did not support the bird-dinosaur connection or cast doubt on the idea. For example, *Jurassic Park*'s special dinosaur effects supervisor Phil Tippett had a challenge "filming" *Velociraptors*. A great deal of the raptors' screen time involved them standing around, which was boring cinematically. Tippett wanted the raptors to do something to "fill the time with interesting action."[17] He explains how he came up with a cinematically satisfactory solution and how Horner shot it down:

One of the things I came up with was a flicking tongue movement. We shot all the animatics that way and it was a great time filler—the tongue movement would really enliven a dead scene. But when Jack Horner—the paleontologist on the show—saw it, he said: "What are you doing? Raptors didn't do that! They physically couldn't do that! This is terrible!" We all wanted to be as authentic with these things as possible, so we got rid of the tongue movement.[18]

From Horner's standpoint, this scene was problematic because it made the raptors look "like lizards or snakes" (figure 6.6). Horner understood the film's larger cultural impact on public perceptions. If Horner had not objected, visuals of tongue-flicking dinosaurs would reinforce conceptions of dinosaurs as reptiles. "Had [the tongue flicking] been left in the scene, all the work that went into making these things birdlike would have been gone," he explained.

Horner also understood that cinematic science should serve the drama, and in this case his objection created rather than solved a problem.

Figure 6.6
The *Velociraptors* in *Jurassic Park* originally included a "tongue-flicking" movement as seen in the preproduction animatics.

Therefore, he suggested a visual alternative that not only heightened the film's drama, but it also made the connection between birds and dinosaurs more transparent. Rather than have raptors flick their tongues, he recommended that as a raptor peers into the kitchen it should snort out a breath that would fog up the window. Only endothermic (warm-blooded) animals such as mammals and birds could fog a window because of temperature differences between the animal's lungs and the air. If a dinosaur's breath fogged the window it must, therefore, be related to birds. Thus, with one suggestion Horner was able to remove elements inconsistent with the bird-dinosaur concept while incorporating an image that visually highlighted this evolutionary relationship.

The point of this analysis is not to challenge the scientific legitimacy of the bird-dinosaur connection. I am trained as an evolutionary biologist and find the empirical evidence for this theory compelling. What I do want to stress, however, is that Horner's position as consultant allowed him to help shape the visualization of a contentious scientific idea in a major Hollywood film—a film that Horner himself admits has clearly had a major impact on public perceptions of dinosaurs. As with *King Kong*, we can imagine what the film might have looked like had filmmakers chosen an opponent of the bird-dinosaur connection as consultant. Would we look

at birds or dinosaurs the same way today if bird-from-dinosaur oppo-nents—such as University of Kansas paleontologist Larry Martin or Wes-leyan University developmental biologist Ann Burke—had served as *Jurassic Park*'s science consultant?

Drawing a Line in the Sand: Personal Black Boxing and Consultant Inflexibility

Harry Collins shows in his work on gravitational waves how scientists, as well as interested outside parties such as funding agencies, in public tend to black box areas of uncertainty, and how they mobilize to reinforce their own conceptions of nature while marginalizing opposing interpretations.[19] In my analysis cinema becomes another mode by which experts with a stake in a particular scientific explanation can propagate their version of natural law. In essence, films act as "demonstrations" that allow audiences to "witness" scientific conjectures as concrete objects appearing alongside real-world elements such as actors, buildings, creatures, and machines. The validity of these conjectures is also confirmed by narratival elements including plot trajectories, dialogue, and exposition. For scientists, films offer opportunities to help construct visual evidence verifying a preferred hypothesis as "natural." Jack Horner's insistence on birdlike depictions of dinosaurs provided a vehicle for millions of people to observe a conception of dinosaur evolution that was "naturalized" in the cinematic space, and propagated this interpretation as naturally authentic.

Unsettled science in cinema illustrates that while consultants often demonstrate flexibility with scientific inaccuracies they become inflexible when the fact under consideration is of professional interest. Horner felt that he was dealing with two categories of scientific questions in *Jurassic Park*: (1) questions about dinosaurs for which "we know for sure what is not accurate" (textbook science), and (2) questions about dinosaurs for which there is little known (unsettled science). According to Horner, Spiel-berg respected textbook science, and found the ambiguity of unsettled science useful: "I could actually say to Spielberg that 'no that cannot be right, we know for sure that is not accurate,' then he would not do it that way. But if I said 'maybe,' then that was something he could use and fic-tionalize. That is why some of the dinosaurs are fictionalized even in their appearance because we don't really know for sure what they look like."

Horner shrugged off most factual errors in textbook science as unimportant because the film was fictional and for most people these inaccuracies were unnoticeable. He also understood that his colleagues would understand that blatant inaccuracies were due to filmmaking needs and not an oversight on his part.

"Inaccuracies" in the category of unsettled science were also unproblematic for Horner because it is currently impossible to conclude what is accurate and what is inaccurate. Why, then, was Jack Horner so adamant that certain factual errors were unacceptable in the film? Why were questions concerning the bird-dinosaur connection, warm-bloodedness, communal dinosaurs, or nurturing parents sacrosanct? Why did he fight hard to get filmmakers to depict *T. rex* more "accurately" by portraying it as a scavenger ("I started right from the get go, right from *Jurassic Park*")? It was a battle he kept waging until he finally succeeded in *Jurassic Park III* ("If you notice in *Jurassic Park III* [*T. rex*] is a scavenger. Director Joe Johnston portrays it as a scavenger"). Horner demonstrated inflexibility with these questions because some scientific "accuracies" are more significant than others in a consultant's eyes.

In relation to film consulting there is a third category of scientific knowledge: those questions for which we do not currently know what is accurate, but for which the science consultant believes there is a satisfactory and definitive answer. Essentially, this represents a personal black boxing of knowledge. Consultants demonstrate inflexibility with personally black-boxed science. While Horner believed that certain theoretical concepts were "true," he realized that some scientists favored alternative explanations. Because he accepted the fact that *Jurassic Park* could popularize scientific ideas he promoted—like birds-from-dinosaurs evolutionary theory—he also understood that the film could have popularized competing explanations instead. Therefore, he felt compelled to defend cinematic representations of topics that fell into the category of personally black-boxed science. Otherwise, another competing explanation would be "naturalized" on the screen.

Other consultants' experiences bear out how a consultant's flexibility, which generally accompanies unsettled science, can be compromised if filmmakers seek out advice that is too close to a consultant's research or encompasses a scientific debate they feel strongly about. Joan Horvath has worked in consulting situations where she has "rode herd" on a group of

Jet Propulsion Laboratory scientists serving as a consulting committee. Providing concrete recommendations was difficult when contentious areas of science were involved because it was likely that at least one member of the committee would have a stake in the debate. She recounted one instance where the producers of the television show *Crusade* (1999) wanted what they thought was basic advice. "Somebody asked what was for the production side a fairly innocent question," she recalled. "What they didn't realize was that this question was inflammatory to various scientists in our group." This particular question led to a "flame war" as committee members emailed each other supporting data for their position and arguments against a colleague's position. According to Horvath, such disagreements were not unusual. For the producers, and the audience, these dynamics were invisible because Horvath chose one side of these debates for producers to display on the screen.

This inflexibility is particularly apparent when a consultant's advice concerning personally black-boxed science does not mesh with filmmakers' visual and dramatic needs. According to production designer Alex McDowell this was the case with several scientists during *Minority Report*'s (2002) think tank. Despite filmmakers' resistance to a visually unappealing theoretical concept, several scientists kept pushing the idea, irritating McDowell, who said, "I was frustrated with these scientists because they would not let go of their pet theory." Ultimately, McDowell "fought them off" and went with a more visually interesting alternative theory. Therefore, these scientists lost out on the opportunity to have their preferred theory depicted as true in a film sure to be seen by millions of people. They also missed the chance to benefit from the publicity and media attention that generally follows when a Hollywood film features a new or controversial idea. Why wouldn't consultants push their "pet theories" when the alternative is seeing a competing concept depicted on the screen as "natural" or as things should be?

Seeking out Hollywood Validation: Nuclear Planet, J. Marvin Herndon, and *The Core*

Scientists are becoming increasingly conscious of the advantages of having a Hollywood film feature their side of a scientific dispute. Some consultants, in fact, have approached filmmakers in an attempt to promote their

Figure 6.7
Dr. Josh Keyes (Aaron Eckhart) uses a peach to explain Marvin Herndon's "nuclear planet theory" in *The Core*.

scientific views. One such scientist is geophysicist J. Marvin Herndon of Transdyne Corporation who actively sought out the makers of *The Core* (2003) to offer his services as an advisor.[20] He phoned the film's director Jon Amiel when he learned that the disaster film was going to be based on his controversial hypothesis about the existence of a giant uranium ball in Earth's center (figure 6.7). According to Herndon, this natural nuclear reactor is burning out, which will ultimately disastrously cause the disappearance of Earth's magnetic field (figure 6.8). Herndon, who has minimal support within the scientific community, felt that a major motion picture would publicize his ideas to the public and also force scientists to take the concept more seriously.

Even though his work has been published in a large number of peer-reviewed journals, including the prestigious *Proceedings of the National Academies of Science* (*PNAS*), Herndon does not feel there has been a fair academic debate. Because screenwriter John Rogers—who has an undergraduate degree in physics—incorporated Herndon's theory, Herndon believed that "the makers of the movie had a much better attitude towards science than many scientists I know."[21] Although Herndon's direct contribution to the film was minimal both he and the filmmakers benefited from his participation. The film's plot hinged on Herndon's ideas and the filmmakers were adamant that his backing meant that the film had a strong scientific underpinning. Producer David Foster even wrote a letter to the

Figure 6.8
The slowing down of the Earth's core produces an "electromagnetic tear" in *The Core*.

editor of his local newspaper, *The North County Times*, defending the film's scientific versimilitude after the paper's reviewer called the film "scientifically inaccurate."[22]

Herndon's name figured heavily in *The Core*'s publicity material, which resulted in extensive news coverage of his nuclear planet theory. In addition to standard publicity material, Paramount Studios also sent out a press release hyping the "coincidental" release of Herndon's *PNAS* article.[23] The press release called attention to the journal's prestige and touted the article's vindication of the film's science. A wide variety of news outlets from print media to television to the Internet covered his concept, often with headlines such as "Sci-fi Thriller 'The Core' Contains Grain of Truth."[24] As Chris Toumey shows, media coverage of controversial science always benefits the person with the least amount of scientific support because of the "pseudo-symmetry principle."[25] Reporters are taught to maintain "balance" in their reportage. Therefore, even when one side of a dispute has more support than another, coverage in news media gives the illusion that each explanation is equally valid.

Science studies scholars have established that science popularization is not just a sharing of scientific knowledge with the public, but also plays a role in knowledge construction.[26] On one level, popularization influences scientific debates by providing a venue where scientists can make a case for their field or research interest receiving greater financial resources, a

topic covered in chapters 8 and 9. However, the influences of popular science cannot be reduced simply to feedback mechanisms of public support. Massimiano Bucchi has persuasively argued that accounts in non-technical media impact science because they "can foster the inclusion or exclusion of actors or theories from the specialist's discourse, and [popular accounts] can make room for new interpretations or confer a different status on existing models by linking them to other public issues and themes."[27] Inclusion in a Hollywood film clearly raises a scientific concept's profile and—as we will see in the next section—forces specialists to debate the merits of a contentious idea. Not only did *The Core* familiarize the public with Herndon's controversial nuclear planet theory, the associated media coverage extended this popularization and further legitimated his ideas in the public's eye. In addition, the film provided a new context for this debate by suggesting dire consequences if scientists and the public do not take Herndon's model seriously.

Accuracy Is in the Eye of the Beholder: Scientific Reactions to Unsettled Science in Cinema

Whether a science consultant has a professional stake in a scientific debate or not, there will be scientists in the audience who *do* have a stake in the outcome of these debates. Cinema's forced consensus on scientific disputes puts scientists who disagree with these depictions at a disadvantage because they must find other media channels—news media, popular magazines, the Internet, and others—to promote their own conceptions about what represents a true scientific representation. Often these responses come in the form of "Real Science of" articles in which a scientist critiques the scientific accuracy of a fictional film in a newspaper/magazine article or in cinematic science reviews for research journals such as *Nature* or *Science*. The many geophysicists who disagreed with Herndon's nuclear planet hypothesis could only respond to depictions in *The Core* through the news media, scientific journals, blogs, and other media outlets. An April 2003 *Popular Science* article on the film is typical of the scientific backlash against Herndon's ideas as depicted in *The Core*.[28] Although Herndon's name is not mentioned directly, several geophysicists roundly criticized his ideas on the causes of the Earth's rotation. In the words of geophysicist David Stevenson the idea that the core would stop rotating was "silly."

Geophysicist Gary Glatzmaier said the reasoning behind the film "is almost completely backward." For Herndon, the film was an accurate representation of what will befall the Earth's core, but for those scientists whose competing positions visually and thematically "lost out" the film consisted of "science bloopers."

Even when a film such as *Deep Impact* receives a warm reception from the scientific community it still generates scientific critiques with regard to its disputed elements. One of the most interesting things about *Deep Impact* is that it clearly demonstrates how consultants and science reviewers can rely on different bodies of evidence and studies to construct their interpretations about what is "accurate." As discussed before, Chris Luchini defended his decision to advise on the presence of large fragments in the comet's coma by citing radar observations of the comet Hyakutake done by John Harmon. Several scientific reviewers singled out this aspect of the comet's environment as particularly "inaccurate" in their film critiques. Astronomer Mike Reed, for example, found the particle distribution problematic and claimed on his Web site that existing evidence showed that "most of the material that leaves a comet is smaller than the thickness of a single, human hair."[29] He also criticized the film's portrayal of the debris field on theoretical grounds: "If the comet were losing [material] this quickly, we'd have nothing to worry about. It would be long gone before reaching the Earth." Astronomer Randall Brooks also disagreed with the depiction of large fragments and said in a newspaper article that he believed that evidence from other studies suggested smaller particles: "The scenes of the rocky approach of the massive *Orion* spacecraft nearing the comet were, on the basis of spacecraft studies of comets like Halley's, overdone. Relatively few large rocks come off comets."[30] Although Luchini felt that studies by Harmon supported the idea of a debris field that could accommodate numerous large fragments, others like Reed, Brooks and fellow consultant Josh Colwell felt the evidence suggested otherwise. All of these scientists claimed "accuracy" based on different interpretations of evidence. Only Luchini, however, was able to influence the portrayal of a comet in a major Hollywood film, thus propelling John Harmon's interpretation of cometary environments with large particle debris fields to the forefront of the film audiences' minds.

Most consultants understand that their scientific colleagues will scrutinize the films for which they advise. Jack Horner recognized that his ability

to communicate scientific ideas through film could be the starting point for scientific discussions. "I guess what makes films interesting for me is that you can get some of these conceptual things that you are working on into a movie and then it either gets people sort of riled up or it gets them interested," he said. The *Jurassic Park* films certainly got paleontologists "riled up" because only one side of dinosaur science got screen time. Scientists who disagreed with *Jurassic Park*'s depictions expressed their theories about dinosaurs in public outlets with significantly smaller audiences than a blockbuster movie can command.

One scientist who disagreed with *Jurassic Park*'s depiction of dinosaurs as fast-moving animals took the step of experimentally testing this notion. Biomechanics researcher John Hutchinson felt that while the dinosaur movements on the screen seemed natural, he did not believe that animals so large would be able to move that quickly. In particular, the scene where *T. rex* chases down a car struck Hutchinson as implausible given the animal's large size: "How a 13,000-pound, two-legged animal would be able to run 45 miles an hour just seemed really strange to me."[31] He and a colleague created their own computer models and found that it was not possible for animals that large to move that fast. Cinema's reality effect made a fast moving *T. rex* seem plausible to other viewers, but not to him, a specialist. It is important to note that Hutchinson was not reacting to a factual "inaccuracy" in the film.[32] The potential speed of large dinosaurs was not known in 1993 and was a contentious issue until Hutchinson and his colleague demonstrated the limitations in their movement.

Notable among scientific reactions to *Jurassic Park* was paleontologist Stephen Jay Gould's review in the *New York Review of Books*.[33] While he mainly expressed concern that "dinomania" was turning museums into theme parks, he also took the opportunity to question the science behind the quick, hot-blooded dinosaurs promoted by Jack Horner, Bob Bakker, and others that form the basis for the film's representations. Gould recognized that the disputed interpretations were not "science bloopers" on the part of filmmakers, but represented competing scientists' visions of dinosaur evolution and ecology. For example, he considered the dinosaur depictions as "professional speculation" and he referred to *T. rex*'s posture specifically as "currently fashionable." He also felt that the film overplayed the potential evolutionary relationship between dinosaurs and birds, and

stated, "[Spielberg] experimented, in early plans and models, with bright colors favored by some of my colleagues on the argument that bird-like behavior (and closeness to bird ancestry) might imply avian styles of coloration for the smaller dinosaurs." Gould acknowledges seeing the handiwork of colleagues in the depictions. "As a practicing paleontologist, I confess to wry amusement at the roman-à-cleffery in the reconstructions. I could recognize nearly every provocative or *outré* idea of my colleagues." In other words, Gould is clearly able to see the debatable scientific ideas that went into the fictional representations. Moreover, he not only disagrees with these ideas, he also considers them *outré* or bizarre. Jack Horner's version of "accurate" dinosaur science became Gould's vision of "bizarre" science.

Gould also perceptively noted how informal scientific activity around the film bled into the formal sphere. He specifically addressed the publication of a cover article in the prestigious journal *Nature* that was timed to coincide with *Jurassic Park*'s premiere. In the article, Raul Cano and his colleagues claimed to have amplified DNA from a 135-million-year-old weevil.[34] This "coincidental" publication of studies related to cinematic science is actually quite common, particularly for science consultants involved in a film production. As noted earlier in this chapter, Marvin Herndon's *PNAS* article came out the same weekend as *The Core* opened in theaters. Jack Horner and his funding agency, the National Science Foundation, deliberately timed a press release about Horner's claim to have retrieved *T. rex* DNA to coincide with the opening of *Jurassic Park*'s theatrical run.[35] Jack Horner continued this activity with an announcement during the premiere of *Jurassic Park III* concerning the excavation of one of the largest *T. rex* skeletons ever found.[36]

Clearly, these deliberately timed releases benefit all interested parties including scientists, journals, filmmakers, and funding agencies. Gould, in fact, argued that the melding of the formal and informal was a beneficial development: "The nearly complete blurring of pop and professional domains represents one of the most interesting by-products—a basically positive one in my view—of the *Jurassic Park* phenomenon. When a staid and distinguished British journal uses the premiere of an American film to set the sequencing of its own articles, then we have reached an ultimate integration." Despite Gould's conviction that this crossover was favorable, scientists who use Hollywood to promote their scientific studies tend to

face a backlash from the scientific community. Geophysicists disparaged Herndon for using the release of a Hollywood film to promote his *PNAS* article.[37] As mentioned in chapter 3, Raul Cano was likewise taken to task by colleagues for linking his scientific work to the promotion of *Jurassic Park*.[38] Jack Horner also had to publicly defend his actions when he altered the discovery date of that large *T. rex* at the behest of Universal Pictures to coincide with *Jurassic Park III*'s opening.[39]

Interestingly, nobody faulted Horner or Herndon for their work on the films where they influenced the depictions of contentious scientific ideas. It was the *promotion* of their scientific work using the film's publicity apparatus that generated negative responses. It is clear that the scientific community considers a scientist's film work as an act of popularization separate from formal communicative work. When science consultants blur this distinction by directly tying formal communication to their popular work on films, the scientific community quickly moves to condemn their actions.[40] Much of the literature on science and mass media, however, confirms that communication outside of technical literature is not limited to disseminating scientific knowledge to nonspecialists; popular works also act as communicative devices within the scientific community. The fact that scientists respond to cinematic representations confirms that popular films also serve as effective channels of communication between specialists. Even if scientists believe they are trying to correct "public" scientific representations, by responding to film depictions they are still arguing about what represents accurate science in the first place.

Clearly, consultants' influence on cinematic science fits into Bruce Lewenstein's "web model" for scientific communication in that cinema, other mass media, and technical media interact in complex ways, informing and referring to each other.[41] The web model allows popularization including science consulting to be considered not as something peripheral to scientific activity, or as deviant or pathological, but as an integral function of normal scientific life. Marvin Herndon's scientific claims, for example, form the basis of *The Core*, which leads to his ideas, and his recent *PNAS* publication, becoming part of the film's publicity including attendant news media coverage that takes his views seriously. This, in turn, prompts other scientists to vent their disagreements with Herndon in newspapers and popular science magazines and over the Internet, which itself generates comments in *Nature* and other formal avenues. While some scientists

may consider Herndon's piggybacking on the publicity of a major Hollywood film as self-serving, it is just an extension of normal communication practices whereby scientists use any outlet available to them in order to establish what they feel represents the correct interpretation of nature.

Cinematic Knowledge: Communicating Science through Cinema

In 2002 the Geological Society of America sent out a press release about geologist Kevin Pope's challenge to the theory that dust from an asteroid impact caused the dinosaur extinction.[42] A *Time* magazine article about this story featured a still from *Dinosaur* (2000) with the caption "Even Disney has accepted the asteroid theory," implying through this caption that the Disney film acted as a cultural barometer to the acceptance or rejection of scientific thought.[43] The film charts the transition from expert knowledge to public knowledge. In fact, the *Time* article showcases the uphill battle Pope faces to get his scientific ideas on the map since "even Disney" accepts the asteroid theory. Pope is not only fighting other scientists but also representations, created with the help of scientists who accept the asteroid impact theory in movies such as *Deep Impact*, *Armageddon* (1998), *Dinosaur*, and *Mission to Mars* (2000). Pope, however, does not (yet) have access to a fictional film to publicize his ideas to millions of people. Realizing that "even Disney" is treating the asteroid theory as black-boxed, Pope reached out to the public and other scientists through alternative communication routes, including sending out a press release to promote his findings.

The creators of these films may or may not have known about scientific debates over what killed off the dinosaurs. In the end, they would not have cared. Given the choice between an Earth-destroying asteroid and the planet's gradual decline due to changing environmental conditions, filmmakers are going to choose the more visually interesting and dramatically exciting asteroid impact every time. Filmmakers' choices regarding unsettled science are never based on which option is the most scientifically plausible. They will always privilege the visual and dramatic. This is why *Deep Impact* featured a jagged cometary surface, powerful cometary geysers, and large debris particles in the coma; why *Jurassic Park* relied on quick-moving birdlike dinosaurs; and why *The Core* depended on the breakdown of the Earth's electromagnetic field. All of these scientific explanations are

more visually dynamic and dramatic than alternative interpretations. The fact that these explanations were provided directly to filmmakers by science consultants makes them even better. The uncertainty of unsettled science justifies filmmakers' artistic license and a consultant's scientific expertise validates their choices. As long as *their* science consultant says something is possible that is good enough.

The flexibility inherent to unsettled science changes as scientific questions touch on a consultant's research specialization. In general, the greater the stake a consultant has in the disputed science under consideration, the more inflexible he or she will be in terms of cinematic depiction. While Marvin Herndon sought out Hollywood validation, this is not to imply that others like Barnum Brown or Jack Horner had ulterior motives for consulting or for suggesting one alternative hypothesis over another. Brown was asked how many digits *T. rex* had on its forearm, and in his opinion the answer of three digits was an indisputable fact. Although Jack Horner used *Jurassic Park* as an opportunity to promote the bird-dinosaur evolutionary connection, he did not initiate the consulting opportunity. When filmmakers asked Horner about topics that he personally black boxed (e.g., *T. rex* as scavenger) he naturally suggested explanations he himself had vociferously argued for in scientific arenas. Nevertheless, Brown and Horner benefited from having their side of a dispute represented over another.

The battleground over scientific ideas is not limited to scientific meetings and publications, or even to traditional popularizing realms such as documentaries and newspapers. Fiction provides an open, "free" space to put forward speculative conceptualizations. Fictional media, in fact, has advantages not found in other avenues of popularization. In particular, the presence of a narrative storyline contributes to the believability of scientific scenarios by providing audiences with explanations and rationales for why events are unfolding. Cinematic depiction has an additional advantage even over written fiction. Cinema's perceptual realism and narrative framework legitimize contentious or speculative scientific concepts by presenting them as "natural" or the "way it is."

To borrow a phrase from literary scholar Ronald Thomas, cinema acts as a "device of truth" by imparting a legitimizing effect on emerging or controversial scientific ideas.[44] During the scientific process there are several competing visions of nature that can make claims to representing

"fact." A fictional film, however, allows for only one of these visions to be presented as "natural" on the screen. Film has the ability to create concrete images of the natural world on the screen and, thus, in the audience's mind; such images include "here is what a comet looks like," "here is how birds evolved," "this is why the Earth's core rotates," and so on. Essentially, cinema's naturalizing lens removes all discourse from a scientific dispute. Fictional films, in essence, force a consensus through its reality effect, even though this consensus is an illusion. Those researchers who consult on fictional films have access to a very effective persuasive tool, one that few other scientists possess, and one that can significantly shape our interpretations of the natural world.

7 Fantastically Logical: Fantastic Science, Speculative Scenarios, and the Expertise of Logic

A distinctive stylistic contrast existed between American and European approaches to science fiction cinema in the 1920s. European filmmakers favored darker lighting and expressionistic sets, while American science fiction followed the form of classical Hollywood cinema featuring a realist visual style that did not call attention to cinema's artifice. Differences extended to narrative elements such as thematic motifs, characterization, and temporality. Film historian John Baxter argues that a significant component of the American approach was the necessity of rational explanations for fantastic situations.[1] According to Baxter, European audiences understood that extraordinary events depicted in such films as the Russian *Aelita* (1924) and the German *Metropolis* (1926), were merely a means to explore social, political, or psychological issues, and so they let slide any gaps in logic. American audiences, conversely, needed to believe that the extraordinary events behind the cinematic spectacles on the screen were *possible*.

This presented a dilemma: how do filmmakers make movies both believable *and* sensational? Science has been the Western world's accepted mode of "truth" since the Age of Enlightenment and idealizations of science are found in many cultural systems such as the legal and policy arenas. As Ulrich Beck has shown, modernity is, in fact, founded upon a belief that rationality is equivalent to science.[2] As the ultimate logic-based activity, then, scientific explanation became the dominant mode by which American filmmakers of the 1920s tried to explain fantastic storylines. The decision to harness science's explanatory power naturally led to filmmakers seeking out scientists' assistance for even the earliest films including *The Invisible Ray* (1920) and *A Blind Bargain* (1922).[3]

The development of sound synchronization techniques led to the downfall of the European style and the dominance of the American form when European studios found it difficult financially to adjust to this new technology.[4] Science fiction scholar Phil Hardy argues that sound synchronization had an especially large impact on science fiction cinema as sound "brought the swift domination of American artistic, aesthetic and above all, commercial practices in filmmaking. Henceforth, with only occasional but important exceptions, science fiction was to become the province of Hollywood filmmakers."[5] This had a profound impact on the utilization of science consultants as scientific explanation for fantastic and extraordinary events became—and remains—the default position. Recent developments in special effects technologies have increased filmmakers' need for science consultants, especially in post-*Jurassic Park* Hollywood. The more perceptually realistic cinematic images become, the more filmmakers require scientists' help in convincing audiences that the events surrounding these images are *plausible*. Filmmakers do not want audiences ignoring their multimillion-dollar special effects shots merely because viewers cannot accept film events as possible.

Because scientific work involves logical deduction, filmmakers perceive that scientists have an expertise in "thinking," or as I refer to it an "expertise of logic." Filmmakers combine scientists' expertise of logic with their own creative expertise to construct stories and images that are both plausible and spectacular. Filmmakers' desire for realism extends beyond visual realism or even the plausibility of cinematic events. They need to maintain a narrative realism that encompasses the totality of events in their fictional world even if these explanations merely provide background information. According to University of Minnesota physicist Jim Kakalios, the makers of *Watchmen* (2009) wanted him to help "fill in the blank spaces" so that everything about the movie's fictional world—whether seen or unseen— had a logical explanation.

In the context of cinematic science I find that extraordinary events fit into two distinct categories: speculative scenarios and fantastic science. What distinguishes one from the other is their potential for occurring in the real world. Speculative scenarios represent situations or technologies that, while improbable or future based, at least could come to exist. Joan Horvath's experiences on the television show *Crusade* (1999) clarifies what I mean by speculative scenarios. During preproduction the producers of

the show convened a scientific team from the Jet Propulsion Laboratory (JPL) fronted by Horvath. As Horvath tells it the team was thrown for a loop when the first question came from the set designer: Would we have floor lighting in the twenty-fifth century? This question exemplifies the challenges consultants face with speculative scenarios. Filmmakers are asking scientists to justify an extraordinary situation—the contents of a typical living space in the twenty-fifth century—using scientific rationales. Four hundred years from now Horvath's team's scientific reasoning may prove to be wildly off the mark. The crucial point with speculative scenarios, however, is that they *could* be proven correct. At a minimum, speculative scenarios are grounded in some aspect of real-world science from the start. Questions about manned space travel toward the Sun or to Mars, as in *Sunshine* (2007) and *Mission to Mars* (2000) respectively, have as their starting point contemporary rocketry. Ultimately, science consultants advising on speculative scenarios hope to create what NASA's media department calls "feasible fictions."[6]

While speculative scenarios have the potential—no matter how distant—of representing reality, fantastic science completely lacks this potential.[7] No matter how much knowledge we gain or engineering skills we develop, the mind-control scenario Daniel Kubat constructed for *The Stepford Wives* (2004) will never come into existence. Unlike speculative scenarios, the creative process for fantastic science presents no identifiable foundation: Where does Jim Kakalios begin in designing a plausible scientific basis for the development of the godlike Dr. Manhattan in *Watchmen* (figure 7.1)? Donna Cline, likewise, has no scientific precursor to help her design scenarios surrounding the evolutionary monster in *The Relic* (1997) or the human/dog transformation narrative in *The Shaggy Dog* (2006). Although fantastic science does not exist in the real world, consultants are asked to make it appear in the film's world that fantastic science is genuine science; that it is accepted as fact by the film's characters.

Spectacular Design: Putting Scientific Constraints to Use

Richard Terrile has been involved with several films that relied extensively on speculative scenarios including *2010* (1984), *Solaris* (2002), *Terminator 3* (2003), and *The Core* (2003). For *Solar Crisis* (1990) a production company employed him to help develop a scientifically acceptable fictional manned

Figure 7.1
There is no logical starting point from which to develop scientific explanations for
nonexistent beings like the superhuman Dr. Manhattan in *Watchmen*, who is able
to replicate himself at will.

mission to the Sun. His first inclination was to convince them that a
manned mission was not necessary and he began proposing alternatives.
As he recalled, "I am sitting in this story meeting thinking of ways, like
heliotomography, so they wouldn't have to go into the sun. So you
could see the inside of the sun without having to go inside the sun. At one
point the art director turns to me and says 'Rich you don't get it.' I said
'What?' He says 'They have to go into the sun.' I said 'Why?' He says
'Because the audience expects it.'" Terrile's experience in this meeting
provides an insight into how successful science consultants approach spec-
ulative scenarios. Presumed audience expectations and genre conven-
tions—not scientific accuracy—determine a movie's storyline. Filmmakers
were not asking him to use science to generate a more accurate but differ-
ent scenario for their mission to the Sun. Rather, they wanted him to use
science to make *their* story more accurate. The manned mission *was* the
story, regardless of how improbable or scientifically inaccurate it seemed
to Terrile.

Solar Crisis's filmmakers believed that audiences would be more emo-
tionally involved in the spectacle of a dangerous mission involving a
human crew than they would be in a more scientifically realistic but
unmanned mission. In addition, the filmmakers were merely following
long-established genre conventions for manned missions in science fiction
and disaster films. Hollywood filmmakers, especially those working on

high-concept movies, are conservative by nature and any deviations from genre conventions could spell box office disaster. After working on *Solar Crisis* Terrile came to a conclusion that informed his work on later films: "The goal of a technical advisor is not to prevent an impossible scenario. The goal is to make an impossible scenario acceptable." For Terrile this meant combining his scientific knowledge with his ability as a scientist to engage in "long extrapolation physics." In the end he developed an acceptable scenario for *Solar Crisis* by employing "acoustic cooling and other energy sources" to validate a manned journey to the Sun (figure 7.2).

Terrile was satisfied with his explanation for *Solar Crisis*, as well as his work on the speculative scenarios in *2010*, *Solaris*, and *Terminator 3*. His dissatisfaction with the handling of the speculative scenario in *The Core*, however, led him to temporarily quit the production. The scenario for this film, a manned mission to the earth's core, was no more implausible than the mission in *Solar Crisis*. Why, then, was he so unhappy with the science

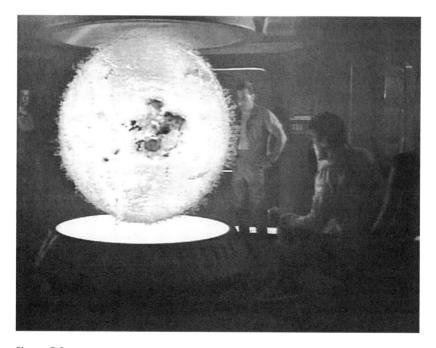

Figure 7.2
Astronauts review their plan for redirecting a potentially Earth-killing solar flare in *Solar Crisis*.

in *The Core*? For Terrile *The Core*'s filmmakers had crossed a boundary into what he considered an unacceptable use of science for a speculative scenario.

To elucidate this boundary we can examine the differences involved in developing the central speculative scenarios for each film. For *Solar Crisis*, filmmakers started with a nonnegotiable plot requirement—a manned mission to the Sun. As discussed, Terrile's role was to provide them plausible reasons why human beings would need to undertake such a mission. The box office draw was the trip to the Sun itself, not its scientific justifications. For *The Core*, the filmmakers also started out with a nonnegotiable plot requirement—a manned mission to the earth's core. However, rather than asking Terrile to generate his own scientifically acceptable motivation for undertaking the mission, they insisted on using the screenwriter's idea—that the earth's core has stopped rotating—which was a scientific concept that Terrile found totally unacceptable.

After seeing the explanation in the original script, he assumed they would ask him to develop a more legitimate motivation for their central mission. They did not. Instead they put Terrile in the awkward position of being asked for his scientific stamp of approval on a concept he found completely unacceptable. "You know there is a line in the movie, 'The core has stopped spinning.' This is an absolutely ridiculous statement to make in any scientific environment," Terrile explained. "I actually quit because of that line, but it was the one that the studio had to have in there because it was so clear to the audience. The core had stopped spinning. What could be clearer than that? We have to re-start the core. So it remained in the movie and was one of the key lines in the movie." Science consultants can accept the need for scientifically unsound narratives; they accept that they are working on a fictional film. Yet, they also believe they should be given the opportunity to modify the science surrounding a central narrative whenever possible. In this case, Terrile was not only forced to accept the filmmakers' outlandish narrative, he was also forced to accept *their* scientific explanation for this narrative.

Terrile's experience on *The Core* certainly demonstrates the low opinion some filmmakers have of an audience's ability to grasp complexity. Terrile's quote also makes it clear that, as with the necessity of the manned mission itself, audience expectations were behind the filmmakers' decision to dictate the film's science to their science consultant. They believed their

consultant could not come up with an explanation easier for an audience to understand than the one already present in the script. According to production designer Alex McDowell, director Steven Spielberg's concerns about audience responses shaped all of *Minority Report*'s (2001) speculative scenarios: "Spielberg gets seduced by certain ideas and runs with them, but at some point he says the audience is not going to get it, or whatever it is that is motivating a particular aspect of a story. Then it just gets [moves his hand across is throat], regardless of whether it is accurate or real. Despite his original request for reality he will cut anything that he thinks will confuse the audience."

When *Minority Report*'s filmmakers originally asked their consultants about technological advances in the next fifty years, they received well-reasoned explanations. Spielberg, however, was concerned that audiences would not accept these explanations. According to McDowell, "Steven felt that these leaps [from the present] were too big and he would lose the audience." In the end, Spielberg ordered his design team, including McDowell, to "pull back" on the consultants' projections. For McDowell, Spielberg's concern drove several decisions to include technologies that will soon or already have become outmoded. For example, bulky earpiece phones were incorporated because projected future technological equivalents did not provide enough visual cues for audiences to determine their functions.

The interaction between scientists and filmmakers on *Minority Report* illustrates how filmmakers look to science to *provide* boundaries when dealing with speculative scenarios. McDowell and consultant John Underkoffler believed that the purpose of employing Underkoffler full time in the art department was to provide McDowell and his crew with constraints which, counterintuitively, freed their creativity. As Underkoffler tells it: "You figure out pretty quickly that, especially in a movie like *Minority Report* where they are making a future, well they can do anything they want and no one is to say differently. You essentially have carte blanche. But actually working with some constraints, as we all know, is actually a helpful thing. People like Alex really liked to have those constraints. They liked to know that it would be like this and not like that." McDowell believes that the rewards of production design come from the challenges of being creative within set parameters, which is something he was worried would not happen on a science fiction film. McDowell's job as production

designer was to *visualize* an immersive fictional world, not to determine how or why this world came to be that way. For those issues he turned to Underkoffler.

It is not due to laziness or lack of creativity that McDowell and the art department left these matters to their science consultant. Rationally developed speculative scenarios in science require expertise the filmmakers do not possess. The art department outsourced this work to Underkoffler so they could instead spend their time and energy putting *their* expertise to work realizing this technology on the screen. Underkoffler's role in the filmmaking process—answering "why" and "how" questions—was not superfluous but integral to McDowell's creative work.

Extrapolating into the Future: *Deep Impact* as a Case Study

Speculative scenarios encompass more than just discrete future technologies. They also include comprehensive storylines that may even form the basis for the entire plot, like restarting the sun in *Solar Crisis* and *Sunshine*. In these cases, speculative scenarios become more than a sum of discrete entities and events. These scenarios involve an extensive process by which consultants not only develop possibilities for each distinct element but also work out how all the elements would fit together. The process is about creating explanations for A, B, and C, then helping filmmakers grapple with how A's explanation affects B's, and how both determine the possibilities for C in order to create D.

A detailed look at the *Deep Impact* (1998) think tank process discussed in chapter 3 provides a unique opportunity to analyze how the science consultants helped the filmmakers create a plausible scenario for the movie's key storyline of a manned comet-destroying mission. The think tank was clearly crucial to the story's development and most of what transpired in the meeting ended up on the screen. Fortunately, the studio videotaped this meeting, recording exactly how the development of a comprehensive speculative scenario proceeds.[8]

As with *Solar Crisis*, it was clear from the outset that the science consultants had issues with a manned mission. At one point production designer Leslie Dilley asked the group the general question: "At what point in our story do we move from science fact to science fiction?" Gene Shoemaker's quick reply, that "the biggest place where you depart from science fact is

doing this as a manned mission in the first place," was greeted by vigorous nods of assent from the other scientists. Similarly, when a filmmaker asked them if the script's—ultimately successful—second plan of flying directly into the comet and setting off nuclear bombs was "good and viable," David Walker's response of "It's better than the first plan" generated raucous agreement from the other consultants. While a manned mission was highly unlikely, the consultants ultimately understood that the storyline was essential and their job was to help make it credible. This is not to say they remained quiet about their objections. Consultants would often— especially early in the think tank meeting—reiterate that the mission was improbable, before offering advice on how it could be achieved. It was as if by discussing the mission on its own terms they were relinquishing their credibility as scientific experts. Therefore, they had to remind filmmakers that they understood the mission was improbable before suggesting ideas to make it seem possible.

Interestingly, one of the suggestions Walker and Gerald Griffin made to make the mission's depiction more acceptable was to push the film's setting three or four years into the future. Walker, for example, said at one point during the think tank, "Again, if you could just move the time frame to four years in the future it would be more plausible because these technologies might exist." As with *Minority Report*, both filmmakers and science consultants clearly believe that plausibility is closely tied to temporal setting. There seems to be an acceptable time frame for speculative scenarios in cinema, ranging between five and ten years. Fewer than five years and audiences may not consider such technological advances possible; more than ten years and the future technologies lose their identification with contemporary technologies.

The questions filmmakers asked during the *Deep Impact* think tank highlighted their priorities. In general, their questions concerning speculative scenarios fell into three distinct categories: (1) scenario plausibility, (2) dramatic enhancement, and (3) filmmaking practicality. In the first instance, filmmakers' questions focused on establishing a defensible scenario for the manned mission. There were eight identifiable stages to the mission. A list of each stage with representative questions looks like this:

• Stage one: *An eighteen-month time frame between the comet's discovery and the mission.* How can we justify the time lag between the comet's

discovery (including projection of its trajectory) and the launch of the mission? How can we justify plotting an earth-bound trajectory with just one set of photographs? How far away must the comet be for the mission to be successful?

• Stage two: *The spaceship launching from Earth to the comet.* What type of ship could get our astronauts to this comet? What type of propulsion system would it contain? How does our crew slow down once the ship reaches the comet? What should we do if we cannot have the rocket launch directly from Earth?

• Stage three: *Scenes of the spaceship approaching the comet.* From which side would our ship approach the comet? What would be visible as it approached the comet? How large would the particles be in the comet's debris field?

• Stage four: *Docking on the comet.* Since the ship that brought the astronauts to the comet cannot land on a comet due to low gravity, how would it dock? Since the "mother" ship cannot dock, what type of ship would this additional docking craft be? How would it detach from the mother ship? What would the comet's surface look like? How does this impact the docking? Should the astronauts tether the craft to the surface? How would this tethering system work?

• Stage five: *A mission to plant nuclear devices on the surface.* How does the low gravity impact our astronauts? Should they be tethered to the surface? Would they have jet packs? What environmental conditions will our astronauts face on the comet? What types of explosives should they plant? Should the astronauts be strategic in planting the bombs? How deep do they have to bury the bombs?

• Stage six: *Failure of the initial plan.* How can we explain why the plan fails? How can the nuclear explosions lead to one large and one small fragment? How long before the big one hits? The small one?

• Stage seven: *A return trip back to earth.* Would the astronauts have enough fuel to get back to earth? What would be on board to indicate they plan on returning to earth?

• Stage eight: *An alternative means of destroying part of the comet.* What do they do when the mission fails? Would the explosion from the successful second plan generate a meteor shower on the earth? How far out would

the explosion have to be to make sure this meteor shower does *not* destroy earth?

Several things emerge from my organizing the semirandom nature of the think tank questions into discrete units. First, it illustrates the level of detail filmmakers pursue in planning a comprehensive speculative scenario. The *Deep Impact* filmmakers not only needed to know what types of explosives would work (nuclear bombs were considered the only option), they also needed to know exactly how many bombs were necessary (four would be ideal), whether these bombs would need to be strategically planted (no), why they might need to be strategically planted (to provide maximum deflection), and, given that for dramatic reasons we want them to be strategically planted, where they should be planted (in places allowing optimum depth), how deep to plant them (50–100 meters), how the bombs would be placed (self-drilling moles), and so on.

This categorization also shows how answers to initial questions change the nature of subsequent questions, a cascade effect by which each answer changes the filmmakers' creative vision of their speculative scenario. We can examine an early discussion about the design of the spaceship to get the fictional astronauts to the comet and follow the cascade effect. The spacecraft in the initial script was not a new design but involved NASA removing the 1969 Lunar Excursion Module (LEM) from the Smithsonian. Director Mimi Leder started the discussion of this topic by saying, "Let's talk about the lunar landing module, which you guys feel is a joke." Walker's response to this prompt was not to embarrass the filmmakers by pointing out how ludicrous their scenario would be if they relied on a technology that was thirty years old. Instead, he pointed out that the LEM was "not an ideal tool for this task" because the craft's interaction with the comet "is not a landing but more like a docking because there is not enough gravity to hold a spaceship down."

This scientific fact—a comet's lack of substantial gravity—was given in response to a specific query about the spaceship that would take the fictional astronauts to the comet. Ultimately, however, it shaped the form of every subsequent question. The filmmakers could no longer envision the fictional mission as being akin to a landing on the Moon. They now had to think about a much more complicated scenario that involved one

spacecraft to get to the comet and one spacecraft to bring the astronauts down to the surface. They also had to adjust character actions on the comet's surface, and the impact of minimal gravity on the planting of the bombs. A quick glance at the types of follow-up questions about the "docking craft" shows how this one scientific point—lack of gravity on a comet—led to a need to elucidate the complete details of a technological entity filmmakers had not originally planned: What type of life support does the docking craft require? What sorts of tools would be on this ship? Which crew would go in the docking craft? Do we need an additional specialist? Which ship talks to Earth? Can the docking craft emerge through the mothership's nose? How exactly does it "dock" with the comet? Each of these answers of course led to further sets of questions. At the end of this process the filmmakers retained the same framework they started with—a manned mission to destroy a comet—but the components and details had all changed in ways dictated by consultants' answers to their initial questions.

Once Walker and the other consultants rejected the LEM as a means of flying to the comet they had to help filmmakers come up with an alternative. This was, in fact, the problem consultants saw as most intractable because of filmmakers' requirement of a manned mission. One of the major issues with a manned mission is that it requires a quick trip out to the comet and *then* rapid deceleration in order to dock and unload the astronauts. Since there is minimal gravity to stop a spaceship's momentum, matching the comet's trajectory becomes extremely difficult. Using a traditional liquid-fuel propulsion system to accomplish this velocity change would require an unmanageable quantity of fuel. When filmmakers returned to the topic of the spaceship later in the meeting Walker bluntly told them, "That is where the physics is the least credible. The velocities and energies we are talking about here are just not practical at all and I do not know any way to get it practical." This lack of a satisfactory solution clearly irked Leder who at one point said to the six scientists, "But there must be a way around this? I know there is a way to get around this." Leder's frustration emerges from a public perception that science provides an answer to *any* question. She expected scientists with their expertise of logic to give her solutions not more problems.

At this point, the consultants realized that they had to provide some possible explanations rather than continually pointing out problems

with the spaceship. Several ideas were proposed and rejected, such as Chris Luchini's tentative suggestion that the dust in the comet's coma could provide enough drag for a parachute to slow the craft down. Executive producer Walter Parkes offered what—to him—seemed to be a simple solution: film the spaceship's approach to the comet as if it were two airplanes refueling in flight. Parkes's suggestion illustrates the major difference between the filmmakers' and the scientists' approach to speculative scenarios. From his perspective it was a matter of how to *film* the spaceship's approach so that it met with audience expectations. If it looked like aerial refueling, something an audience would be familiar with, then it met his visual requirement for plausibility. From the scientists' perspective the scenario was plausible only if it had a scientifically viable explanation of *how* the spaceship matched the comet's trajectory even if this explanation did not show up on screen. In the end, Gene Shoemaker suggested the same theoretical propulsion system, Project Orion, which Stanley Kubrick had rejected for *2001: A Space Odyssey* (1968) (figure 7.3).

The think tank was also crucial in developing the film's drama. Most of the dramatic elements relating to this mission were not part of the initial script. Dramatic situations evolved only after discussions with scientists about how cometary science—both textbook science and unsettled science—could be used to create these situations. Filmmakers then engineered the production script so that these situations *would* happen. Without scientific input, for example, they would not have known to use self-drilling nuclear bomb "moles," which allowed for the possibility of an astronaut going into a hole to dislodge a stuck mole. By providing filmmakers with a logical explanation for inserting bombs into the comet, the consultants allowed the filmmakers to utilize their own expertise in developing engaging drama.

Practical concerns also frequently surfaced during *Deep Impact*'s think tank, especially when questioning was turned over to the visual craftspeople (costumers, set designers, cinematographers, and special effects supervisors) who required information crucial to their job performance. As I have emphasized throughout this chapter, filmmakers are grateful for the constraints that science provides for speculative scenarios. But however much they appreciate having set parameters, they are also faced with the task of how to film under these constraints.

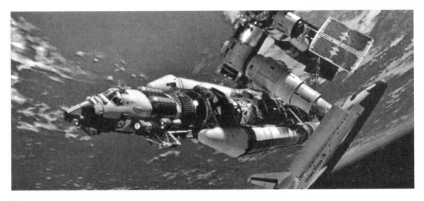

(a)

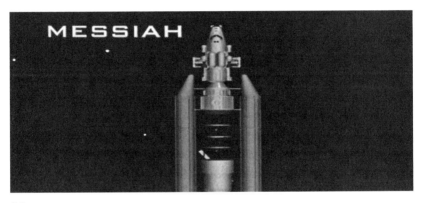

(b)

Figure 7.3
Lengthy discussions from the think tank concerning the *Messiah* spacecraft were condensed to one minute of screen time (a) accompanied by computer models (b).

Perhaps the best way to illustrate how consultants help filmmakers deal with practical filmmaking issues is to examine a crucial concern: How should the film crew light these scenes?[9] The consultants had made it clear to the filmmakers that the mission would be most plausible if the docking occurred on the comet's dark side. Leslie Dilley, however, kept telling them he wanted to have the ship dock on the comet's light/active side. Leder finally explained to the consultants why Dilley kept insisting upon a course of action contrary to their advice: "What Les is getting at is if we are on a completely black surface it's visually more difficult to photograph and our

illumination would just be our flashlights. So what he is getting at is if we see some light in the distance or coming up from underneath then we have an opportunity to get more." Filming on the comet's dark side would be extremely problematic from a technical perspective because film cameras require a significant amount of lighting. Yet, if audiences could see light without visible sources it would destroy any illusion that the astronauts were actually on a comet. Ultimately, the consultants provided practical suggestions for surreptitiously including light sources on props and sets including "headlights" on the landing craft and mother ship, headlamps on the spacesuits, and ambient light from sunlight reflected off the coma (figure 7.4). Consultants' advice on lighting allowed filmmakers to meet practical filmmaking needs while still maintaining a plausible speculative scenario.

None of the consultants would claim that the speculative scenario they helped design was likely to ever occur. The ability to execute this scenario in the real world was not the point. At the end of this process consultants provided filmmakers exactly what they required: a scenario that could be defended as plausible and one that allowed them to create drama through the visualization of extraordinary events.

Fantastical Science: *Hulk* as a Case Study

Despite *Hulk*'s (2003) comic book origins, director Ang Lee made it clear during his initial interview with science consultant John Underkoffler that accurate science was central to the film's success. Recalling this interview Underkoffler said, "Ang emphasized to me that all the major characters were scientists. He felt the science was crucial to the story and he did not want it just slapped on like paint at the end. He wanted these people to really be scientists and he wanted to really know how you could create the Hulk. Ang wanted the film to be soaked in science, in an entertaining way first and foremost, but full of real science." In addition, Lee's wife was a practicing microbiologist; Lee told Underkoffler "his wife was accusing him, or suggesting, that he would be ruining the science." Underkoffler understood that Lee was using his wife's statements to voice his concern about negative reactions from the scientific community. Underkoffler's major task for Lee was to devise a scientifically acceptable explanation for the Hulk's origin. Implicit in their discussions was the notion that there

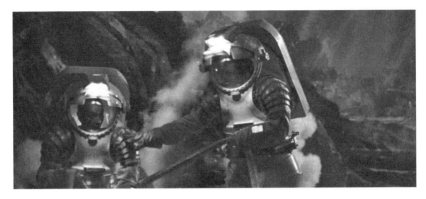

(a)

(b)

Figure 7.4
Deep Impact's consultants offered several suggestions for the placement of light sources including the use of headlamps on spacesuits (a) and lights on the docking spacecraft (b).

is a "correct" science for the Hulk (figure 7.5). Their concentration on an "accurate" Hulk begs the question: What constitutes scientific accuracy for a film about a comic book creature that does not and could not exist?

It is important to point out that scientific explanations are not requirements. Filmmakers have to use their skills as storytellers and as movie marketers to decide whether scientific plausibility is necessary, especially in genres like comedy and comic book films. If filmmakers believe that all an audience expects from a Hulk film is "Hulk smash," meaning scenes of Hulk destroying objects, then they do not need a logical explanation

Figure 7.5
John Underkoffler's challenge was to create a plausible explanation based on real science for a comic book character in *Hulk*.

for his transformation. The makers of a more recent Hulk film, *The Incredible Hulk* (2008), decided to forego any attempt at scientific logic for their action film and went with the straightforward gamma-overdose explanation for how Hulk came to be. Lee, on the other hand, wanted to explore his characters' psychological issues in *Hulk*. This required an atmosphere of realism that necessitated a plausible scientific explanation explaining how the human Bruce Banner becomes the monstrous Hulk. The challenge for Underkoffler was to take information from the categories of textbook and unsettled science and combine them in ways that made the creation of a "Hulk" seem plausible. To do this, he started looking for ways to restrict the multitude of scientific options available in fantastic science.

Underkoffler did have some constraints imposed by the source material, Lee's aesthetic preferences, marketing concerns, and the script's existing narrative. First and foremost, Lee required that the Hulk remain green as he is in the comic book. Underkoffler understood this request to be non-negotiable. Green is Hulk's defining characteristic. Even a clever, narratively interesting, and scientifically sound explanation was unacceptable if it did not result in a green Hulk. As Underkoffler put it, "It does not matter if you say the Hulk would actually logically be plaid or paisley or

have pink skin. It doesn't matter because the Hulk *has to have* green skin. You just have to work under this constraint and flush out an entire explanation for why the Hulk does have green skin [Underkoffler's emphasis]." Underkoffler also had to account for Hulk's other well-known characteristics including his gigantic size, incredible strength, impermeable skin, regeneration, toxin resistance, and rapid healing. In addition, Lee insisted that an accidental overdose of gamma radiation play a role in Hulk's origins in order to acknowledge the comic book and the popular 1970s television show. The emerging science of nanotechnology was a significant component of the original script and Lee asked Underkoffler to maintain this aspect. Moreover, Underkoffler had to take into account the narrative's "mad scientist" theme for the father and the repressed scientist theme for the son. He had to create a plausible story in which the activities of David Banner in the late 1960s could account for significant biological changes in his son, Bruce Banner, in 2003.

Setting Parameters, Working Backward, Script Constraints, and Internal Consistency

For fantastic science, the challenge is not to figure out how something did happen, but to develop a case for how something *could* happen. The biological nature of Bruce Banner's changes immediately suggested to Underkoffler an alteration in his DNA. It seemed logical, then, to make David Banner some sort of genetic engineer. This choice immediately had several advantages in terms of storytelling and visuals. Genetic engineering is about transformation, which is also the essence of the Hulk's story. Its methods also allow for interesting visuals including colorful electrophoresis gels, spinning centrifuges, and DNA radiograms. In addition, it meets audience expectations for a plausible scientific explanation. Whether contemporary audiences understand genetic engineering or not, they are familiar with the concept and would readily accept its role in altering Bruce Banner's biological makeup.

At this point Underkoffler faced a challenge in accounting for how David Banner's genetic engineering research could lead to changes in his son Bruce's DNA. The obvious choice was to have David experiment directly on his son. While it seemed the logical choice, it would clearly be problematic from a marketing standpoint. Even for a comic book film

featuring a mad scientist, genetic experimentation on one's own child is a bit too unsavory to go over well with a mainstream audience. The most viable scientific explanation left to Underkoffler involved genetic transmission from father to son. So Underkoffler added a plot element involving David Banner's own manipulated DNA being inherited by his son whose "Hulk genes" are expressed later in life. While it was a bit convoluted this solution maintained the required mad experimentation element, allowed the father to self-experiment rather than experiment on his child, and accounted for Bruce's altered DNA.

Next, Underkoffler needed to establish David Banner's specific research topic and the aims of his experiments, which were important plot points. It was decided early in preproduction that there should be a connection between the father's research field and the son's research, but that the goals of their research would be at opposite ends of the spectrum. As a mad scientist, David Banner is working toward nefarious ends, while Bruce is a good-hearted, albeit emotionally repressed, character who wants to improve the human condition (figure 7.6). Therefore, Underkoffler had to take into account both scientific logic and the internal logic of the story in determining the nature of David's research. Underkoffler reasoned that immunology

Figure 7.6
John Underkoffler had to take into account the relationship between the scientific work of the father David Banner (Nick Nolte, right) and the son Bruce Banner (Eric Bana, left) in *Hulk*.

could serve both the scientific and narrative needs. While the father is trying to create genetically engineered super soldiers whose immune systems can withstand the biological weapons developed by his country's military, the son hopes to eradicate communicable disease by enhancing the human immune system. Underkoffler's solution gave David Banner an appropriate research topic, a legitimate methodology, and an incentive to manipulate human DNA.

To complete Bruce Banner's scientific profile Underkoffler had to determine how Bruce's research leads to the activation of his "Hulk" genes while also incorporating gamma rays and nanotechnology. The emerging science of nanotechnology opened up the possibility of using "nanomeds" to explain the Hulk's enormous size. The key was to use what was known about the *potential* of nanotechnology to create a situation in which it could lead to unregulated growth. Underkoffler reasoned that if these nanomeds were replacing diseased cells with healthy cells a situation could arise in which "the nanomeds have imbalanced behavior then you get more duplication than dismantling. You get a kind of controlled cancer that would make Banner bigger and bigger and bigger." The rhetoric surrounding nanotechnology frequently incorporates science fiction narratives and one of the most widely speculated applications for nanotechnology are "nanomed" bots for repair of individual cells.[10] The blurring of science/fiction in nanotechnology's popularization allowed Underkoffler to take a narrative constraint—the need to use nanotechnology—and turn it into the centerpiece of his scientific backstory.

Underkoffler's biggest challenge was integrating gamma radiation into a scientifically sound scenario. No matter what he did, there was no logical way to fit gamma rays into his carefully constructed scientific explanation. Ultimately, he would forgo scientific accuracy and used the gamma rays to "activate" the nanomeds. Given the narrative precedent of the comic book and television show's use of gamma radiation nobody could fault him for attributing a function to gamma radiation he knew it could not have.

What is a Hulk? The Scientific Logic behind Hulk's Powers

Once Underkoffler established genetic engineering as his scientific mechanism he needed to establish *which* genes were engineered to turn Bruce

Banner into the Hulk. He decided that for visual and storytelling reasons it would be best if they established that Bruce's "Hulk" genes came from the fusion of human DNA with DNA from other organisms. To make this work Underkoffler had to establish a clear connection between a donor organism's genetic properties and the Hulk's powers. At one point he believed he had come up with an ideal scientific explanation for all of Hulk's properties including his green skin:

> In the early days of *Hulk* I was casting about for what could have led to the Hulk. It seemed like one great explanation for his "greenness" could be chlorophyll: there is an accident that fuses human genes with some kind of plant element. It would also explain his healing properties and his immunity to bullets. So I went a ways into developing a plausible explanation, making research contacts, and so on. I presented this elaborate thing to Ang. He has this great look when he doesn't like something. His eyes kind of scowl a little bit. His eyes, not his mouth, and he says, "Sooo, Hulk is a plant?" You realize that maybe this is not such a hot idea and you scamper back to your office to think of another explanation.

Fantastic science does not mean that any explanation, even a scientifically reasonable explanation, is acceptable. Lee rejected Underkoffler's plant gene backstory because it did not meet his other filmmaking requirements for a lean, green fighting machine. Lee's professional experience told him that Underkoffler's explanation would prove narratively and thematically problematic. Plants are not known for their mobility. If the Hulk were plant-based, audiences would be asked to overlook this fact in their acceptance of a fast-moving, agile Hulk. A plant-based Hulk would also work against Lee's intention of using *Hulk* as a means to explore submerged human aggression. The Hulk loses some of his power as a symbol of humanity's inherent animalism if he is a flower.

The *Hulk* example underscores the strengths and weaknesses of incorporating fantastic science in film. Fantastic science provides a consultant creative freedom in designing explanations. But this freedom also means that, unlike textbook science, they cannot rely on the certainty of natural law. Fantastic science forces consultants to rely on their own creativity in order to develop a logical explanation that meets the aesthetic and narrative demands of their employer.

Once Lee nixed plants, Underkoffler had to decide which animals could provide appropriate genes for the father's recombinant DNA experiments. The most important criterion for Underkoffler was maintaining a one-to-

one relationship between an animal's qualities and Hulk's properties. So, he listed Hulk's characteristics and began an intensive search for animals that have these same properties. He searched through technical journals, popular science magazines, and the Internet, and he approached other scientists including Wendy Plesniak from Harvard University. Like textbook science, any filmmaker with Internet access and a library card can uncover the "facts" associated with fantastic science. The major difference between textbook science and fantastic science is that filmmakers cannot just pull down a reference book from the library shelves and learn about "Hulk genes." Since Hulk genes do not exist, the science consultant has to use his or her own professional experience, knowledge base, and research contacts to start defining the search.

Underkoffler's research provided him with a list of suitable animals. He discovered that jellyfish have a unique type of immune system, which is consistent with David Banner's field of research and could also explain Hulk's rapid healing. As a bonus, he found that one species of jellyfish, *Aequorea victoria*, produces a green fluorescent protein (GFP) that could account for the Hulk's coloration. From Plesniak he learned that the sea cucumber is the only creature that can physiologically harden its tissues, which could explain the Hulk's impermeability to bullets. He also discovered that certain lizard species possess high-level toxin resistance. Finally, he ran across research on the regenerative properties of starfish that suggested that starfish could theoretically live forever. Mad scientist David Banner could fuse together genes from all of these organisms in his quest to make a super soldier and unwittingly provide the genetic elements necessary for the Hulk to emerge from his son. What is important for Underkoffler in this process is that each individual piece is "latched into reality." This does not render the overall explanation "real." The Hulk is still fictional, but by basing individual components on established scientific facts Underkoffler makes the overall explanation *plausible* which is what truly matters for fantastic science in cinema.

When he approached Lee with his new plan he found that "this was all music to Ang's ears." Not only did each element conform to scientific reality, each animal in Underkoffler's scheme provided Lee with the raw material for strong visual motifs. Jellyfish are visually interesting animals that "float" around the screen in various scenes. Jellyfish and lizards became recurrent images in Bruce's dream sequences. Lee also took advan-

tage of the starfish's regenerative properties to film a starfish growing a new limb in time-lapse photography. In addition, the starfish's potential "immortality" offered Lee a symbolic opportunity within the narrative to add to David Banner's mad scientist persona since immortality is a traditional alchemical pursuit.

An Impossible but Plausible Hulk

At the end of this process Underkoffler and Lee had a plausible explanation for the Hulk that can be summed up in a couple of sentences: In the late 1960s, mad scientist David Banner fuses genes from a variety of animal species in an attempt to create super soldiers with enhanced immune systems. Lack of access to human subjects forces him to experiment on himself. His son, Bruce Banner, inherits David's altered genome. In 2003, Bruce is working to improve the human immune system using nanotechnology. An accidental overdose of gamma radiation causes his latent "Hulk" genes to be expressed and an overdose of nanomeds leads to a growth in size.

Fantastic science forces a balancing act between providing options and imposing constraints. By providing scientific constraints science consultants begin to limit filmmakers' options in explaining fantastic situations, but they also have to be careful that they are not imposing their ideas on filmmakers. Underkoffler saw his job not so much as constraining Lee but as providing choices that let Lee be a "taste machine" who decided what options would work. It was then up to Lee, the screenwriters, and the other filmmakers to work Underkoffler's backstory into the visuals and the narrative. Consultants, however, play an important role in deciding the options from which filmmakers can make their choices.

The Hulk creation episode reveals how the development of fantastic science predominantly consists of combining information from textbook science, unsettled science, and speculative scenarios. As long as the science consultant is able to combine this information—from factual to speculative—in creative ways, the creation process renders fantastic science almost critic-proof from a scientific standpoint. It is not the Hulk itself that is accurate, but the scientific elements that compose the Hulk each conform to genuine science. Underkoffler's insistence that each component of the story be based on known (e.g., GFP proteins) or unsettled science (e.g.,

nanobots) ensured that each component is solid in its own right and could be "fact checked" by any scientist. Underkoffler's research, cleverly depicted in *Hulk's* opening credits, provided filmmakers, and ultimately viewers, with a comprehensive backstory.

Hulk is not unique in having such a well-worked-out scientific explanation for the fantastical. Jim Kakalios, for example, drew on well-established physics concepts to explain Dr. Manhattan's "quantum mechanical powers" in *Watchmen*. Fantastic science relaxes the constraints imposed by textbook or even unsettled science. The decision for filmmakers is not whether to adhere to known facts or to bend reality to fit their fiction. With fantastic science the choice for filmmakers is to decide *which* scientific fact meets their cinematic need, guaranteeing that each component of a fantastic phenomenon will conform to reality. Like Kakalios's explanation for *Watchmen*, the strength of Underkoffler's rationalizations is that they are self-consistent and up to date, and each element is scientifically defensible. Rather than being a difficulty to work around, as is the case with much of textbook science, science becomes a constructive tool for creating fantastic science.

8 Preventing Future Disasters: Science Consultants and the Enhancement of Cinematic Disasters

Implausible as the movie scenario might be, it's not impossible at all. I think it's terribly important that we realize as a society that these things go on all around the world. The movie may be extreme or exaggerated by its Hollywood standards, but alarmist? Please. People need to get alarmed. We have just been lucky so far.
—Pioneering HIV researcher Donald Francis and consultant on *Outbreak* (1995)[1]

Outbreak is but one example of the recent epidemic of entertainment products peddling pestilence propaganda. . . . [*Outbreak*] typifies a distressing willingness on the part of some public health officials to focus on lurid scenarios at the expense of sound science.
—Contributing editor Robert W. Lee of the *New American*[2]

In "The Imagination of Disaster," her seminal work on 1950s science fiction cinema, Susan Sontag argues that these films offer audiences pleasure in watching the "aesthetics of destruction" while presenting morality plays about dangers inherent to science and technology.[3] For Sontag, science fiction films play to the medium's strength in visualization, what she calls its "sensuous elaboration," in communicating these dangers.[4] While 1950s cinema highlighted the dangers of science, the tide has turned with regard to disaster films in the 1990s and 2000s. They are no longer about scientific perils. Rather, recent cinema's sensuous elaboration of disaster highlights our need to acquire scientific knowledge and new technologies in order to *prevent* these disasters.

Science consultants have found the extremely popular medium of film to be an effective way to convince the American public that a research field or a scientific subject needs more political, financial, and scientific attention. This is especially true for issues where scientists believe inaction will lead to serious global consequences. It is fictional film's ability to create

images of "scientific possibilities" in audiences' minds that leads scientists to believe that realistic depiction can result in public attention. A science consultant's goal is to make sure a film is plausible enough so that it becomes an asset and not a liability.

Film theorist Joel Black refers to the connection between realism in disaster films and public awareness as the "*War Games* effect" after the 1983 film. Black claims that "by presenting apocalyptic narratives in the fictional form of movies or thrill rides, special-effects technicians are . . . playing (or banking) on the notion that by presenting these doomsday scenarios in a fictional form, they are *preventing* them from happening" (italics in original).[5] Black's conception is an accurate assessment of cinema's rhetorical power, but it is not special effects technicians who are invested in the success of the *War Games* effect. A successful *War Games* effect benefits those who have a stake in these issues: a film's science consultants and the scientific community.

Essentially, science consultants act as the "Ghost of Christmas Future," presenting audiences with bleak visions while indicating that the public has the power to see that this future does not come to pass. While he did not work on *Deep Impact* (1998), astrophysicist David Morrison believed the movie could act as a "public service announcement" about the need for more research on Near Earth Objects (NEOs). "The overall framework of the film is entirely plausible, from the perspective of planetary science as well as the impact hazard," he said, and urged, "See this film. It may do more to alert the public to the impact hazard than anything in the past. And its images may even keep you up at night wondering if we are doing enough to protect our planet against this threat." Morrison's comments hit upon the three key elements of how disaster films shape the technoscientific imaginary: (1) a big budget film from a major studio will effectively "alert the public" about a potential disaster, (2) movies graphically visualize disasters in such a way that the public will "be kept up at night" thinking of how they could prevent them, and (3) a film's impact depends critically upon the plausibility and credibility of its disaster scenario.

Consultants influence the third element by adding plausibility and credibility. Virologist Peter Jahrling consulted on *Outbreak* and was clearly motivated by the film's capacity to stimulate increased research funding for the study of emerging viruses. In a *Health* magazine article on *Outbreak*

he makes the connection between realism in popular film, public aware-
ness, and increased research funding:

"If the film has a ring of truth to it, people will walk out thinking, Jesus, that story
may have been fiction, but it could happen, couldn't it? But if it's clearly just science
fiction, they'll write it off like the latest Sylvester Stallone movie." Which would be
too bad, says Jahrling, because only a fired up public will favor spending research
dollars on vaccines and other precautions against an obscure killer virus *before* it
goes global, not after [italics in original].[7]

From Jahrling's perspective the only way to avert this danger is to learn
more about viruses and that requires more research support, a point he
hopes the film conveys in a more or less realistic fashion (figure 8.1).
Jahrling's fellow consultants on *Outbreak*, such as Donald Francis, expressed
similar sentiments about the need to maintain a veneer of plausibility if
the film was to be useful in informing the public about emerging viral
dangers. Consultant David Morens believed that filmmakers could have
gone even further in dramatizing the film's exaggerated viral outbreak
scenario within the confines of realism: "I don't think they sensationalized
it. If anything they toned it down."[8] Although Jahrling was using an aural
metaphor in his quote, the phrase "ring of truth" works equally well as a
spatial metaphor for gauging how far a film can deviate from scientific
accuracy before it loses its promotional value. Jahrling, Francis, and Morens

Figure 8.1
Outbreak's many action scenes were executed in scary-looking biohazard suits.

clearly felt that their advice kept *Outbreak* enough within the ring of truth for the film to be used as an effective public relations device.

It is important to note that Jahrling, Francis, Morens, and other consultants are not slick "PR men and women" who use Hollywood depiction as a way to fleece the public. Science consultants who work on disaster films truly believe that the scientific issues they are working on are so important to the future of humanity that it justifies calling attention to these issues by any means necessary. These scientists all have experience with granting agencies and understand that "public attention" is a limited resource.[9] They realize that in order to tap into the limited funding available or to generate social action they need to convince the public that their research field addresses a vital issue. For some scientists, this means lending one's scientific credentials to a fictional text's creation not only for entertainment reasons but also for promotional purposes. This is where scientists play a tricky game. Robert W. Lee's quote about *Outbreak* shows how easily scientists who work on disaster films open themselves up to charges of selling out scientific integrity for publicity. Consultants' advice regarding cinematic disasters demonstrates how the flexibility of the metaphorical ring of truth can both benefit and harm science.

Reality Follows Fiction: Creating Nuclear Disaster in *The China Syndrome*

Scientists and scientific organizations are often willing to become involved in fictional enterprises promoting science-based social causes. Historically, public health and environmental issues are the two primary science-based social concerns for which cinematic cautionary tales were made with scientists' help. Public health officials, physicians, and medical researchers frequently cooperated with filmmakers in making issue-based dramatic films in the first half of the twentieth century.[10] Eugenics, in particular, was a high-profile public health concern that featured in numerous message films focusing on the notion that personal choices had larger social implications.

In contrast, environmental issues take advantage of cinema's visual power by graphically depicting global disasters. Scientists working on environmental films are not appealing for more research funding but are pleading for political action. By the 1970s the deteriorating natural environment became a high-profile issue both for the public and the scientific community. The decade remains a high-water mark for ecologically themed movies

including *Silent Running* (1971), *Z.P.G.* (1972), and *Soylent Green* (1973). Scientists' involvement in these message films is in line with the strong political activism within the scientific community in the late 1960s and early 1970s.

Scientists' advice for *The China Syndrome* (1979) heightened the film's political utility, as it became the dominant narrative for nuclear energy concerns in the late 1970s. The film's narrative was easily applied to real-life concerns when the Three Mile Island nuclear disaster struck in Pennsylvania on March 29, 1979, fewer than two weeks into the film's theatrical release. Many news commentators at the time noted that the resemblance between the real industrial accident and the fictional incident was "eerie."[11] This resemblance was not a random coincidence. It was due specifically to the presence of former General Electric (GE) nuclear engineers who helped create the accident scenario in *The China Syndrome* (figure 8.2).

Upon their departure from GE in 1976 Gregory C. Minor, Richard B. Hubbard, and Dale Bridenbaugh formed MHB Technical Associates. They toured the country as advisors for antinuclear groups while also testifying at antinuclear power hearings.[12] Their film consulting work complemented their other advocacy activities and this allowed them to graphically illustrate their hypothetical disaster scenario in a film that, given Columbia Pictures' massive advertising budget and the star power of Jane Fonda and Jack Lemmon, was guaranteed to be seen by millions of people. In addition to MHB's work, the film's verisimilitude benefited from preproduction photographs and tours of the control room of the Trojan Nuclear Power Plant in Oregon.

MHB contributed to the film's disaster scenario in several ways including script advice setting out specific parameters for a credible nuclear disaster scenario. Minor, Hubbard, and Bridenbaugh were brought in as advisors to primary scriptwriter Michael Gray who claimed they provided the "really essential stuff" for the fictional accident's details.[13] This is because MHB used real-life incidents, such as defective pump supports, doctored x-rays of faulty equipment, and a monitoring device whose needle sticks, to help filmmakers create a *possible* accident scenario involving a nuclear power plant; an industrial accident scenario that they had been traveling around the country telling people would eventually happen.[14] As Minor tells it, "Each aspect of the plot is based on documentable actual or potential events."[15] MHB's recommendations directly shaped

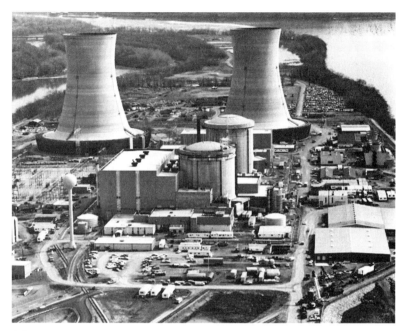

(a)

(b)

Figure 8.2

The nuclear accident at Three Mile Island (a) was "eerily" similar to the disaster scenario in *The China Syndrome* (b) because of the input of the film's science consultants, who were nuclear engineers.

Source: (a) courtesy of United States Department of Energy.

a popular film's plot that showed that human error, faulty equipment, and corporate coverups were serious problems for the nuclear industry.

MHB's nuclear disaster scenario struck a chord with film reviewers who found the narrative to be highly plausible. *New York Times* film critic Vincent Canby's comments are indicative. Ten days before the incident at Three Mile Island he said of the movie, "Could this happen? I've no idea but the film makes a compelling case."[16] Scientific reviewers were not as surprised that the scenario was plausible since the individual mishaps in the film *had already occurred in real life*. The *Los Angeles Times* correspondent for nuclear issues Robert Gillette asks the same question as Canby—"Could it happen?"—but answers it knowingly: "Parts of it have happened at different times and places over the last decade."[17] Ultimately, Gillette concludes, "It seems fair to say, however, that 'China Syndrome' succeeds as documentary with small deviations in portraying *possibilities* by drawing on real safety problems that have plagued the industry" (italics in original).[18] Of course, as Gillette himself recognizes, the filmmakers would not have known about these safety issues or at least they would not have known how to combine these previous smaller incidents into a *plausible* disaster scenario without MHB's technical assistance.

Even the film's harshest scientific critics, in fact, conceded the disaster scenario was possible. The issue for pronuclear scientists was that the film gave no indication or disclaimer as to the *probability* of the cinematic disaster occurring. Such a gesture would have been useless in any case. Film's capacity to naturalize and normalize events on the screen turns probability into certainty. Even if the odds were astronomical against such a nuclear accident in the real world, the fact that the film's narrative required the disaster to happen makes the probability of an occurrence in the fictional space 100 percent. The narrative need for certainty leads to a cinematic inevitability for any disaster no matter how improbable.

The events at Three Mile Island also confused the question of possibility versus probability because the film events appeared to be happening in real life. With public comments such as "we are not in a China Syndrome type of situation," Three Mile Island's spokespeople attempted to disassociate the plant from the film's nuclear scenario.[19] Their constant reference to the film, however, actually increased the public perception that the plant's accident and the fictional accident were related.

MHB and the filmmakers felt that Three Mile Island could be regarded as a response to pronuclear critics who had called the film irresponsible or unrealistic. For Richard Hubbard, Three Mile Island and subsequent nuclear accidents justified MHB's willingness to work on the film's fictional text. "We never regretted our decision," he said. "Subsequent events, from Three Mile Island to Chernobyl, have really shown there were problems."[20] The pronuclear lobby spent months before the film's release in a PR campaign to discredit the film's message and its scientific veracity. The U.S. Department of Energy had an opportunity to work with filmmakers but they declined.[21] Al Baietti, a pronuclear scientist from the Nuclear Regulatory Commission, did have a chance to disseminate his views on the benefits of nuclear power through the movie. He regretted his decision to appear as himself in the film, however, since his presence lent legitimacy while his own message became a casualty of the editing process.[22]

Scientific organizations face a delicate situation in determining whether or not to become involved in films whose narratives feature their science in a negative light. One the one hand, if they choose not to get involved they have no chance to affect how a film depicts their science. On the other hand, if they get involved and do not have any leverage with the filmmakers their involvement could backfire and legitimate a film whose message goes counter to their interests. Instead of having its views disseminated through a popular film, the pronuclear lobby had to rely on traditional PR methods like press releases and ghostwritten editorials. Similar to complaints biotechnology executives made about *Jurassic Park* (1993), Jack Young, vice president of the pronuclear Edison Electric Institute, lamented nuclear energy proponents not having their own popular film, for "if we could make a $6 million movie and spend $5 million promoting it, we'd sure try."[23] MHB, on the other hand, had access to a movie *and* influence with the filmmakers, which turned out to be the ultimate PR tool.

The China Syndrome began a "second wave" of Hollywood environmental films that moved away from the genre of eco-horror toward the genres of docudrama and biopic. These second-wave films differed from earlier ecological films by focusing on corporate responsibility and local environmental issues as in *A Civil Action* (1998) and *Erin Brockovich* (2000). As with public health issues, these second-wave environmental films do not imagine global disaster but focus on local communities with the impli-

cation that the "local is the global." The second-wave films also differ from earlier environmental films in that they are not depicting scenarios that *could* happen but scenarios that *did* happen. The hope for environmental scientists who worked on these second-wave films is that the presentation of historical disaster narratives in cinematic form could spark outrage and generate public action to prevent similar scenarios from occurring again.

The Politics of Science and Disaster in *The Day After Tomorrow*

A notable exception to the trend of depicting local disasters in environmental films is the big-budget disaster movie *The Day After Tomorrow* (2004). In this film human-generated global warming leads to the melting of the polar ice caps, which causes the salinity of the world's oceans to fall. This, in turn, disrupts the Atlantic Ocean's current in such a way that temperatures around the world drop rapidly, leading to global freezing and a new ice age (figure 8.3). The film's central premise is based on a legitimate, if marginal, scientific hypothesis, but the overall disaster scenario was hampered by obvious scientific inaccuracies that were visually exciting but scientifically suspect including "super tornadoes" destroying Los Angeles, the flooding of New York city by a giant tidal wave, and, most significantly, a five-day time scale for the global freeze.[24]

Despite these flagrant inaccuracies, climatologists quickly capitalized on the film's popularity to lobby for political action and extra research funding. The National Oceanic and Atmospheric Organization (NOAA), in particular, found the film a useful vehicle for raising awareness of climate change research, especially since the film's hero is a scientist within their organization. NOAA used its presence in the film to promote its scientific work through news media outlets: "We thought this movie presented an incredible education opportunity to create a public dialogue that would demystify these widely misunderstood problems and showcase some of the things we do here at NOAA to help observe the earth system."[25] An editorial in the premier science journal *Nature* even asked scientists to "contact their local media, who will seize on the chance to trade on a disaster movie while tapping into the public fascination with science."[26]

Climatologist Shakoor Hajat believed the film's potential to raise awareness far outweighed its scientific inaccuracies, and said, "The threat of

Figure 8.3
Global warming causes changes in the ocean's currents that leads to a global freeze
in *The Day After Tomorrow*.

global warming is real, the exact consequences and timescales proposed in *The Day After Tomorrow* may not be, but this entertaining Hollywood blockbuster does no harm in raising awareness of a serious issue."[27] Many scientists shared Hajat's sentiments. Climatologist David Viner also felt that the film's message excused any scientific flaws: "The film got a lot of the detail wrong, and the direction of change as well—cooling of this sort is very unlikely with global warming. But the fact that *The Day After Tomorrow* raises awareness about climate change must be a good thing."[28] For Hajat and Viner, inaccuracies could be ignored as long as the movie adequately conveyed the *dangers* of global warming and the need for political action, a line of reasoning that surfaces again and again in regard to the other disaster movies such as *Outbreak, Twister* (1996), *Dante's Peak* (1997), *Armageddon* (1998), and *Deep Impact*.

Not all scientists are as forgiving of inaccuracies in disaster films. Some are clearly not willing to accept the Faustian bargain required in film production, believing that fictional depiction is detrimental enough without

the added problem of scientific errors. Inaccuracies in disaster films can be especially problematic for the scientific community because the majority of errors are exaggerations of scale that are designed to heighten drama such as the number/size of tornadoes in *Twister*, the extreme virulence of the virus in *Outbreak*, or the accelerated global-freeze scenario in *The Day After Tomorrow*. Additionally, scientists may ultimately look like they are "crying wolf" when these extreme disaster scenarios fail to emerge and the public wonders why so much attention was paid to these issues. Scientists like Hajat and Viner who embrace disaster films like *The Day After Tomorrow* also run the risk of opponents labeling them "Chicken Littles" who are being alarmist without scientific substance. Scientists fighting battles in a contentious area like global warming can little afford to have critics label their ideas as "science fiction." Celebrity scientist David Suzuki points to a potential concern within the scientific community about *The Day After Tomorrow*, saying that the "'global warming is a myth' weirdoes . . . will no doubt point to this movie as an example of how the whole idea of global warming is based on impossible doomsday scenarios that cannot be taken seriously."[29] Climatologist Gerard Roe is even more cynical as to the merits of fictionalizing global warming for dramatic effect, calling the film "shameless scientific prostitution."[30]

Of course, criticism from within the scientific community put the film's primary science consultant, climatologist Michael Molitor, in an awkward position. He had to defend both publicly and professionally his participation in a fictional endeavor that knowingly twisted science even if it was in the service of what he believed to be a good cause. The situation was especially delicate for Molitor because the narrative involved extreme exaggerations in the time frame of an unsupported hypothetical global-freeze scenario. However, influencing its scientific accuracy was not Molitor's main motivation for working on the film. Rather, he saw his consulting work as a golden opportunity to sway public opinion by depicting dire consequences for humanity if the United States did not change its climate change policies. Said Molitor, "Nothing I have done in the twenty-three years of my climate change career may have a greater impact than this film."[31] He believed in the film's political utility and made several public comments such as: "This film could do more in helping us move in the right direction than all the scientific work and all the U.S. Congressional testimonies put together."[32]

Molitor clearly felt that the political gains from a major Hollywood film offset by a wide margin the potential negative consequences of any scientific flaws. His flexible position on the importance of scientific accuracy points to a tension every consultant faces when working on films they consider important advocacy opportunities. Consultants realize that a film's entertainment value is just as important in publicizing their concerns as the instructional value of the science. Scientific accuracy, in fact, potentially hinders a film's ability to get its message out. A completely accurate but dramatically boring fictional movie about global warming would have zero utility for the scientific community. Molitor took this approach to the science in *The Day After Tomorrow*: "No one has ever made any public claims that this film is completely accurate. This is entertainment. The trade-off is between a significantly more accurate film that would depict a more accurate story that is only seen by a million people, or a film with a more exaggerated storyline that is seen by 500 million people."[33] Molitor, like other science consultants, gauged how wide he felt the ring of truth could be stretched before it became problematic and harmed his cause.

Molitor was tolerant of questionable science because he was able to impact the film's depictions of the science/politics interface. The film would not have attracted as much political attention if it were not for the inclusion of scenes focusing on the interactions between scientists and politicians (figure 8.4). The filmmakers could have easily bypassed the political elements as well as the film's thinly veiled jabs at the Bush administration's global warming policies, but by including credible science policy aspects the film articulated the political debates surrounding global warming, science's place within these debates, and the Bush administration's policy position on this issue. Thus, the film became more than just a high-profile summer action film.[34] The film's overt political agenda provided a real-world context for the disaster. Whether deservedly or not, it posited the Bush administration's policies as responsible for the onscreen global warming disaster and, by extension, any potential real-world disaster. If the film's political elements were not portrayed realistically then the film would have been far less useful in the political struggle over global warming policy. Political conservatives could easily challenge the film's scientific integrity, but they could not, and did not, challenge the film's portrayal of their political stance on global warming.

The day before tomorrow

The *Day after Tomorrow* is more science fiction than science fact, yet the danger of a climate crisis is very real, and we've got to take action right now to prevent it.

Reality: the Earth's atmosphere is heating at a rate faster than any time in human history. Sea levels are rising, storms are intensifying, heat waves, like the ones which swept through Europe last summer, are longer and more deadly. Right now we are in the middle of an unfolding climate crisis, with more frequent extreme weather events causing chaos and havoc both here and worldwide. Whilst tidal waves engulfing Manhattan may remain in the science fiction realm, right now people are being evacuated from their homes in Pacific Islands, suffering water shortages, crop failures and flooding. The people who are bearing the brunt of climate chaos today have done the least to cause it. The UN's panel of climate experts attributes this to emissions of carbon dioxide from burning fossil fuels - oil, gas, and coal.

The UK is in a powerful position to change this. We politically and financially support oil companies such as BP and Shell, and we collude with the Bush administration in waging war for oil. Right now people are suffering from the wars fought for oil, the pollution from refineries and power stations, and the social exclusion from lack of decent public transport. We can take action, break the denial and reclaim our right to a fossil free future.

Act now. Because we can't wait until the day after tomorrow.

The time to take action is now - see the contacts below for local groups active on climate change. From using energy efficient lightbulbs to tackling corporations, nothing is too small.

- Cut our personal energy consumption & switch to Green Electricity for the rest
- Don't buy Esso www.stopesso.com
- Demand an end to our taxes supporting oil expansion

So who's to blame?
We are all part of a fossil fuel economy, but the ones perpetuating our addiction and lack of real choices to break away from it are governments and oil companies.

For further info:
Rising Tide - info@risingtide.org.uk / 01865 241 097 / www.risingtide.org.uk
Friends of the Earth - 020 7490 1555 / www.foe.co.uk/campaigns/climate
People & Planet - people@peopleandplanet.org / 01865 245 678 / www.peopleandplanet.org
Greenpeace - www.thedayaftertomorrow.org - a fantastic spoof website

Figure 8.4

Political action groups and environmental organizations used *The Day After Tomorrow* as political propaganda, hoping the film would sway the 2004 presidential election. This poster was distributed by Rising Tide and Friends of the Earth.

Source: Courtesy of Rising Tide.

It was Molitor's political experience, not his scientific work, which convinced filmmakers to bring him on board as the film's primary science advisor. Molitor is former director of the Climate Change Program at the University of California-San Diego (UCSD) and is now CEO of Carbon Management Group, a consulting organization providing corporations with advice on climate change policies. As his current position indicates, he has considerable familiarity with science in the political realm. He has also testified before Congress on issues related to climate change and U.S. Senator Dianne Feinstein frequently consulted him when he was at UCSD. Of course, he did help filmmakers with scientific advice by coordinating meetings between filmmakers and other scientific experts.[35] His main utility, however, was clarifying the Bush administration's global

Figure 8.5
Climatologist Michael Molitor provided filmmakers with advice on depicting the science/politics interface as shown in this scene set at a UN climate change workshop in *The Day After Tomorrow*.

warming policies for the filmmakers, describing the science/politics interface, and scrutinizing scenes and dialogue concerning political interactions.

One scene in particular highlights the polarized political positions over climate change in the United States (figure 8.5). The scene is set at a UN conference on global warming in New Dehli and filmmakers asked Molitor to develop the scene's authenticity based on his experiences in the political realm. As Molitor recalled, "They understood I was also involved in the Kyoto negotiations and there was a scene in the film involving the negotiations in Dehli and I had been at those negotiations, so I also provided some advice about what those meetings are like and what actually takes place there."[36]

The setting's authenticity, the characters' actions, and dialogue helped explicate in a realistic fashion the Bush administration's stance on the one hand and that of the scientific community on the other. After delivering a scientific speech at the conference, the primary protagonist, Jack Hall, engages in a debate with the American vice president (VP)[37] about the cost of implementing the Kyoto Protocol:

Hall: What I do know, is that if we do not act soon it is our children and our grandchildren who will pay the price.
VP: And who is going to pay the price of the Kyoto accord? It would cost the world's economy hundreds of billions of dollars.

Hall: With all due respect Mr. Vice-President, the cost of doing nothing would be even higher. Our climate is fragile. At the rate we are burning fossil fuels and polluting the environment, the ice caps will soon disappear.

VP: Professor, uhm (looks at name on sheet) Hall. Our economy is every bit as fragile as the environment. Perhaps you should keep that in mind before making sensationalist claims.

Hall: Well, the last chunk of ice that broke off was about the size of the state of Rhode Island. Some would people might call that pretty sensational. (The room laughs and the VP appears angry).

This scene established several things about the political climate in the United States during the presidential election year of 2004. First, it clarified the current presidential administration's stance on global warming as a zero-sum tradeoff between the economy and the environment. It also posited expense as the major reason why the Bush administration was unwilling to ratify the Kyoto Protocol and demonstrated the tendency for politicians to ignore objective scientific data. Most importantly, the scene established that we currently have the means to prevent a global warming disaster but that these steps are not being taken for political, not scientific, reasons. In the end, Hall's speech about the dangers of global warming seemed reasonable to audiences because they had just "witnessed" this ice sheet break off in a previous scene and it *was* both visually and dramatically sensational.

Given Michael Molitor's input into these scenes it is not surprising that the film's depiction of global warming's political elements rang true for scientific observers at the political frontline. Physicist Stefan Rahmstorf of the Potsdam Institute for Climate Impact Research thought that the political depictions in the film were spot on: "The politics of climate change is also presented well. It is chillingly realistic how the head of the U.S. delegation (the vice-president in the film) responds to Hall's presentation. Thus small scenes with few sentences of dialogue are cleverly used to introduce a number of key ideas and conflicts, which are familiar to climatologists but not to most of the people who will go and see such a movie."[38] Sir David King, the UK government's chief scientific advisor, also identified with the film's political interactions, noting, "the scientific-political interface are in my view remarkably realistic. I think paleoclimatologists can closely identify with the discussion."[39] While the film's global-freeze time frame took a beating from the scientific community, scientists applauded the political depictions for their accuracy.

It is important to keep in mind that the filmmakers did not have to include these politically charged scenes. They could have easily made a big budget disaster film without any overt political elements. Because writer, producer, and director Roland Emmerich insisted on a politically charged film he required the help of an expert to ensure these political scenes fell within an acceptable ring of truth. Michael Molitor, scientific commentators, and political organizations were willing to accept a large ring of truth for the film's science because they were hoping the film could do what scientists themselves could not: make people realize that global warming was a real and dangerous possibility, and that the only people standing between scientists and global action were politicians like George W. Bush and Dick Cheney. Molitor understood that *The Day After Tomorrow* could make a graphic statement that global warming is real, potentially devastating, and preventable through appropriate action, and he was more than willing to offer filmmakers his expertise.

Death from Above: *Deep Impact, Armageddon,* and NEO Policy Debates

Near Earth Objects (NEOs) permeated the scientific and cultural climate in 1998, the year two major films, *Deep Impact* and *Armageddon*, were theatrically released (figure 8.6). The two films became an integral part of the scientific and political rhetoric surrounding the funding of NEO research and deflection strategies in both the United States and the UK.[40] Although science consultants may have chosen to work on these films for reasons other than advocacy, they all believed that their contributions would enhance each film's ability to convince people that the NEO threat is real and, most importantly, preventable. What I find, however, is that the advisors for the two films had opposite experiences regarding their influence over scientific accuracy. In a sense, these films illustrate how big the ring of truth can be for a film to still be effective as an advocacy vehicle. In the end, these films were both politically useful because consultants influenced the final product in ways other than just adding scientific verisimilitude.

Scientific reviewers overwhelmingly lauded *Deep Impact*'s accuracy using emphatic responses such as "Terrific!" or "Zowie!"[41] *Armageddon*'s filmmakers, however, frequently ignored their science consultants' advice. Not surprisingly, the scientific community roundly criticized the film. Never-

(a)

(b)

Figure 8.6
Consultants were able to significantly influence the presentation of the NEO threat in *Deep Impact* (a) and *Armageddon* (b).

theless, *Armageddon's* consultants did have a broad interest in promoting the need for additional NEO research and for a technologically sound contingency plan for averting any earthward-bound NEOs. *Armageddon's* consultant Ivan Bekey was NASA's former director of advanced concepts and was responsible for researching the long-range future for the civil space program, including studies of how to intercept potential NEO impactors. He currently consults for the federal government on matters of NEO protection. NASA itself allowed *Armageddon's* filmmakers unprecedented access to its facilities and personnel.

In voiceover comments accompanying *Armageddon*'s DVD, Ivan Bekey made explicit his hope that the film would generate funds for NEO surveillance and research: "There is no question that if astronomers and NASA were given more money that we could put sensors in space, we could activate more telescopes, pay people to operate them and we could basically map everything that could be of danger to us for the next several decades but we are not doing it. There is no money. I certainly hope that movies like this will make people aware that the possibility is real."[42] Bekey felt that his work on *Armageddon* would help reduce the "giggle factor" that tended to accompany calls for federal funds for detecting and monitoring potentially threatening asteroids in the early 1990s.[43]

Bekey, like Michael Molitor on *The Day After Tomorrow*, did not feel that scientific flaws hindered the film's promotional utility, claiming: "I think it is beneficial whether people take it literally or not."[44] While Bekey's suggestions for more accurate science were often shut down, he did have significant influence over the narrative representation of the NEO threat, NASA's image, and the technology involved in the deflection scenario. Bekey was able to influence the construction of *Armageddon* in such a way that the film makes a compelling case that scientific research can avert the NEO danger. Dialogue in several scenes overtly states that the cinematic disaster could have been prevented if NASA had more funding. In one key scene NASA scientists inform the president that an asteroid is on a collision course with the Earth. The incredulous president asks, "Why didn't we see this thing coming?" The NASA mission director, in dialogue reminiscent of Bekey's own public comments, replies that NASA's budget for NEO searches is very small: "Well, our object collision budget's about a million dollars. That allows us to track about 3 percent of the sky, and begging your pardon sir, but it's a big-ass sky." The implication is, of course, that NASA could have, and can, prevent this scenario if it has a sufficient budget to look at the other 97 percent of the sky. For Bekey, the ability to shape dialogue in a way that highlighted the benefits of scientific research, especially in a high-profile film, outweighed any problems with the inaccuracy of the asteroid itself.

Josh Colwell, in contrast, was adamant that *Deep Impact*'s utility in promoting the dangers of NEOs was critically dependent on its scientific accuracy. As with Bekey on *Armageddon*, Colwell hoped that his contributions to *Deep Impact* would reduce NEOs' "giggle factor." Unlike Bekey,

however, Colwell felt that *Armageddon* actually contributed to the giggle factor: "*Armageddon*, in contrast, while about the same threat, is so completely off base on so many fundamental aspects of reality that, on its own, it is dismissed as pure fantasy in its entirety. The reality of the threat of asteroid impact in that movie is completely lost in the clutter of physical nonsense. I believe that it is possible for the public to come away from that with the idea that we don't need to worry about that at all because that was just complete fantasy." Colwell repeatedly emphasized to me that *Deep Impact*'s overall message "that something like this can happen, that the effects if it hit would be devastating, and that you do something about it with nuclear bombs" would have been seriously undercut if the film's science had not been as accurate as possible. In fact, he was so upset by an article in *People* magazine,[45] in which popular television science personality Bill Nye lumped *Deep Impact* in with *Armageddon* and *Godzilla* (1998) as examples of bad movie science, that he became involved in a lengthy email dispute with Nye. By lumping *Deep Impact* in with a fantasy like *Godzilla* Colwell feared that Nye's article would "promote the idea to the public that both of them can be equally dismissed."

As discussed in chapter 6, Colwell felt strongly enough about the need for filmmakers to heed consultants' advice that he held back from disagreeing with another consultant he believed had extrapolated too wildly from scant data. If the filmmakers witnessed disagreement among their consultants on any point, even one that would be acceptably contentious within the astronomical community, Colwell reasoned they might start questioning other more well-established facts, such as the appropriate level of gravitational forces on the comet or the appropriate size of the tidal wave.

Accuracy for Colwell was not limited to the comet's look or the impact's scientific details; it extended to the entire explanation behind the impact scenario. According to Colwell the original script included a prologue describing the comet being put into the Earth's trajectory by bouncing off one of Jupiter's moons like a "billiard ball." From the filmmakers' perspective such a scene would provide audiences context as to why a comet was headed toward the Earth. From Colwell's perspective this scene would dramatically change the film's message about the NEO threat. Such a prologue would portray the collision threat as due to a one-time random bit of bad luck rather than a constant and prevalent threat.

Although filmmakers removed the prologue, the billiard ball idea remained in a line of dialogue spoken by the president in a television speech: "Every now and then [a comet] gets bumped, like a billiard ball on a pool table and is knocked into a different orbit." Colwell acknowledged this dialogue, and its accompanying graphic, was probably just an oversight due to the hectic nature of film production, but he remained unhappy about its inclusion. Does this line of dialogue alter the plot in any meaningful way? No. In fact, Colwell admitted that sometimes collisions in space do change celestial orbits. There is even evidence that the supposed dinosaur-killing asteroid from sixty-five million years ago was put in Earth's path after a random collision in space.[46] Technically, therefore, the president's remark is not incorrect. Does this dialogue change the way the film could be used to argue for more NEO research and an NEO surveillance program? Yes it does, and this is the source of Colwell's unhappiness. Why should the public spend money inspecting the sky for potential Earth impactors if random events in space could knock previously surveyed bodies into the Earth's path? In fact, several scientific reviewers referred to the president's billiard ball remark as "misleading imagery" that alters the film's message.[47]

As with *Outbreak* and the 1995 Zaire Ebola outbreak and *The China Syndrome* and Three Mile Island, *Deep Impact*'s and *Armageddon*'s scientific plausibility received a boost from a real-world event. A few months before the release of both films astronomer Brian Marsden reported a potential Earth impactor. News organizations were quick to use the trailers from both films to graphically illustrate the dangers of NEOs. As with *Outbreak* and *The China Syndrome*, news organizations used fictional images created with the help of scientists as if they were actual scientific images or simulations.[48] Although other astronomers quickly found fault with Marsden's calculations, the news media's conflation of the factual and the fictional in their news coverage showed how *Deep Impact* and *Armageddon* had already become part of the technoscientific imaginary before they were even shown in theaters. Such intertexuality between the films, newspaper articles, magazine stories, and television features, in fact, is an important means by which a popular film enters into, and often dominates, the technoscientific imaginary. *Deep Impact* and *Armageddon* not only raised the level of public awareness of the NEO issue, they also provided the standard narrative and visuals for NEO impact stories.

Each film's science consultants and other astronomers realized that no matter how many scholarly papers they published their ability to call attention to the impact threat paled in comparison to the effect of a high-profile, visually spectacular summer blockbuster. Additionally, news media stories surrounding these major Hollywood films provided consultants, as well as other scientists, numerous opportunities to express their concerns about NEOs and the need for research funds. Colwell considered media attention a significant side benefit to his consulting work, saying that "many news outlets wanted to talk to me about the whole impact business. I think that was one of the good things about the movie." News coverage of cinematic science transforms entertainment news into science news.

Ivan Bekey and Josh Colwell accurately assessed that *Armageddon* and *Deep Impact* would indeed remove the giggle factor from NEOs as the two films impacted legitimate science policy debates in the United States and the UK.[49] The films, and associated media texts, were a major factor in contributing to the radical change in public opinion about NEOs as the idea of a killer rock from space went from a "preposterous conceit" to a serious danger worthy of governmental funding. While the films were in the cinema, the chair of an official Congressional hearing on NEOs claimed about the films that "it's important for all of us to realize that this is not science fiction."[50] What is particularly significant is that while the films' topics are a part of serious scientific debate, the films themselves *are* science fiction. The impact scenarios shown in the films are not "real" impacts but are cinematic simulations based on scientific input provided by science consultants and created by special effects technicians.

Thwarting Disaster through Cinema as a Promotional Strategy

The mere presence of science consultants is often enough to make popular films useful promotional tools. Consultants lend scientific *legitimacy* to movie disaster scenarios. Science consultants also attract significant media coverage and increased attention from the scientific community. In essence, scientists on the set participate in constructing Sontag's "aesthetics of destruction." People in the audience can revel in global cinematic destruction in the comfort of the theater. There they can find pleasure in the fear factor while in the back of their minds thinking, "You know, this technically could happen. Maybe we should do something to prevent it."

Audience reception studies on disaster films are limited, so it is hard to know what impact these films had on public opinion. One exception is *The Day After Tomorrow*, because anticipation of the politically charged movie allowed several researchers the time to arrange surveys and focus group-based studies of public attitudes about global warming before and after the film's release in Germany, Britain, and the United States. The studies actually provide conflicting evidence as to whether or not the film changed public attitudes about the dangers of global warming.[51] All these studies agree, however, that the film raised *awareness* of the issue, providing it utility within the political arena whether or not it actually changed attitudes. The same is true for all of the other high-profile films mentioned in this chapter. Whether or not popular films have any real impact on public opinion, they all significantly contribute to the technoscientific imaginary.

The fictional *The Day After Tomorrow*'s narrative and visuals of global disaster primed audiences for former Vice President Al Gore's 2006 climate change documentary *An Inconvenient Truth*. Gore's rhetoric of impending disaster resonated even more with audiences who had already seen the consequences of unchecked global warming in the earlier, fictional movie. The film's visualizations of natural disaster were a literal part of the documentary's own visual construction. One of the most stunning shots in *An Inconvenient Truth*—a flyover shot of the Antarctic ice shelves—turned out to be footage borrowed from *The Day After Tomorrow*. Although the reasons for the inclusion of these shots in the documentary are unknown, the fictional scenery turned out to be as effective as nature itself in conveying the natural world's beauty—so effective that audiences could not tell the images were not real. The fact that nobody questioned the veracity of these images shown in *An Inconvenient Truth*—until a 2008 news article on the American news program *20/20* critiqued the inclusion of these scenes—demonstrates the power of cinematic visuals in creating authentic visions of nature.[52]

Consulting on a popular disaster film brings risks to a consultant that are not associated with other genres like comedies or biopics. Any time consultants becomes involved in a disaster film they lend credence to the film's narrative and message whether that is their intention or not. Plant geneticist Bob Goldberg helped *Warning Sign*'s (1985) filmmakers create a realistic disaster scenario featuring the dangers of plant genetic engineer-

ing, a message that he vehemently opposes. His decision to become involved in the film was motivated by the thrill of working on a Hollywood production and he did not consider the possible damage the film might do to the public's perception of biotechnology. He has since devoted a lot of his time to convincing the public of the benefits of genetically engineered plants. In a sense, I believe that the two years he devoted to making the probiotechnology documentary *History's Harvest: Where Food Comes From* (2002) was his penance for contributing to the disaster film. As he tells it he was motivated to make the documentary because "I got so sick of the negative propaganda against genetically modified plants that I was going to do something in retrospect to counter these people." Even those who support a disaster film's message are making a Faustian bargain. They can generate enormous publicity for a scientific topic, but they also open themselves up to cries of propagandizing and selling their soul to the Hollywood devil. For many scientists, however, the ends justify the means and they find popular film to be the best means by which they can rally public support for stopping potential global disasters.

The NEO case illustrates how big the ring of truth for scientific accuracy can be for a disaster film to still be an effective promotional tool. Consultants' influence over cinematic elements other than factual accuracy, such as plausibility, institutional identity, political and social context, as well as narrative justifications, is what enhances a film's PR value. Despite Josh Colwell's concerns, the scientifically ludicrous *Armageddon* was just as useful as the more accurate *Deep Impact* in public and political debates over NEO funding. Politicians did not distinguish between the two films in their calls for more research into NEO detection and deflection because they understood the role each high-profile film played in calling *attention* to the topic. In addition, the science consultants' advice made them useful in different ways. While *Deep Impact* benefited both financially and politically from its adherence to verisimilitude, *Armageddon*'s science consultants were able to shape the depiction of NASA as an institution capable of stopping the NEO threat through scientific research and technological development, which was more politically useful than any inaccuracies in the asteroid's depiction.

Factual accuracy *can* impact the promotional utility of a disaster film. A basic level of scientific accuracy, the veneer of authenticity, is essential to stave off the worst critical attacks by opponents. Michael Molitor had

to certify the scientific validity of the basic hypothesis underlying *The Day After Tomorrow*'s plot in order for filmmakers to get away with other scientific exaggerations. Otherwise, opponents could have dismissed the film completely out of hand as the Republican National Committee tried to do.[53] In addition, the more accurate a disaster film is, the less likely scientists are to complain about inaccuracies in the press and the more likely they are to rally around a film. *Deep Impact*'s accuracy impressed some astrogeologists enough that they were not afraid to use the film as the title of their high-profile, real-life, NASA-funded "Deep Impact" research mission completed in 2005—a research mission whose methodology mirrored the plot of the movie.[54] "Deep Impact" the mission probably would not have been funded without *Deep Impact* the film's publicity, and the mission's scientific data may help prevent the film's disaster scenario from becoming a reality.

9 The Future Is Now: Diegetic Prototypes and the Role of Cinematic Narratives in Generating Real-World Technological Development

I want to make humans-to-Mars real in the minds of the viewing public.
—Film director James Cameron speaking to the Mars Society[1]

On September 19, 1981, audiences witnessed the first successful implantation of a permanent artificial heart. The patient, a twenty-year-old woman, did not experience any physical complications after the surgery. As she walked out of the hospital the doctor told her that he had given her "a heart as good as any God ever made." We will never know how long this woman lived because this transplant took place within the fictional film *Threshold*, not in the real world. A year after the film's release the first real permanent artificial heart transplant took place on December 2, 1982, at the University of Utah Medical Center.[2]

Audiences watching *Threshold* today could be forgiven for mistaking the film for a historical docudrama or a reenactment of the artificial heart's development. The film listed eleven medical doctors as consultants including Denton Cooley and Robert Jarvik who played significant roles in the 1982 real-world transplant. Given that Jarvik was the inventor of the artificial heart (the *Jarvik-7*) used in the operation, he, in particular, had valid reasons for participating in the production of a film that could ease public fears and demonstrate the possibilities of his future medical technology. Other controversial medical technologies, including test-tube babies, the pacemaker, and artificial limbs, had seen fierce public resistance in the 1960s and 1970s as researchers moved toward clinical trials.[3] After an initial wave of enthusiasm about the technology in the late 1960s, even heart transplants involving living organs had received heavy public criticism including a ban in Great Britain.[4]

In order to overcome public anxiety, scientists had to establish: (1) the *necessity* of this technology, (2) the *normalcy* of a person with an artificial heart, and (3) the heart's *viability*. Jarvik, Cooley, and the other consultants clearly believed that this film was an important public relations opportunity and they helped filmmakers construct a narrative that overtly addresses these three concerns.

A key theme in the film's first half is the rarity and fallibility of donated hearts. One early plot thread follows the character named Henry who is waiting for a heart donor. As another character crudely puts it, Henry is waiting for "one good motorcycle accident." Henry's body rejects the donor heart, prompting the central protagonist Dr. Vrain to rail against those who would prevent the development of an artificial heart (showing its *necessity*). In addition, dialogue highlights scientists' concerns about "irrational" fears that accompany new medical technologies. The character who invents the heart, for example, tells a skeptic, "The fact is that fifteen years ago when the pacemaker was introduced it created a furor. People said it was unnatural. That it was better to let the sick die in peace. Now it is considered an everyday affair. No one questions its use." *Threshold* also addressed the public's concern that a mechanized heart might make the recipient feel like a mechanized person. The surgeon and scientist repeatedly assure their patient that although the heart is a "miracle," she will be the "same person" (this speaks to *normalcy*).

Most importantly, the film's visualization of a working technology within its realist orientation established the achievability of a permanent artificial heart (underscoring its *viability*). Jarvik designed the film's heart model, which he modeled after his *Jarvik-7*. The film demonstrated how the Jarvik heart solved the problems associated with older technologies. In a crucial scene Dr. Vrain inserts the Jarvik heart into the woman's body and switches it on. The audience then heard a sound recognizable to anyone familiar with modern electronic devices: a faint whirring sound that reassured the audience that the machine works. The subsequent closeup of blood flowing through the artificial heart shows that it will indeed be a life-saving device. Through its plot, narrative, dialogue, and visual effects *Threshold* made something unfamiliar and frightening seem familiar and worthwhile.

The concept behind the *War Games* effect discussed in chapter 8 is to create plausible depictions of disasters in order to arouse fear. In this

chapter I discuss how scientists also create filmic portrayals of technological possibilities with the intention of reducing anxiety and stimulating desire in audiences to see those possibilities become realities. For science consultants, cinematic depictions of future technologies are what I term *diegetic prototypes* that demonstrate to large public audiences a technology's utility, harmlessness, and viability. Diegetic prototypes have a major rhetorical advantage even over true prototypes: in the fictional world—what film scholars refer to as the *diegesis*—these technologies exist as "real" objects that function properly and that people actually use. Within the film world, Robert Jarvik's artificial heart diegetic prototype worked properly, was safe, and saved lives.

Social Contextualization and Diegetic Prototypes as Performative Artifacts

If scholarship in the history and sociology of technology has taught us nothing else, it is that technological development is not inevitable, predestined, or linear. Any number of obstacles can impede or alter the development of a potential technology including a lack of funding, public apathy over the need for the technology, public concerns about potential applications, or a fundamental belief that the technology will not work.[5] For scientists, the best way to jumpstart technical development is to produce a working physical prototype. Working physical prototypes, however, are time consuming, expensive, and require initial funds. James Cameron's quote opening this chapter illustrates the faith filmmakers and science consultants place in cinema's ability to entice public support for technological development by revealing possible technological futures. As *Threshold* demonstrates, cinematic depictions can foster public support for potential or emerging technologies by establishing the need, harmlessness, and viability of these technologies. It is fictional film's ability to create images of "technological possibilities" in the audience's mind that leads filmmakers and scientists to believe that depictions embedded within cinematic narratives can help overcome developmental obstacles.

Prototypes are what Lucy Suchman and colleagues call "performative artifacts" that establish in the social realm the viability and possibilities of a nascent technology.[6] These performative aspects are especially evident in diegetic prototypes because a film's narrative structure contextualizes

technologies within the social sphere. Narratives in cinema require certainty to move their stories forward. Cinematic texts require technologies to work and provide utility to their users. Technological objects in cinema are at once both completely artificial—all aspects of their depiction are controlled—and normalized as practical objects. Characters treat these technologies as a "natural" part of their landscape and interact with these prototypes as if they are everyday parts of their world. For technologist Julian Bleecker fictional characters are "socializing" technological artifacts by creating meanings for the audience, "which is tantamount to making the artifacts socially relevant."[7] Thus, the need for a potential technology is established as given within the framework of a popular film.

My aim in this chapter is to focus on the actions of science consultants and interested filmmakers in order to show specifically how they construct cinematic scenarios—their diegetic prototypes—with an eye toward generating real-world funding opportunities and the ability to construct real-life prototypes. Filmmakers and science consultants craft diegetic prototypes and enhance their realism by creating a full elaboration of the technological diegesis, which includes any part of the fictional world concerning the technology. Through their actions they construct a filmic realism that implies self-consistency in both the real world and the story world. The creation of diegetic prototypes involves the inclusion of scenes that provide opportunities to demonstrate this realism and posit a real-world need for the technology and the avoidance of scenes that would undermine the technology or cast it as risky. Technological advocates who construct diegetic prototypes have a vested interest in conveying to audiences that these fictional technologies *can* and *should* exist in the real world. In essence, they are creating "preproduct placements" for technologies that do not yet exist.

I began this chapter with the case of a medical technology that had already been built, tested in animals, and made ready to use, but that required public willingness to allow human use because of ethical issues. In contrast, nonmedical technologies, such as computer technologies, may pose few physical dangers to users but incur huge financial risks to entrepreneurs because of high development costs amid uncertainties about potential consumer markets. Similarly, space technologies have no obvious social benefits and an extremely high price tag alongside easily understood challenges and risks. What better way to generate public interest in a

potential technology than to demonstrate its potential in a popular movie? In sections that follow I explore cases of technological development in which diegetic prototypes played a role in generating public excitement (and subsequent governmental or corporate action) for moving these technologies from the fictional into the real world.

Virtual "Virtual Reality": Visualizing the Potential of Computer-based Technologies

Technological entrepreneur and film director Brett Leonard created an entire movie, *The Lawnmower Man* (1992), which highlighted the potential of virtual reality (VR) and 3D interactive technologies (figure 9.1).[8] The film was based on a Stephen King short story and the minimalist nature of the source material presented Leonard with an opportunity to create a film based on the VR technologies he had been discussing socially with digital pioneers such as Jaron Lanier. The film's computer-generated visual effects served a dual purpose for Leonard. First, the state-of-the-art computer graphics would be a major selling point. Second, the VR world inhabited by the film's central character, Jobe, would illustrate for the audience VR technology's potential real-world applications. For Leonard VR represented an extreme example of the types of interactive technologies

Figure 9.1
The Lawnmower Man took audiences for a "virtual reality" ride.

he was publicly promoting. His goal for *The Lawnmower Man* was to create a modern "technological mythology" featuring interactive technologies. As part of this mythmaking process he created a "narrative environment" in which the technologies on display became a natural part of the film's visual landscape.

Leonard also understood that the inclusion of emerging but unknown Internet technologies enhanced the plausibility of this elaborate diegetic prototype. Through his social contacts he was able to discuss upcoming developments in digital technology with several people who were at the forefront of computer science, including Nicholas Negroponte and Steve Wozniak. According to his production designer, Alex McDowell, the filmmakers also toured various computer companies including Sun Microsystems and Apple. They were looking for nascent technologies that would make the film's VR technology seem more cutting edge and prescient. While the horror aspects of the film angered many VR proponents, the film's visuals were an important vehicle in promoting the *potential* of VR. The film provided audiences with a VR "experience" that contemporary VR technologies could not. An *Omni* magazine article from 1992 captures this sense of presenting an alluring vision of a VR future: "In the graphics scenes you will see what such worlds might look like in the future. At present, most VR systems are fairly crude, but the technology is developing extremely fast. According to David C. Traub, an immersion computing expert from Centerpoint Communications who was a consultant on the film, by 'looking beyond the futuristic luster of these new toys to the somewhat pained fantasies they often portray,' *The LawnMower Man* will give us some powerful hints about what might be in store."[9] *The Lawnmower Man* was a financial success and Leonard followed it up with another VR-based film, *Virtuosity* (1995).

As Leonard had hoped, his cinematic depictions of VR technology created a "modern myth" that whet the public's appetite for immersive entertainment technologies. *The Lawnmower Man*'s success was a key component in his ability to acquire the venture capital needed to start L-Squared Entertainment where he could develop new interactive entertainment technologies. After making *Virtuosity*, Leonard began to create the types of interactive experiences he hinted at in *The Lawnmower Man,* including the first IMAX 3D movie, *T-Rex: Back to the Cretaceous* (1998), which Leonard believes "was the closest thing to an amazing immersive virtual reality

experience as you could have in the context of a narrative." For Leonard, this technological development was only possible because of his successful diegetic prototypes.

John Underkoffler's engineering firm has also benefited from his opportunity to create the underpinnings for the cinematic depictions of computer-based technologies in films such as *Aeon Flux* (2005) and *Iron Man* (2008). He has worked as a science consultant on several other high-profile films including the Steven Spielberg technology-laden blockbuster *Minority Report* (2001) starring Tom Cruise. Underkoffler is well aware of cinema's ability to instill in the public a desire to see the real-world development of fictional technologies. In fact, he approaches every consulting opportunity with the explicit goal of creating cinematic technologies that enter into the "technological imaginative vernacular" of real-world scientific discourse. To do this, Underkoffler treats his diegetic prototypes as if he were designing not only physical prototypes but also real-world objects that are a part of "everyday life" in the diegesis.

Although Underkoffler was responsible for helping design all of the technologies in *Minority Report*, his chief concern was the gesture-based computer interface technology that protagonist John Anderton uses to manipulate computer data with his hands (figure 9.2). *Minority Report* was a golden opportunity for John Underkoffler to demonstrate to the public, and potential funders, not only that his gestural interface technology would work but also that the technology would appear as if it were

Figure 9.2
Police detective John Anderton (Tom Cruise) uses science consultant John Underkoffler's gestural interface technology in *Minority Report*.

"natural" and intuitive for users. The important factor was that Under-koffler conscientiously treated this cinematic representation as an actual prototype: "We worked so hard to make the gestural interface in the film real. I really did approach the project as if it were an R&D thing."

The most successful cinematic technologies are taken for granted by a film's characters, and thus, communicate to audiences that these are not extraordinary but rather everyday technologies. For *Minority Report*, this meant that the gestural interface technology appeared to be something Anderton has used before it appeared on the screen and will use again even when the camera is somewhere else. Yet, for audiences these filmic creations *do* represent extraordinary technologies because they do not exist in the real world. This means that these cinematic technologies come across to audiences as both ordinary *and* extraordinary. To achieve the sense of an extraordinary technology appearing as ordinary within the film, Underkoffler established the gestural interface as a "self-consistent technological entity" that adhered not only to the rules of the diegetic world but also to its own internal logic and the constraints of real-world computer technologies.

To achieve self-consistency Underkoffler worked out an entire new gestural language based on American international sign language, SWAT team commands, air traffic control signals, and the Kodály hand system for musical notes. Although only a small fraction of the language appears in the film, Underkoffler believed it was essential to develop an entire system of commands and gestures. To make sure his diegetic prototype functioned appropriately and conveyed a sense of internal consistency with established protocols for use he created training videos and manuals and a dictionary of gestures. For production purposes, Underkoffler's comprehensiveness allowed actors to engage in improv work. In terms of the technology's cinematic realism, a completely worked out gestural interface minimized the possibility of the types of logical inconsistencies that call attention to cinema's constructed nature. Self-consistency of the gestural interface enhanced the film's realism, but more importantly for Underkoffler it made it appear that anyone could operate the technology.

Underkoffler also established the gestural interface as a "real" technology in the diegesis by acknowledging potential design flaws. Perfection is a mistake made with most fictional technologies because it is a portrayal that does not mesh with audiences' experiences. In the case of the gestural

interface, Underkoffler reasoned that the technology's design would make it incredibly sensitive to the user's hand motions. Therefore, the data on the computer screen would follow any hand movements, intentional or otherwise. Underkoffler suggested to Spielberg that he add a scene in which someone extends his hand to Anderton while he is using the gestural interface. Anderton would instinctively move to shake this person's hand, and by doing so, he would shift all the data on the screen into a corner. Underkoffler successfully conveyed to Spielberg that rather than detracting from the technology's realism, this flaw would *add* to the believability because it highlighted the technology's self-consistency. Spielberg found the idea visually interesting and so he incorporated it. This "flaw" also served Underkoffler's goal of convincing the public that his technology could function in the real world. One concern with potential gestural interface technologies is that they will not be motion sensitive enough. Thus, the "flaw" in the movie was not really a design flaw; Underkoffler meant for it to highlight the fact that the technology worked *too* well.

In the end, Underkoffler's diegetic prototype was extremely successful on many fronts. His gestural interface quickly became a focal point for discussions about interactive technologies. Underkoffler himself was able to generate significant capital because of his diegetic prototype: "In the wake of *Minority Report* there have been countless approaches from individuals, organizations, and companies that saw a piece of technology in the film and want to know from Alex [McDowell] or me is that real? Can we pay you to build it if it is not real? Chief among those technologies, of course, is the gestural interface." These approaches led to the funds he needed to start the company Oblong Industries and to turn Underkoffler's diegetic prototype into a physical prototype of his G-Speak technology (figure 9.3). This real-world prototype in turn led to a development contract with defense giant Raytheon.[10] From Underkoffler's perspective, his work as science consultant on *Minority Report* was not simply a minor component in this story; his well-worked-out diegetic prototype was the *crucial* element in the development process.

Cinematic Test Rockets: Demonstrating Space Travel's Viability in *Woman in the Moon*

Diegetic prototypes can be particularly effective for technologies like space travel whose development hinges strongly upon public support. As

Figure 9.3
John Underkoffler operates a real-world prototype of his G-Speak gestural interface technology.
Source: Courtesy of John Underkoffler, Oblong Industries.

discussed in chapter 5, director Fritz Lang hired Hermann Oberth, Willy Ley, and the German Rocket Society (VfR) to serve as consultants/assistants for his 1929 film *Frau im Mond* [*Woman in the Moon*] (figure 9.4). The collaboration seemed a win-win situation. Lang was one of Germany's greatest cinematic artists who created the science fiction classic *Metropolis* in 1926. In addition to increasing scientific verisimilitude, Lang hoped that linking the well-known Oberth to his film would add significant publicity value. Lang and the film's production company, Universum Film AG (Ufa), even commissioned Oberth to build a rocket to be launched as a publicity stunt at the film's premiere.[11] For Oberth, a film by one of the world's most famous film directors provided a significant means for promoting rocketry, especially his own research on liquid-propellant rockets, to a worldwide audience including potential financial backers. Additionally, Oberth received vital research funds from Ufa and Lang. Oberth envisioned the premiere launching as a means to demonstrate the feasibility of his ideas.

Despite his pioneering work on rocketry and his status as a leading figure in the German space movement Oberth was desperately in need of research funding.[12] He was also desperate for experimental validation of

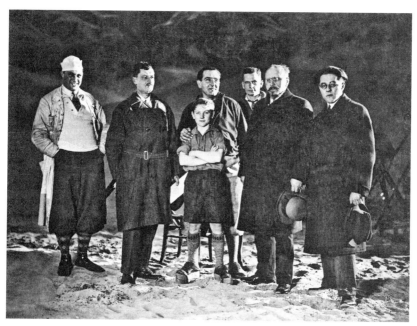

Figure 9.4
Production photo on the set of *Woman in the Moon* showing Hermann Oberth (second from left), Fritz Lang (center), and Willy Ley (right).
Source: Courtesy of National Air and Space Museum, Smithsonian Institution (SI 2006-26085).

his ideas about liquid-propellant rockets since all of his work to this point was theoretical. Essentially, Oberth was in a catch-22 that would be familiar to any present-day scientist who applies for funding. The only way for Oberth to obtain funds for experimental research was to convince investors of the viability of his approach. Yet, Oberth could only show his approach's viability by successfully firing a test rocket, and building that rocket, of course, required financing.

Although there were few channels for research funds in 1920s Germany, there was enormous public excitement about rocketry and space flight.[13] The VfR was founded in 1927, in part to obtain funding for Oberth's research.[14] Popular science writer Ley was one of the founders of the VfR, and its initial vice president. Ley was an enthusiastic crusader for space travel in general and for Oberth's ideas in particular. However, while the VfR was able to gather some capital through donations and membership

fees, there was not enough money available for Oberth to pursue experiments.

Despite his need for funds Oberth was initially reluctant to serve as consultant. Writer Otto Folberth recalled in an article in 1930 that Oberth was "surprised by the offer of Ufa to be an advisor on the film *Frau im Mond*."[15] Despite his own positive experiences with the novels of Jules Verne and H. G. Wells, Oberth had misgivings about communicating the idea of space travel through fiction. He worried that rather than conveying space travel's feasibility, the film would add to cartoonish visions he had seen in other popular culture creations. As Folberth states, "Oberth had to overcome a number of misgivings before he decided to accept the offer. For the newspapers, magazines, novels, comic strips had already significantly compromised the scientific rigor of the idea." Despite his misgivings, Oberth accepted Lang's invitation and moved to Berlin in the fall of 1928 to begin his film work.

Ley joined Oberth to serve as astronomical advisor and write publicity articles. Unlike Oberth, Ley had no misgivings and he foresaw great promotional possibilities in having Germany's most famous director make a space travel movie. According to Ley: "The news that Fritz Lang was going to make a film on space travel was very good news indeed. It is almost impossible to convey what magic that name had in Germany at that time. . . . A Fritz Lang film on space travel, consequently, meant a means of spreading the idea which could hardly be surpassed in mass appeal and effectiveness."[16]

Ley was hoping that Oberth's diegetic prototype would galvanize public support for governmental research funds. A "Fritz Lang film" had the added bonus of being a major social event in Germany. Invitations to the film's premiere requested "tails or black-tie."[17] This provided an opportunity to convey the message directly to influential individuals who might actually have the means to support rocket research:

The first showing of a Fritz Lang film was something for which there was no equivalent anywhere as a social event. The audience—it was an unwritten but rigid rule that one had to wear full evening dress, not just a dinner jacket—comprised literally everybody of importance in the realm of arts and letters, with a heavy sprinkling of high government officials. It is not an exaggeration to say that a sudden collapse of the theater building during a Fritz Lang premiere would have deprived Germany of much of its intellectual leadership at one blow.[18]

If done properly the scenes of space travel could "demonstrate" its feasibility sufficiently to acquire funds for actual experiments. Thus, Oberth treated the design of the fictional rocket and the trajectory as if he really was designing a trip into space. Although Lang constantly battled with his consultants over depictions of the Moon (see chapter 5), he gave Oberth wide latitude in designing scenes featuring the rocket, its takeoff, and technical details of its flight scenes (figure 9.5).[19] For Oberth, the opportunity to create depictions of rocket travel in a Fritz Lang film outweighed any disappointment he may have felt about the Moon's scientific accuracy.

In conjunction with their filmmaking duties, Oberth was also constructing the publicity/test rocket. While the test rocket was nominally promotion for the film, Oberth, Ley, and the VfR realized that the rocket was as much about promoting the rocket itself as it was about promoting the film. Moreover, Oberth and Ley saw a significant connection between the film and the test rocket. Since Oberth designed the fictional rocket—

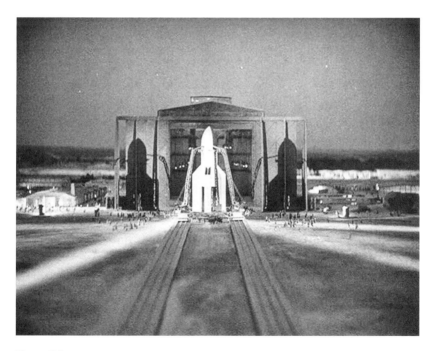

Figure 9.5
For Oberth and Ley the takeoff scene was *Woman in the Moon*'s most crucial element.

his diegetic prototype—based on his Model B liquid-fuel rocket, then a successful rocket launch at the premiere would ultimately legitimate the film's vision of space flight. According to Ley, "The idea was to say that this actual rocket represented the first step toward the solution of the problem shown in the movie."[20] In the end, Oberth envisioned the launching of the test rocket at the premiere as a way for him to demonstrate the feasibility of the ideas that the audience was going to see on the screen.

By accepting Ufa and Lang's offer of research funds Oberth committed himself to constructing and perfecting a rocket capable of soaring fifty miles high in fewer than four months. Unfortunately, Oberth's previous work consisted mainly of theoretical studies with few experiments. According to Ley, "[Oberth] was the greatest authority on rocket propulsion at that time, but he was a theorist, not an engineer."[21] Four months after construction had begun on the rocket, there was only a series of explosions—one almost blinded Oberth—to show for their efforts. Oberth feared that failure to produce a much-publicized rocket would endanger his reputation and call into question the feasibility of the liquid-fuel rocket. He fled Berlin when he realized that he could not get a working model ready in time for the premiere.[22]

Despite Oberth's failure in the real world, the diegetic liftoff that he designed for the film was a complete success, since it visually and dramatically conveyed the possibilities of rocket travel to influential individuals, including Albert Einstein, as well as potential funders and government officials at the film's premiere. According to Ley's account, the takeoff of the rocket from Earth caused a roar of emotion from the premiere audience:

There is without question no other scene, either on Earth or on the Moon, that would have ruffled the poise of this cool, reserved, expert audience—these journalists, scholars, diplomats, men of affluence, and film stars. In the face of these outstanding technical achievements, the audience exploded. Electrified, carried away. The fiery jets of this film rocket swept away their carefully prepared skepticism, indifference, and satiety with the same speed with which the rocket raced across the screen, giving their minds a small glimpse of the tremendous possibilities.[23]

Film critics also acknowledged seeing the "tremendous possibilities" in that takeoff scene. Despite overall mediocre film reviews, the takeoff and rocket

scenes impressed film critics throughout the world including art historian Rudolph Arnheim and French journalist Jean Arroy.[24]

Other rocket scientists quickly recognized the film's capacity to visually render rocketry and show audiences technological "possibilities," and they used the takeoff scene as a promotional device and a fundraising tool.[25] Robert Esnault-Pelterie, one of Oberth's scientific rivals, showed the takeoff scene from *Woman in the Moon* at a 1931 fundraising event in New York City.[26] The *New York Times* report on the event captures the essential elements of a diegetic prototype: "The moving picture graphically illustrated some of the amazing experiences which travelers to the moon could expect. Last night's spectators watched it [footage from *Woman in the Moon*] as if it were a newsreel of an actual happening today."[27] The success of the rocket takeoff on the screen made Oberth's failure to produce a functioning rocket for the premiere irrelevant. The premiere audience in Berlin, and elsewhere, walked away *thinking* they had seen Oberth's rocket because they saw a successful rocket takeoff in the film. In the end his virtual rocket—his diegetic prototype—succeeded in ways that his test rocket could not. Like a Latourian immutable mobile, the cinematic demonstration provided advantages missing from an actual demonstration; the film was portable, repeatable, and larger than life.[28] These advantages would again prove critical as space travel appeared in cinema twenty years later during the next big step in aerospace engineering: moving from rockets to manned space travel.

Documentary of the Future: Space Travel as a Dire Necessity in *Destination Moon*

Destination Moon reached theaters as the Cold War was heating up and propagandists in the United States and the U.S.S.R. were beginning to use technological supremacy as a symbol of ideological superiority.[29] While the space race was well underway scientifically by 1950, the public campaign started in earnest with the release of producer George Pal's documentary-like film, *Destination Moon*, about a privately financed trip to the Moon. The film's financial and critical success launched a long-lasting space film cycle in Hollywood that was bookended in 1968 by Kubrick's *2001*. Space travel's future was of critical concern to the numerous scientists (astronomer Robert S. Richardson, rocket scientist Werner Von Braun, and

physicist Robert Cornog among many others) and scientific experts (Willy Ley, artist Chesley Bonestell, and science fiction writer Robert A. Heinlein) who assisted filmmakers during production.

I will focus on *Destination Moon*'s initial scriptwriter and main science consultant, Robert A. Heinlein, who also wrote the 1947 book *Rocketship Galileo*, on which the film was nominally based. I will show that Heinlein's role in constructing this "documentary of the future" went well beyond technical recommendations (figure 9.6). Whereas Herman Oberth was initially reluctant to lend his scientific credibility to a fictional film, Heinlein envisioned the film as a major opportunity to demonstrate to the American public the feasibility of and the need for rocket travel. Also unlike Oberth, Heinlein was not looking to acquire research funds. He was, however, a strong advocate for developing rocket travel in America. He held

Figure 9.6
This production photo shows Robert A. Heinlein and wife Virginia on the set of *Destination Moon*.
Source: Courtesy of the Robert A. and Virginia Heinlein Collection, University of Santa Cruz.

membership in several rocket societies, such as the Pacific Rocket Society, and had published several short stories and novels based on space travel. Although he received financial compensation for his script and his technical assistance, the film provided him an opportunity not only to advocate ideas about the viability of space flight itself, but also to visually explicate the reasons for going into space. In fact, this one technological advocate fundamentally created a new genre—the space film. Before *Destination Moon* there were no preconceived expectations of what a space movie should look like. Heinlein's influence over the look of *Destination Moon*, his emphasis on realism and believability, and his anxiety about beating the Soviets into space shaped this new genre for the next twenty years.

According to Heinlein, the key to the film's rhetorical power was its adherence to scientific veracity, and his correspondence shows a consistent insistence that the filmmakers approach the film as if they were planning a real trip to the Moon. Based on his archival material I would argue that Heinlein had several reasons for insisting upon verisimilitude, all of which were in line with his belief that cinema was a legitimate and powerful means for promoting a vision of space travel. First, as a "hard" science fiction author Heinlein thought it would be intellectually dishonest to create a space-based fictional text and disregard scientific accuracy. In addition, he felt that it would be deceitful for filmmakers to publicize the film as "realistic" if they did not make a sincere effort to adhere to scientific principles.

Fundamentally, Heinlein believed that scientific realism was the key to the film's box office success—something filmmakers and financial backers wanted to hear. Heinlein conveyed his belief in realism's box office benefit through various memos and letters: "If people believe in our picture emotionally, accept it as real while they are seeing it, it will be a success—a box office success. . . . Those who see it will tell others what a wonderful, thrilling, out-of-this-world experience it was—'My dear, you have no idea! They actually made you feel that you were on the Moon!'"[30] Heinlein also recognized that a scientifically accurate film would generate significant positive publicity within scientific circles and that it would be a picture "the New York Times science editor would praise . . . and that scientists would commend publicly." He also worried that an unrealistic film would lead to negative publicity from scientists and teenage audiences because he knew "what the 'hep kids in the first six rows' like." Box office success

meant that the largest possible audience would witness Heinlein's diegetic prototype.

For Heinlein, accurate representations spoke for themselves. A scientifically accurate film was "truthful," thus it was a legitimate promotional tool and *not* propaganda. As an ardent anticommunist and staunch libertarian, Heinlein was sensitive to the charges of sloganeering and propagandizing. Despite the fact that the film reeks of propaganda to present-day viewers, he believed at the time that the film's message was subtle. Heinlein was adamant that "reality" was the key to political transparency. He warns filmmakers on several occasions that the "one purpose of this picture is to show what free men and free enterprise can do—but such an effect can never be achieved by blatant propaganda. It must be handled gently. Specifically, we must not *say* it, we must *show* it." Space travel on the screen had to be based on "genuine" science, not science in the service of political motives.

Heinlein felt that audiences could "sense" when something was authentic. Therefore, he approached the film as if he were modeling an actual trip to the Moon. Like Underkoffler, Oberth, and other successful science consultants, Heinlein approached this film project with the attitude that the film's fictional nature was irrelevant. Heinlein's archival material contains dozens of pages of hand calculations for every technical aspect of the cinematic space flight including the mass ratio, jet speed, trajectory times, and fuel requirements. As he explained, "none of these calculations would appear on screen but the results do."[31] Similar to Oberth, he viewed the most crucial aspect of the film as the technical details of the takeoff, flight, and landing on the Moon. Heinlein was so concerned about these scenes that he generated a lengthy letter to Pal and production supervisor Martin Eisenberg entitled "The Care and Feeding of Spaceships," which was to provide them with technical details "in case I should be hit by a taxi, go to jail, or otherwise be unavailable."[32] He complained during James O'Hanlon's script rewrite that he "was assured repeatedly that the part of the picture from takeoff to the end had not and would not be tampered with."[33] As with Oberth, Heinlein believed that the reputation of space flight as a serious scientific endeavor was at stake and he could not afford for the film to be sloppy or lenient with the technical details. Unlike Underkoffler, Heinlein could not afford to let any technical "flaws" appear in the film, even ones that could add to the technology's realism.

Despite believing that these technical details would "feel" authentic, Heinlein was concerned that audiences would not grasp the scientific principles enough to believe the cinematic space trip was "authentic." His initial script treatment contains side notes to coscreenwriter Rip Van Ronkel expressing this concern: "I have a mild fear that, in attempting to maintain good story and strong drama, we may be skipping over explanations necessary in understanding *the issues on which our drama is based*. In a Western, one does not have to explain steers, revolvers, lariats, nor branding irons—whereas we are practically forced to explain acceleration, reaction, planet vs. star, vacuum, free flight, et cetera ad naseum. Sad but true" (emphasis in original).[34] To quickly educate the audience on complex technical principals, Heinlein recommended several didactic elements, which while cliched now were groundbreaking at the time, including expository dialogue, lecture scenes, and, most famously, the use of a Woody Woodpecker "animated movie" (figure 9.7).

Figure 9.7
A Woody Woodpecker cartoon was used in *Destination Moon* to explain complex scientific ideas.

The studio did not immediately embrace Heinlein's commitment to film realism. At the time, cowboys and musicals sold movie seats; science lectures did not. The filmmakers hired veteran script doctor James O'Hanlon to add elements with box office appeal. O'Hanlon radically altered Heinlein and Van Ronkel's original screenplay by adding several surefire movie staples of the period, including comedy, musical interludes, and cowboys. The film's financial backers, including N. Peter Rathvon, preferred O'Hanlon's version because it included elements they knew would make it profitable. Heinlein was furious when he saw the O'Hanlon rewrite. He spent "five days of unrelenting toil" composing a memo that he fired off to Rathvon and Pal. In it he rants that their profit motives would be better served by spending money on the rocket and special effects. He tells them that in this script their money is needlessly spent on extraneous elements "at the expense of that part of the picture on which it was agreed that money would be spent, to wit, the special effects needed to give it authenticity. We skimp the space ship to put in a dude ranch, a horse, a barbeque pit!"[35]

Heinlein's lengthy memo is a scathing critique. While he points out the script's factual inaccuracies, he aims most of his criticisms at the additions of fantastical elements to the plot, such as the singing cowboys. He knew that these clearly fictional elements would, by proximity, cast doubt upon the legitimacy of the cinematic space flight. The addition of a musical interlude, for example, created too great a disconnect from the real world and thus threatened the believability of the space flight. He complains, "We put the audience into a musical comedy farce mood, where anything goes, when we are about to try and get them to believe in a trip to the Moon." He also understood that any money budgeted toward portraying barbeque pits and dude ranches would detract from the money allocated to the space trip itself. In a later memo Heinlein sums up his belief that the audience's acceptance of the space flight scenario depended on their buying into the entire film: "There is to my mind, a basic criterion which should be axiomatic in dealing with this picture: if the audience believes emotionally that they are making a trip to the Moon while they are seeing this picture, the picture will be a success, financially and other ways. If they don't, we're a flop."[36] Heinlein successfully argued for the removal of every fantastical element. His strong comments as science consultant

wiped out an entire script that the film's funders were keen on producing by convincing them that scientific accuracy would sell better at the box office. Ultimately, the final filming script looked nothing like the O'Hanlon script because the director "removed practically every objection I had to its predecessor."

Heinlein also influenced the narrative so as to remove elements that portrayed the trip to the Moon as risky, such as a meteor shower that originally featured in the O'Hanlon script. He was also able to enhance narrative elements to make the space journey appear to be a necessary and highly desirable future. He inserted dialogue that provided several justifications why a trip to the Moon would be advantageous including potential mineral deposits, scientific progress, and industrial patents. Most importantly, Heinlein believed such a trip was essential for military reasons, and his dialogue about the possibility of launching nuclear missiles from the Moon became part of the era's national rhetoric. Publicity material for the film also highlighted the military necessity of a Moon trip with several articles addressing the topic, including one entitled "Must America Engage in a Race to the Moon in Self-Defense?"[37] The film's meticulously constructed diegetic prototype effectively enhanced Heinlein's cinematic argument about the Moon's military importance. If the film could convince American audiences that their scientists could make it to the Moon, it also needed to convince them that America's enemies could as well.

Judging from reviews and box office returns, Heinlein was successful in conveying both the excitement of space travel and its military necessity. Bosley Crowther of the *New York Times*, for example, stated, "They make a lunar expedition a most intriguing and picturesque event."[38] Crowther also singled out the military rhetoric as particularly convincing, claiming, "It is arresting to hear an eloquent scientist proclaim that the first nation which can use the moon for launching missiles will control the earth." The intervention of real-world events heightened the effectiveness of the film's rhetoric. As if to underscore Heinlein's argument, the 1950 adaptation of *Destination Moon* on NBC's radio program *Dimension X* was actually interrupted by a news bulletin reporting on North Korea's invasion of South Korea.[39] Not only were communists on our doorstep, they were threatening to invade the heavens as well.

Despite Heinlein's belief that his film was legitimate promotion of space flight, it was certainly viewed as propaganda by the Soviets, who considered *Destination Moon* and subsequent space-based films such as *When Worlds Collide* (1951) and *Red Planet Mars* (1952) as attempts to scare Americans into space. One Soviet journalist even claimed that the American Department of Defense created the films in order to "propagandize the idea of conquering the universe."[40] Of course, Heinlein was correct in stating that Soviet scientists were also aiming for the Moon. It was not just American scientists who understood cinema's rhetorical power. Futuristic Soviet space films such as *Planeta Bur* [*Cosmonauts on Venus*] (1962) employed several technical advisors including astrophysicist Aleksandr Vladimirovich Markov. While a film like *Doroga k Zvezdam* [*Road to the Stars*] (1958) inspired Soviet audiences with its depictions of colonies on the Moon and Mars, these same scenes caused "heavy breathing" among American audiences.[41] One audience's shiny spaceship future is another audience's impending doom.

Figure 9.8
A Soviet spacecraft lands on the Moon in *Road to the Stars*.

Diegetic Prototypes after the Moon: Missions to Mars and Beyond

It is tempting to view the experiences of Oberth, Heinlein, and other science consultants on these space-based films as relics of a bygone era where filmmaking was a much simpler process. Such a view would not only be ignorant of filmmaking's history, it would also discount the fact that scientists still promote space travel through cinema. For more than eighty years, from 1920 when Robert Goddard advised Max Fleischer on the combination animation-live action short movie *All Aboard for the Moon* to NASA's involvement in films such as *Space Cowboys* (2000) and *Sunshine* (2007), scientists and filmmakers have worked on space travel films as a means of promoting all kinds of futures in outer space.

The Disney film *Mission to Mars* (2000) served as a high-profile platform for physicist Robert Zubrin's Mars Direct plan. Filmmakers brought in Zubrin, president of Pioneer Astronautics and founder of the Mars Society, to help them design a plausible plan for an initial Mars mission. Zubrin's proposal for a trip to Mars became a major focal point for the filmmakers after producer Tom Jacobson read an excerpt from Zubrin's 1996 book *The Case for Mars*. Jacobson subsequently hired Zubrin as a consultant during the development of the script and purchased the book's film rights. "There is so much detail about how we could go to Mars, including proposals for spaceships, Mars habitats and mission plans," said Jacobson. "Once we started preproduction, we gave the book to practically everyone involved in the movie. It's very inspirational."[42] Production designer Ed Verreaux acknowledged, "A lot of stuff is based on Zubrin's ideas, sending up unmanned robotic ships, going slowly to conserve fuel."[43] A comparison between the Mars Direct plan and the film bears out the fact that Zubrin's plan served as a key blueprint for the filmmakers (figure 9.9). The "success" of the mission on the screen allowed the Mars Society to set up stalls in theater lobbies across America where society members informed moviegoers that the public could turn the cinematic Mars colonization scheme into a real future by pressuring Congress for governmental funds.[44]

Given the space science community's familiarity with Zubrin's Mars colonization scheme, it is not surprising that other scientists saw Zubrin's hand in the film production. Astrophysicist Philip Plait was critical of the Mars Direct plan in reviews of Zubrin's work before he saw the film, referring to elements of the plan as "shaky."[45] He notes that he was not

Figure 9.9
The colonization vehicles depicted in this still from *Mission to Mars* look remarkably similar to illustrations from Robert Zubrin's book *The Case for Mars*.

surprised to learn that Zubrin acted as consultant on the film: "He is the author of the 'Mars Direct' plan, which is basically a quick and easy way to get to Mars. His plan is controversial; many space experts think it won't work. I have serious doubts as well." Although he still has doubts about Zubrin's ideas, Plait also claims that he is impressed by the plan as it is depicted in the film, calling it "very clever, and a good idea." He concludes, "When we do it for real, it might be the working model of the actual method employed." While reading Zubrin's work Plait had reservations, but when he saw the ideas portrayed in film the scheme became "clever" and a "good idea." Although Plait certainly isn't a true convert to Zubrin's Mars Direct plan (he still expresses some doubts), Zubrin's cinematic Mars mission appeared to Plait to be workable.

Given the incredible expense involved in developing space-based technologies, *Mission to Mars* was the most effective form of advocacy Zubrin could have hoped for. Not only was Zubrin paid for the rights to develop a cinematic version of his Mars Direct plan, he also received all the advantages associated with a diegetic prototype. He was able to demonstrate to the public and other scientists that a trip to Mars was desirable and that his Mars Direct plan could work successfully without serious incident. As with Underkoffler, Oberth, and Heinlein, Zubrin gained these benefits because he took his diegetic prototype seriously and planned it as if it were a real, not fictional, space trip.

Technological Development, Diegetic Prototypes, and Happy Endings

In her influential study of science fiction films and American culture Vivian Sobchack regards 1950s space films as a form of technology worship. According to Sobchack, films such as *Destination Moon* and *When Worlds Collide* (1951) "visually celebrate the spaceship and dwell on its surfaces with a caressive photographic wonder which precludes any ambiguous interpretation of its essential worth."[46] Sobchack singles out *Conquest of Space* (1955) "with its lavish treatment of takeoffs, maneuverings, and landings" as a particularly blatant form of technological worship,[47] but she overlooks the fact that it is not only filmmakers who are worshipping at this altar. *Conquest of Space*'s science consultants, including Chesley Bonestell, Robert Richardson, and Werner von Braun, significantly helped in creating the film's takeoff and landing scenes because they had an enormous stake in establishing the "essential worth" of space travel. Movies have provided many scientists with the opportunity to create diegetic prototypes establishing the necessity, viability, and minimization of risk associated with space travel.

These films then served as promotional tools for other scientists and scientific organizations that used the films, or at least the technical parts, to bolster their own lectures. Such public showings offered glimpses of a future that *could* happen. Hermann Oberth and the VfR were so successful in creating a sense of future possibilities that film stills from *Woman in the Moon* were routinely used as illustrations in journals and magazines until the 1950s.[48] Film footage was also spliced into several research films and one such film was shown by the British Interplanetary Society in the War Office at Whitehall.[49] Likewise, it is telling that the only two films shown at the groundbreaking First International Astronautical Congress in Paris in 1950 were a film of V-2 launches at the White Sands missile range in New Mexico, and *Destination Moon*.[50] These films gave the collected experts a vision of the present state of rocketry and a vision of where they wanted rocketry to be in the future. We have ample evidence that space travel films were extremely successful in exciting the public about the possibility of space travel.[51]

Diegetic prototypes' usefulness may be understood most clearly through an examination of space films, but their advantages are certainly not limited to this type of technology. Brett Leonard and John Underkoffler's

diegetic prototypes of embryonic computer-based technologies directly resulted in funding opportunities and the ability to construct real-life prototypes. Audiences could see with their own eyes "real" people effortlessly interacting with these futuristic computer technologies in *The Lawnmower Man, Virtuosity, Minority Report, Iron Man, Paycheck* (2003), and other computer-based films. Underkoffler, in fact, felt that cinema's potential for technological development should be brought into the scientific community. After *Minority Report* Underkoffler and Alex McDowell helped form an organization called MATTER Art and Science whose objective is to transfer cinema's creative methods into scientific work. For MATTER Art and Science every potential technology should be treated as a diegetic prototype. This allows them to map out a technology's social, political, economic, and practical possibilities before it is even considered for development.

Fiction's lack of constraints and filmmakers' creative assistance provides an open, "free" space to put forward speculative conceptualizations; it also embeds these speculations within a narrative that treats these ideas as already actualized within a social context. The key to diegetic prototypes is that they allow consultants to visualize *specific* methods and technologies within the social realm of the fictional world. Each science consultant can use cinema's narrative and visual framework to contextualize and model potential futures for their particular technology whether medical-, computer-, or space-based. Cinema provided an ideal vehicle for establishing a technology's necessity, its viability, and its harmlessness within society. The depictions on the screen represent Robert Jarvik's artificial heart, Brett Leonard's and John Underkoffler's computer-based technologies, and Hermann Oberth's and Robert Heinlein's visions of space travel. Disney's Touchstone Pictures provided Robert Zubrin the opportunity to show the public that his Mars Direct plan *could* work and the narrative provided reasons why the public should *want* it to work. For science consultants who are trying to get funding for their undeveloped technologies, diegetic prototypes allow for "happy endings."

10 Improving Science, Improving Entertainment: The Significance of Scientists in Hollywood

In his 1959 Rede Lecture entitled "The Two Cultures," C. P. Snow made a distinction between the cultures of science and of the arts that still forms the basis for discussions about art and science. These two cultural activities traditionally are seen as representing incommensurable world views and as distinct ways of knowing. On the surface, the interaction between scientists and the entertainment industry seems to conform to this generalization. There is certainly a long-standing perception among scientists and members of the entertainment industry that they represent two distinct cultures, with different languages, customs, value systems, cultural assumptions, and practices.

This conception of a cultural divide is especially true for scientists and entertainment producers who have never been involved in a working relationship. I recently gave the opening address for a meeting between scientists and entertainment producers who were trying to start an initiative furthering collaboration. At the end of the talk I reiterated two of the main conclusions for this book: that science consultants can have a positive influence on fictional texts and that scientists should respect an entertainment professional's expertise in deciding what is best for their artistic products. The discussion following this talk highlights the challenge in overcoming perceptions of an art/science divide. In their comments the scientists kept repeating "Kirby's right, science helps make films better" while the entertainment producers kept repeating "Kirby's right, filmmakers are the experts." Each group had clearly only taken away the conclusion that already matched their preconceived notions of what scientists and filmmakers offer to the creation of art.

One of the challenges is to convince the experts on each side that they have something useful to offer each other. Many scientists still hold to

what science communication scholars call the "deficit model" of popular-
ization in which scientific concepts are simplified and passed down to a
passive public, including those in the entertainment industry.[1] Scientists,
on the one hand, assume that if filmmakers contacted them for their advice
then what they do is important enough to be taken seriously. Entertain-
ment producers, on the other hand, tend to get defensive about the depic-
tion of science in cinema and television. They fall back on the artist's
imperative to "control" his or her art. Both scientists and artists are attempt-
ing to reveal truths about the world. The difficulty is in convincing them
that each does not represent a better way of uncovering the truth but a
different way.

At a basic level the interaction between scientists and filmmakers shows
that the notion C. P. Snow expressed of "Two Cultures" is an oversimpli-
fication. We cannot talk about "art" and "science" as if these are mono-
lithic entities. Movies are artistic creations but they are also created with
entertainment and commercial interests in mind. Nor is "science" defined
exclusively by scientific experiments or university research. What I find is
that once the two groups interact in a professional setting their members
realize that rather than being at odds their differences in expertise comple-
ment each other. Entertainment production does not have to be about
entertainment or science; instead, it can encompass both entertainment
and science. It is not correct to say that scientists only benefit from verisi-
militude in art. By the same token it is not fair to claim that science hinders
the artistic imperative. The relationship between science and entertain-
ment does not have to be one of animosity. Movies and television are a
major part of our culture as is the scientific enterprise. Each of these com-
munities contributes something valuable to the other and the more each
side respects the other the better our entertainment and our science will
be for it.

**Value Added: Science, Entertainment, and Scientific Expertise in
Hollywood**

Every science consultant I spoke with believed that their filmmaking
employers respected science as an activity and scientists as a group. Some
filmmakers, like James Cameron and Tom Hanks, have even become advo-
cates for science after their experiences working on science-based films.

Still, filmmakers do not bring in science consultants because they feel a duty to science or the scientific community. They do not pursue scientific verisimilitude because they believe it is the "right" thing to do or because they want to educate the public. Hollywood filmmakers bring in science consultants because they believe science and scientific thinking adds entertainment value to their texts.

Science provides both necessary constraints and flexibility in helping filmmakers utilize their own expertise as creative artists. Unlimited options can sometimes overwhelm creativity so the certainty of textbook science provides boundaries for filmmakers to work within. Scientific facts serve as the starting point for filmmakers, who then use their professional judgment to determine whether, and if so how, to alter these facts during production if adherence to accuracy conflicts with filmmaking constraints including budget, technical limitations, dramatic needs, narrative necessity, or aesthetic requirements. Filmmakers also take into account additional criteria in deciding how to deal with established facts in cinema, such as how likely it is that the general public will recognize deviations from accuracy (expert versus public science) and what to do when an established fact contradicts audience expectations (folk science). Hollywood movies are not documentaries. Science is merely a creative tool for entertainment producers. The job of a science consultant, then, is to help them use this tool.

To be successful, a modern science-based film must adhere to a sense of scientific authenticity. Yet, the production of a Hollywood film is a complicated process during which multiple actors may have competing agendas for science. Scientific accuracy becomes a flexible concept for filmmakers— a concept that is not subverted but is negotiated in the service of entertainment. Laboratory sets, for example, may have real scientific equipment that is surrounded by containers of colorful bubbling liquids, making these spaces simultaneously accurate and inaccurate. Not every choice, however, is a binary choice between accurate and inaccurate. Variability in the natural world, as well as our limited understanding of many natural phenomena, provides filmmakers with plenty of room for interpretive flexibility. Scientists tend to take a very strict view of what represents an accurate depiction of nature. In their public statements they convey an idealized description of scientific phenomena that often overlooks natural variation. Natural variability, however, provides filmmakers leeway in their cinematic

depictions. A depiction that falls within the accepted range for what is possible is still an accurate depiction of nature, even if it exists at the extreme end of this range. In this same way, filmmakers can use the lack of scientific consensus inherent in unsettled science to their advantage. In cases of science in the making, a consultant's expertise validates filmmakers' choices and uncertainty justifies artistic license. In fact, a consultant's expertise is most valuable with regard to scientific uncertainty. A scientific expert knows better than anyone else *what it is we do not know* about the natural world.

Studying scientists in Hollywood broadens our conceptions of scientific expertise by demonstrating facets that are not as evident in other public arenas such as the political and legal realms.[2] Scientific expertise in an entertainment context is not predominantly based on factual knowledge. In fact, the expertise involved in fact checking textbook science for entertainment productions can come from anyone with a good reference book or Internet access. Rather, scientific experts bring to entertainment culture their professional experiences and skills that other experts are unable to offer. At a basic level, scientists provide insight into what it means to be a scientist, including the use of jargon-laden language. Scientists' experiences also furnish them with an expertise on the visual culture of science, including an understanding of science's cryptic symbolism. Given the significance of visuals for cinema it is not surprising that filmmakers rely on scientific experts to help them design scientific spaces and technologies that are both realistic and visually interesting. Scientists also provide filmmakers with an understanding of the science/society interface, including what it means to discuss science with those outside of the scientific community. Although these areas of expertise might seem trivial only those who practice science on a daily basis can speak about them accurately.

Scientists also contribute an expertise of logic that helps filmmakers create more believable narratives. Seeking to make fantastical situations believable, however, is not the same as requiring realism. Entertainment texts create their own reality with their own set of internal rules. Scientists' expertise in logical thinking helps filmmakers maintain consistency within these fictional worlds. By imposing order within fictional narratives, scientific frameworks impart a sense of possibility for speculative scenarios and fantastical situations. Nothing is plausible in a fictional world in which

anything is possible. Scientific thinking provides boundaries that limit a fictional world's possibilities, but it also means that scientific experts can provide filmmakers with justifications as to why specific events within that world *might* be possible. Scientific experts' explanatory skills, culture of objectivity, and logical methodology, when matched with filmmakers' own narrative abilities, contribute a great deal to an audience's willing suspension of disbelief.

A common public perception of the scientific process is that it is devoid of creativity or that creativity hinders a practice built around objectivity. Yet, studies of scientific activity show that it is an incredibly creative process.[3] Scientists must draw together and identify connections between disparate strands of knowledge in their work. They condense the hetero-geneity of scientific thought into a single coherent narrative. They also routinely engage in speculation, a process that forms a significant compo-nent in any formal scientific paper. Hypothesis formation, modeling, and experimental design are scientific activities that require creative thinking. Scientists focus on questions of "how?" which is useful for filmmakers in setting constraints. But, scientists also consistently ask the more artistically inclined questions of "why?" and "what if?" Scientists, like artists, are trying to create narrative explanations about the world. Speculation, syn-thesis, integration, and problem solving are all creative skills that filmmak-ers rely upon when they bring scientific experts into productions. These abilities complement scientists' expertise of logic, allowing them to add plausibility to a film's narrative, speculative scenarios, and fantastical situations.

Is It Worth It? The Importance of Scientific Authenticity for Filmmakers

Contemporary filmmaking practices now emphasize realism, whether visual, dramatic, or scientific, in every genre from fantasy to drama. Science consultants' expertise clearly provides dividends for a film production in terms of adding realism and enhancing plausibility. However, it is difficult to objectively measure precisely how consultants contribute to the "success" of the final product. From a studio's perspective the only objective mea-sures for a film's success are box office take and, to a lesser degree, critical reception. The problem with judging science consultants' value based on these measures is that it is not clear what role scientific authenticity plays

in either a film's financial success or in film reviews. The scientifically ludicrous *Armageddon* (1998) certainly had a higher box office total than the more scientifically accurate NEO film *Deep Impact* (1998). Would *Deep Impact* have made more money if it had jettisoned its science consultants? Would *Armageddon* have made less money if it had adhered more closely to scientific authenticity?

It is impossible, of course, to answer these questions given how many other factors determine a film's box office success and critical reception. *Deep Impact* was a serious film focusing on character development whose main star power came from dramatic actor Robert Duvall. *Armageddon* was directed by the master of blockbuster action films Michael Bay and starred reliable action hero Bruce Willis. *Armageddon* also had a much larger budget than *Deep Impact* as well as access to the Disney publicity machine. Given these other factors, the role of scientific accuracy in the success of these films becomes debatable. Each production made decisions about the importance of scientific accuracy in relation to other cinematic concerns. Despite conjectures as to whether they would have made more or less money if the filmmakers had made different decisions about levels of scientific accuracy, the fact that both films were profitable given their relative production and promotional costs indicates that their filmmakers made a successful calculation about how best to employ science consultants.

At a minimum, science consultants are good publicity investments. NASA's involvement in *Armageddon* is one of the most overt examples of how association with a prestigious scientific organization adds publicity value. Regardless of how much NASA's involvement imbued *Armageddon* with authenticity, the agency's public endorsement—its stamp of approval on the cinematic science—legitimized the film's narrative and depictions of space travel. In addition to enhancing the believability of speculative scenarios, the presence of science consultants enables films to avoid negative publicity from within the scientific community by helping filmmakers identify and rectify the most egregious scientific errors.

There is evidence throughout this book that science consultants are becoming a more significant presence within film productions. The growth of the National Academy of Sciences' (NAS) Science & Entertainment Exchange program and the development of the National Science Foundation's Creative Science Studio collaboration with the University of South-

ern California's School for the Cinematic Arts will increase scientists' involvement in the filmmaking process even more as these institutions lend their organizational prestige to this activity. The reasons for consultants' increased influence can also be traced to technological changes in modes of film production, promotion, and distribution. The development of CGI and other special effects technologies have put a premium on visual realism that has transferred to other categories of realism including dramatic and scientific realism. Just as the emergence of television in the 1950s put pressure on the movie industry to evolve its production and promotional strategies, the expanding number of television networks throughout the 1990s and 2000s—as well as the development of other entertainment technologies such as computer games and the Internet—has forced filmmakers to come up with novel ways to bring in audiences including an emphasis on scientific authenticity. In addition, competition with television for a shared, and shrinking, consumer base has meant that filmmakers are less likely to risk alienating audiences by producing films with plausibility issues.

Science consultants are also becoming a selling point in this new era of film distribution via DVDs. Scientists have become regular contributors on the various "Making of" and "Behind the Scenes" features on DVDs. In fact, the NAS envisions DVD extra features as a major source for outreach activities. With Warner Brothers' assistance Jim Kakalios made a professional-quality video explaining the science of *Watchmen* (2009), which he released on the video sharing Web site YouTube. This increased his public outreach potential tremendously. Kakalios said, "I could teach a 1,000 students a year for a 1,000 years and I still would not reach the 1.5 million people my YouTube video did." It behooves the makers of any science-intensive film to feature science consultants in these glimpses behind the curtain. Filmmakers can even use DVD extras to disseminate aspects of a scientific backstory they were not able to include in the finished film, as was the case on the *Watchmen* DVD.

A better way to establish the value of science consultants to a production may be to examine the success of films that did not employ, or cursorily employed, science consultants. Such films are not easy to identify given the informality of many consulting arrangements. Films that may not appear to have employed science consultants could have used them

Figure 10.1
The Sixth Day's failure at the box office can partially be attributed to its absurd cloning depictions.

on an informal basis. There is evidence for *The Sixth Day* (2000), however, that scientists did not have a very substantial role in the film's production. According to the film's director, scientists did nothing more than read the script and help design lab spaces.[4] The lack of scientific input on the film is evident in the film's cloning scenario, which features instantaneously grown human clones that retain their memories (figure 10.1). Such a ludicrous scientific foundation did not work in the film's favor. Not only did *The Sixth Day* receive brutal reviews in scientific publications, it was a critical and box office failure.

More scientific advice might not have helped *The Sixth Day* either critically or financially, but it certainly would not have hurt. Scientific experts could easily have improved the film's plausibility at little cost to the studio in terms of time or money. Even the scientifically maligned *Armageddon* employed a host of science consultants including some from NASA to help the filmmakers generate plausibility for the film's space mission and technologies. It is clear that filmmakers are taking a risk if they do not consult with scientific experts. A studio never knows when a perception of implausibility or inaccuracy will sink a film's box office potential. Scientific realism may or may not equal box office success, but implausibility certainly does not. Science consultants are a low-risk, low-cost investment that could yield box office and critical rewards when they complement filmmakers' own expertise.

Choosing the Important Battles: Scientific Accuracy and the Cultural Meanings of Science

Almost every scientist with whom I spoke enjoyed his or her experiences working within Hollywood. They appreciated an opportunity to use their expertise in a context removed from the world of laboratories or field sites. Scientists may choose to consult on popular films for reasons unrelated to their science, but their contributions to films serve as communicative actions. What this book establishes is that science consulting is a process of *communication* that is received by both the public and other scientists. It may be surprising to learn that American and British politicians used films like *Armageddon* and *Deep Impact* in formal policy debates or that scientists respond to scientific depictions they disagree with, as in the *Jurassic Park* (1993, 1995, 2001) films, through both informal and technical communicative channels. Movies *can* have an impact on science whether it involves influencing policy debates, shifting public attitudes to science, or producing public knowledge through contributions to the cultural meanings of science.

Science consulting demonstrates how extensive the avenues for science communication run. However, the backstage nature of this decision-making process has rendered science consulting a hidden aspect of scientific culture. Entertainment media serve as vehicles for communicating science because the presence of science consultants within the production process influences filmmakers' choices. There are concrete examples throughout this book showing how scientists' advice significantly shaped cinematic depictions and narratives, such as Jack Horner's input concerning dinosaur evolution in *Jurassic Park*, Michael Molitor's science policy advice for *The Day After Tomorrow*, and Brian Cox's discussions with the director, screenwriter, and actors about science and religion for *Sunshine* (2007).

Entertainment products may serve as an alternative, informal mode of communication, but we should not confuse alternative and informal with insignificant. Film's reality effect renders scientific representations plausible because it naturalizes images and events within the fictionalized world. Cinema is a powerful medium of communication because its reality effect provides it with a capacity to serve as a virtual witnessing technology. The more cinematic technologies advance, the better cinema becomes in serving as a virtual witnessing technology. Advances in special effects have

certainly created perceptually realistic images, but cinema's reality effect is imparted through the totality of the cinematic construct. Most importantly, perceptually realistic images are not extraneous features in a film. They are integrated within narratives and treated as a "natural" aspect of the landscape by characters. This cinematic naturalization can have an important influence over audiences' perceptions of science and the natural world by legitimizing scientific depictions. The naturalization of scientific images and scenarios in cinema poses a problem because cinema's reality effect naturalizes both accurate and inaccurate science. This is why individuals involved in fringe sciences like cryptozoology, UFOlogy, and parapsychology have jumped at the chance to consult on films such as *Close Encounters of the Third Kind* (1977), *Altered States* (1980), *Mindbender* (1985), and *White Noise* (2005) (figure 10.2).

Cinema's naturalization of scientific depictions is particularly important because science in cinema rarely exists as a solitary entity. One need only look at *Jurassic Park* in its incarnations in novels, films, comic books, and computer games as well as its incorporation into television documentaries and news articles to see the high degree of intertexuality in science-based media. Cinematic science also travels on the coattails of the Hollywood PR machine. Movie publicity campaigns further disseminate cinematic science on late night television talk show programs, in commercials, on poster advertisements, and through DVD distribution. Movie science can take on a life of its own outside the confines of the screen.

For the scientific community, cooperation with filmmakers places one of their members in a situation to significantly transform one of science's main cultural bogeymen: movie science. For those who ascribe to the deficit model of science popularization the naturalization of film images is a dangerous aspect of cinematic science. If your only concern with cinematic science is its impact on science literacy, however, you are fighting a losing battle. The presence of scientists in the production process vastly increases the chances that a film will contain a higher percentage of accurate science. Yet, there is no possibility of a fictional film entirely conforming to scientific accuracy because of filmmaking constraints.

Entertainment media *can* significantly influence public discourse regarding science if we look beyond simplistic notions of science literacy and consider cinema's impact on the cultural meanings of science. It is not the

(a)

(b)

Figure 10.2
Cinema's naturalizing lens benefits the presentation of paranormal science in films such as *Close Encounters of the Third Kind* (a) and *White Noise* (b).

facts themselves but the impact of these facts on perceptions of science that matter for the scientific community. Cinematic images carry a cultural currency that both reflects and impacts public attitudes toward the scientific enterprise. Cinema interacts with other mass media and with formal scientific discourse to create a technoscientific imaginary that impacts what science means to the public. Cinematic images and narratives can have an impact on the public's conceptions of science by provoking reactions, from encouraging enthusiasm for the scientific endeavor to instilling fear about science and technology, and often both. Scientists on the set

can help filmmakers craft images and narratives that convey the excitement of scientific research or communicate a sense of awe about the natural world.

Scientists and scientific organizations concerned with science literacy need to focus less on cataloging every factual inaccuracy within a film and more on those inaccuracies that impact our cultural meanings of science. They need to recognize that some scientific facts are more significant than others in shaping our perceptions of science. Based on what we know from the fossil record the representation of *Dilophosaurus* in *Jurassic Park* was completely inaccurate. It was too small, had a neck frill, and there is no evidence that the species could spit venom. Does this inaccuracy matter in terms of the public discourse about science? Certainly, people walking out of the theater will have an inadequate understanding of this particular animal, but that is the extent of the damage. The far greater impact *Jurassic Park* had on scientific culture came instead from the film's depictions of scientists as heroic figures, paleontology as an exciting career, and genetic engineering as a potentially dangerous scientific endeavor, as well as the film's conceptions of bird evolution. All these depictions contextualize science as an activity and the interplay between science and society.

Although film studios have no obligation to adhere to factual accuracy, they are sensitive to negative publicity coming from the scientific community. Studios spend enormous amounts of time, money, and resources imbuing their films with a sense of scientific "realism" and promoting their "authenticity." It does not benefit them to have this illusion questioned by a community whose support they would appreciate in selling their films. Studios, however, easily shrug off complaints from the scientific community that are pedantic in nature. They expect these types of analyses and often refer to them as "exercises in nitpicking." Critiques of cinematic science dilute their efficacy when they identify every minor factual inaccuracy.

Scientific criticisms of films are most effective when they focus on factual inaccuracies that potentially have significant ramifications on public beliefs about science or the natural world. The depiction of a nuclear meltdown in *K-19: The Widowmaker* (2003), for example, is misleading in a way that alters the meaning of nuclear science in society. As science consultant Daniel Kubat told the filmmakers, meltdowns in nuclear reactors do not lead to thermonuclear explosions. Yet, crucial dialogue in the

film posits this as true and the plot hinges on this idea. This is a problem for those advocating nuclear energy because it reinforces a common misperception about the danger of nuclear power plants. Scientific criticisms that provide alternatives for how a film could have retained accuracy and maintained its entertainment value are even more effective.

Not every consultant experiences a satisfactory consulting experience. Consultants who felt strongly enough that a film's misrepresentations would harm their research area's scientific image have even pulled out of productions and/or publicly spoken out against a film as Jack Horner did when he objected to the idea of talking dinosaurs with lips in the Disney film *Dinosaur* (2000). IBM famously removed its support for and the use of its logo in *2001* when it realized that the computer was going to murder the human crew and that the letters in HAL were each one letter removed from IBM.[5] Pulling out of a production is not the only option for science consultants who become disenchanted with a film production's approach to significant scientific representations. Computer scientist Jaron Lanier, for example, contributed as part of *Minority Report*'s (2002) think tank. When the film came out, however, he was so unhappy with the film's dystopic depiction of technological development that portrayed an antagonistic relationship between people and technology that he undertook a personal media campaign to protest the film (figure 10.3).[6] Although it may seem disloyal for science consultants to speak out against a film they worked on, it is important to remember that just as filmmakers have no obligation to the scientific community, scientists have no duty to support

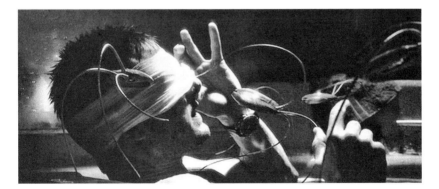

Figure 10.3
Eye-scanning robots in *Minority Report* depict a negative relationship between people and technology.

entertainment producers. Even if they risk the wrath of Hollywood studios, scientists better serve the scientific community by speaking out against films they worked on that disseminate dangerous or misleading depictions than they do by remaining silent.

Message Received: Cinema and Scientific Discourse

Despite filmmakers' flexible interpretations of accuracy, most science consultants are not unhappy with their film work. In fact, many find consulting to be a great opportunity to popularize science by contextualizing scientific activity in film narratives. Scientists working on entertainment products are able to shape science's institutional identity. Consultants can help create images that cultivate a positive view of the scientific endeavor and their presence can prevent stereotypical depictions of scientists and scientific spaces. Control of an organization's cultural identity can be a prime motivator for collaborating with the entertainment industry. Popular films often depict a scientific institution's or a research field's public identity in ways that do not fit its self-image. The best way to avoid being in a reactionary position with regard to cinematic representations is to become involved in the production of the film from the beginning. NASA's involvement in film productions, for example, is a beneficial arrangement for both parties. Studios receive credibility from NASA's stamp of approval, while the scientific organization is able to showcase its technological and scientific relevance in high-profile movies. Without NASA's involvement, the makers of *Armageddon* would not have been able to position a camera on the launch pad during a real shuttle takeoff.[7] But without *Armageddon's* glowing depiction of NASA, the organization might not have received the funding it required for its NEO detection mission. In a sense, NASA is "selling out" by lending its scientific credibility to Hollywood's promotional juggernaut. For an organization that constantly has to justify its existence to the American public, however, the cultural stakes are too high for NASA not to participate in entertainment productions.

Scientists who consult on fictional films are engaged in a mode of popularization that has a unique capacity to function as a promotional activity. By helping craft scientific images in high-profile Hollywood films, scientific organizations and individual science consultants can focus the public's attention on a particular scientific issue, especially if they perceive that an

issue poses an imminent threat to humanity. Scientists increase the rhetorical power of a film's message not only by helping construct more realistic depictions but also by adding political and social contexts. Scientific disaster films scare audiences with visions of future calamities, but they also provide narratives for how political and scientific actions can prevent these disasters. These films also interact with other popular texts and formal scientific discourse in what Heather Schell calls "genre interpenetration."[8] Genre interpenetration was clearly evident in the case of *Outbreak* (1995) as popular science texts, documentaries, political treatises, and scientific works all borrowed imagery and narratives from the film. News media incorporated the film's images and narratives in their coverage of a real-life outbreak of Ebola in Zaire that occurred while the film was in theaters in the United States and Europe.[9]

Overall, what consultants find is that popularization through fictional films allows them to effectively communicate their scientific ideas and conceptions to the nonspecialist audience. The presentation of science within the cinematic framework can convince the public of the validity of ideas and create public excitement about research agendas or nascent technologies. Fiction's lack of constraints and filmmakers' creative assistance provides an open, "free" space to put forward speculative conceptualizations; it also embeds these speculations within a narrative that treats these ideas as already actualized within a social context. This freedom allows science consultants to treat cinema as a sophisticated modeling space. The cinematic modeling space allows scientists to create diegetic prototypes that foster a public desire for technological developments. Roughly every twenty years since 1929's *Woman in the Moon*, for example, a highly authentic space travel film has emerged in theaters (*Destination Moon* in 1950, *2001* in 1968, and *Apollo 13* in 1995) and has energized the public with the possibilities of space travel while succeeding at the box office.

Science consulting in Hollywood also shows that the battleground over scientific ideas is not limited to scientific meetings and publications, or even to traditional popularizing realms such as documentaries and newspapers. Scientific speculation in cinema plays a role in knowledge production. Filmmakers frequently ask science consultants to provide advice on phenomena when scientists do not yet agree on what best represents an established "correct" explanation. Yet, a film can only show a single

explanation as representing natural law in the context of the narrative. Essentially, the naturalizing lens of the cinema removes all discourse and forces closure on scientific disputes. Scientists understand that it is a rhetorical advantage to have their position on a scientific debate naturalized on the screen. This is why a science consultant who is an internal participant within these debates will lobby very hard for cinematic incorporation of the particular scientific explanation that the consultant supports.

While consulting on a film is not a guarantee that a scientist's side of a dispute will appear on the movie screen, it increases the likelihood. As paleontologist Jack Horner can attest, the chances of your hypotheses making it into a film are much greater when you act as the consultant. Horner describes a scene in *The Lost World: Jurassic Park* in which a paleontologist who "bears a striking resemblance to a guy [Robert Bakker] who argues with me a lot" about dinosaur paleobiology gets eaten by a *T. rex* near the beginning of the film.[10] Although he was referring to this scene, Horner could just as easily have been talking about scientific disputes when he said, "If you are ever arguing with someone, don't let them be the advisor on a movie." The significance of scientists in Hollywood, then, is that their involvement transforms cinema into an act of communication received by both the scientific community and the public. Consultants assist filmmakers with scientific narratives and visualizations that add meaning and value to the construction of ideas and to our perceptions of science as an activity.

Notes

The following archive materials, which the author used extensively in preparing this book, are referred to in abbreviated form, by name only, in the chapter notes that follow: **Robert A. and Virginia Heinlein Archives**, University of California, Santa Cruz, Special Collections; **George Pal Papers**, University of California, Los Angeles, Arts Library Special Collections; **Samuel Herrick Collection**, Archives of American Aerospace Exploration, Virginia Polytechnic Institute and State University (Virginia Tech), Blacksburg, VA; **Warner Brothers Pictures Archive**, University of Southern California, Los Angeles; **Willy Ley Papers**, Smithsonian Institution Archives, Washington, DC; and the **Eric Burgess Papers**, Manchester, UK.

Preface

1. All information and quotes concerning Wayne Grody come from an interview by David Kirby, March 30, 2005.

2. This meeting for *Life Goes On* was unusual enough that famed *Variety* gossip columnist Army Archerd mentioned it in his "Just For Variety" column. A. Archerd, "'Life' Character Goes from HIV to AIDS," *Variety* (December 2, 1992): 10.

3. Grody's concern about the show's potential negative impact on AIDS patients' behavior had merit. While there were no audience reception studies of *Life Goes On*, subsequent research on media effects has consistently demonstrated television programs' effectiveness in changing behavior regarding public health. See A. Singhal, M. Cody, E. M. Rogers, and M. Sabido, ed., *Entertainment-Education and Social Change* (Mahweh, NJ: Lawrence Erlbaum, 2004); and L. Henderson, *Social Issues in Television Fiction* (Edinburgh: Edinburgh University Press, 2007).

4. For a review of work on science in entertainment media see D. A. Kirby, "Cinematic Science: The Public Communication of Science and Technology in Popular Film," *Handbook of Public Communication of Science and Technology*, ed. B. Trench and M. Bucchi (New York: Routledge, 2008), 67–94.

Chapter 1

1. S. Borenstein, "NASA Lost Moon Footage, but Hollywood Restores It," *U.S. News & World Report* (July 17, 2009), retrieved March 8, 2010 from www.usnews.com/articles/science/2009/07/17/nasa-lost-moon-footage-but-hollywood-restores-it.html.

2. See, for example, G. Wisnewski, *One Small Step?* (Clearview Books: East Sussex, UK, 2007).

3. R. Kolker, "Introduction," in *Stanley Kubrick's 2001: A Space Odyssey*, ed. R. Kolker (New York: Oxford University Press, 2006), 3, 5.

4. A partial listing of individuals and organizations who advised on *2001* is found in J. Agel, ed., *The Making of Kubrick's 2001* (New York: Signet, 1970), 321–324.

5. P. Bizony, "Shipbuilding," in *The Making of 2001: A Space Odyssey*, ed. S. Schwam (New York: Modern Library, 2000), 44.

6. F. I. Ordway, "*2001: A Space Odyssey* in Retrospect," (1982), retrieved March 8, 2010 from www.visual-memory.co.uk/amk/doc/0075.html.

7. A. C. Clarke, "Christmas, Shepperton," in Schwam, note 5, 41.

8. Ibid., 37.

9. Quoted in J. Agel, note 4, 247.

10. See Bizony, note 5, 53.

11. See Schwam, note 5, 248.

12. J. Hagerty, "*2001*: A Space Science Odyssey," *Filmfax* 85 (June/July, 2001): 38–45, 84.

13. Ordway, note 6.

14. O. G. Mitchell, "Human Hibernation and Space Travel," in *Advances in Space Science and Technology*, ed. F. I. Ordway (New York: Academic Press, 1972), 249.

15. R. Kolker, *A Cinema of Loneliness* (New York: Oxford University Press, 1988), 79.

16. See H. E. McCurdy, *Space and the American Imagination* (Washington, DC: Smithsonian Institution Press, 1997).

17. L. Trilling, *Sincerity and Authenticity* (Cambridge, MA: Harvard University Press, 1972).

18. All information and quotes concerning John Underkoffler come from an interview by David Kirby, March 25, 2005.

19. All information and quotes concerning Carolyn Porco come from an interview by David Kirby, August 26, 2009.

20. For example, see G. Hoppenstand, "The Relationship Between Film Content and Economic Factors," in *The Motion Picture Mega-Industry*, ed. B. R. Litman (Boston: Allyn and Bacon, 1998), 222.

21. Unless otherwise noted, all information and quotes concerning Donna Cline come from an interview by David Kirby, March 30, 2005.

22. Unless otherwise noted, all information and quotes concerning Dave Bayer come from an email from Dave Bayer to David Kirby, August 7, 2008.

23. A. McDowell, "Notes Following the Science in Hollywood: Content and Communication Meeting," January 11, 2003, cba.mit.edu/events/03.01.NAS/McDowell .html.

24. All information and quotes concerning Richard Terrile come from an interview by David Kirby, March 22, 2005.

25. On the relationship between cinema and scientific practice see L. Cartwright, *Screening the Body* (Minneapolis: University of Minnesota Press, 1995).

26. See A. Irwin and M. Michael, *Science, Social Theory and Public Knowledge* (Maidenhead, UK: Open University Press, 2003).

27. A. Irwin, *Citizen Science* (London: Routledge, 1995).

28. L. E. Kay, *Who Wrote the Book of Life?* (Stanford, CA: Stanford University Press, 2000).

29. On the subject of spectacle in nineteenth-century popularizations, see I. Morus *Frankenstein's Children* (Princeton, NJ: Princeton University Press, 1998). For the media's impact on science in the cold fusion affair, see M. Bucchi, *Science and the Media* (London: Routledge, 1998).

30. See A. Desmond, *Archetypes and Ancestors* (Chicago: University Of Chicago Press, 1984).

Chapter 2

1. "'Jurassic Park' Jug Cause for Alarm," *The Cleveland Plain Dealer* (November 2, 1993): 1B.

2. This incident was so worrisome to the Thermos Company that it made stickers to cover up the warning symbols.

3. See G. Gerbner, "Science on Television: How It Affects Public Conceptions," *Issues in Science and Technology* 3, no. 3 (1987): 109–115; A. Tudor, *Monsters and Mad*

Scientists (Oxford: Basil Blackwell, 1989); and P. Weingart with C. Muhl and P. Pansegrau, "Of Power Maniacs and Unethical Geniuses: Science and Scientists in Fiction Film," *Public Understanding of Science* 12, no. 3 (2003): 279–287.

4. See Gerbner, note 3; A. Singhal, M. Cody, E. M. Rogers, and M. Sabido, ed., *Entertainment-Education and Social Change* (Mahweh, NJ: Lawrence Erlbaum, 2004); and L. Henderson, *Social Issues in Television Fiction* (Edinburgh: Edinburgh University Press, 2007).

5. S. J. Gould, *Rocks of Ages* (New York: Ballantine, 1999), 16.

6. S. Shapin and S. Schaffer, *Leviathan and the Air-Pump: Hobbes, Boyle, and the Experimental Life* (Princeton, NJ: Princeton University Press, 1985).

7. Ibid., 60.

8. S. Shapin, "Pump and Circumstance: Robert Boyle's Literary Technology," *Social Studies of Science* 14, no. 4 (1984): 481–552, 508.

9. D. Gooding, "'Magnetic Curves' and the Magnetic Field: Experimentation and Representation in the History of a Theory," in *The Uses of Experiment*, ed. D. Gooding, T. Pinch, and S. Schaffer (Cambridge: Cambridge University Press, 1989), 183, 202.

10. T. Gunning, "The Cinema of Attraction: Early Film, Its Spectator and the Avant-Garde," in *Early Cinema*, ed. T. Elsaesser (London: British Film Institute, 1990), 56–75.

11. See O. Gaycken, "The Sources of *The Secrets of Nature:* The Popular Science Film at Urban, 1903–1911," in *Scene-Stealing*, ed. A. Burton and L. Porter (Trowbridge, Wiltshire: Flicks Books, 2003), 36.

12. G. Mitman, *Reel Nature* (Cambridge, MA: Harvard University Press, 1999).

13. J. Hallam with M. Marshment, *Realism and Popular Cinema* (Manchester: Manchester University Press, 2000).

14. N. Carroll, *Theorizing the Moving Image* (Cambridge: Cambridge University Press, 1996), 78.

15. J. Black, *The Reality Effect* (New York: Routledge, 2002), 7. On 9/11 survivors' remembrances and cinema, see G. King, *The Spectacle of the Real* (Bristol: Intellect, 2005).

16. See D. D. Perlmutter and N. Smith Dahmen, "'(In)visible Evidence: Pictorially Enhanced Disbelief in the Apollo Moon Landings," *Visual Communication* 7, no. 2 (2008): 229–251.

17. S. Prince, "True Lies: Perceptual Realism, Digital Images, and Film Theory," *Film Quarterly* 49, no. 3 (1996): 27–37, 32.

18. Ibid., 34.

19. R. Baird, "Animalizing Jurassic Park's Dinosaurs: Blockbuster Schemata and Cross-Cultural Cognition in the Threat Scene," *Cinema Journal* 37, no. 4 (1998): 82–103.

20. Prince, note 17, 34.

21. Letter from Robert A. Heinlein to Duke Goldstone, November 30, 1949, Robert A. and Virginia Heinlein Archives.

22. "Destination Moon, Final Revised Script," October 24, 1949, George Pal Papers.

23. Quoted in *Contact* production notes (1997), Warner Brothers Pictures, Burbank, CA.

24. P. Plait, "Review of *Contact*," Philip Plait's Bad Astronomy (1997), www .badastronomy.com/bad/movies/contact.html.

25. M. Barker, *From Antz to Titanic* (London: Pluto Press, 2000), 171.

26. M. A. Shapiro and T. M. Chock, "Media Dependency and Perceived Reality of Fiction and News," Paper presented at the International Communication Association, San Francisco (1999).

27. M. Barker and K. Brooks, *Knowing Audiences* (Luton, UK: University of Luton Press, 1998).

28. K. Padian, "The Case of the Bat-Winged Pterosaur: Typological Taxonomy and the Influence of Pictorial Representation on Scientific Perception," in *Dinosaurs Past and Present, Vol. 2*, ed. E. C. Olson and S. M. Czerkas (Los Angeles: Los Angeles County Museum of Natural History, 1987), 65.

29. Ibid., 71.

30. Ibid., 76.

31. B. Lewenstein and S. Allison-Bunnell, "Creating Knowledge in Science Museums: Serving Both Public and Scientific Communities," in *Science Centers for This Century*, ed. B. Schiele and E. H. Koster (St. Foy, Quebec: Editions Multi Mondes, 2000), 185–203.

32. Unless otherwise noted, all information and quotes concerning John Horner come from an interview by David Kirby, January 30, 2003.

33. S. Hilgartner, "The Dominant View of Popularization," *Social Studies of Science* 20, no. 3 (1990): 519–539.

34. M. Bucchi, "When Scientists Turn to the Public: Alternative Routes in Science Communication," *Public Understanding of Science* 5, no. 4 (1996): 375–394, 386.

35. Quoted in D. G. Stork, "Scientist on the Set: An Interview with Marvin Minsky," in *Hal's Legacy*, ed. D. G. Stork (Cambridge, MA: MIT Press, 1997), 30.

36. P. M. Jensen, *The Cinema of Fritz Lang* (New York: A. S. Barnes, 1969).

37. M. Freeman, *How We Got to the Moon* (Washington, DC: 21st Century Science Associates, 1993), 48.

38. W. Ley, *Events in Space* (New York: David McKay, 1969), 29.

39. T. Lowe, K. Brown, S. Dessai, M. de França Doria, K. Haynes, and K. Vincent, "Does Tomorrow Ever Come? Disaster Narrative and Public Perceptions of Climate Change," *Public Understanding of Science* 15, no. 4 (2006): 435–457.

Chapter 3

1. "Phone message from Ralph Waycott, Jr., 20CF-F2," January 1951, Samuel Herrick Collection.

2. S. Herrick, "Notes on 'The Day the Earth Stood Still,' 20CF-1," February 1, 1951, Samuel Herrick Collection.

3. Quotes in this and subsequent paragraph from S. Herrick, "Financial Considerations, 20CF-F3," date unknown, Samuel Herrick Collection.

4. Interestingly, Robert Heinlein had previously rejected Herrick as a science consultant for *Destination Moon* (1950) in favor of Bonestell and Richardson because Herrick was "reputed to be red-headed and touchy." R. Heinlein, "Note to Ripper," August 30, 1948, Robert A. and Virginia Heinlein Archives.

5. All information and quotes concerning Daniel Kubat come from an interview by David Kirby, March 30, 2005.

6. Unless otherwise noted, all information and quotes concerning Alex McDowell come from an interview by David Kirby, January 17, 2005.

7. Yeah Studios, "Deep Impact Think Tank Tape," DreamWorks Viewing Copy, April 28, 1997, Pasadena, CA.

8. All information about the NAS and the Science and Entertainment Exchange comes from an interview with Jennifer Oullette, August 10, 2009.

9. All information and quotes concerning Jim Kakalios come from an interview by David Kirby, August 14, 2009.

10. This category of science consultant is discussed in greater detail in D. A. Kirby, "Hollywood Knowledge: Communication Between Scientific and Entertainment Cultures," in *Science Communication in Social Contexts: Strategies for the Future*, ed. D. Cheng, M. Claessens, T. Gascoigne, J. Metcalfe, B. Schiele, and S. Shi (New York: Springer, 2008), 165.

11. M. Hollstein, "Killer Viruses: Hollywood Gets the Facts from UH Researcher," *Ku Lama: The Newsletter of the University of Hawaii System* 1, no. 43 (1995): 1.

12. Bryce contacted members of the "Tornado Project" for recommendations. They recount the search for a consultant at www.tornadoproject.com/misc/twstr.htm, retrieved March 13, 2010.

13. Quoted in D. Bradley, "'It's the Dilithium Crystals, Captain!' Science on the Screen," *The Beagle* 110 (2001), retrieved April 8, 2010 from www.bioscience .heacademy.ac.uk/ftp/employability/hmsbeaglecareers.pdf.

14. All information and quotes concerning Bryan Butler come from an interview by David Kirby, March 17, 2005.

15. Unlike the filmmakers, Summers understood the limitations of his expertise and brought in several specialized experts over the course of his consulting work. See A. Abbott, "Science at the Movies: The Fabulous Fish Guy," *Nature* 427, no. 6976 (2004): 672–673.

16. H. Nowotny, "Dilemma of Expertise: Democratising Expertise and Socially Robust Knowledge," *Science and Public Policy* 30, no. 3 (2003): 151–156, 152.

17. All information and quotes concerning Brian Cox come from an interview by David Kirby, April 28, 2007.

18. See Warren Betts Communications' Web page at www.zoomwerks.com, retrieved March 10, 2010.

19. Unless otherwise noted, information and quotes concerning Matthew Golombek come from an interview by David Kirby, June 11, 2002.

20. C. Toumey, *Conjuring Science* (New Brunswick, NJ: Rutgers University Press, 1996).

21. Quoted in *Armageddon* production notes (1998), Touchstone Pictures, Burbank, CA.

22. T. Gitlin, *Inside Prime Time* (Berkeley: University of California Press, 2000), 248.

23. J. Golinski, *Science as Public Culture* (New York: Cambridge University Press, 1992).

24. This dialogue appears at the end of *Dante's Peak* in reference to a fictional tracking device developed by NASA.

25. On source dependence see D. Nelkin, *Selling Science* (New York: W.H. Freeman, 1995).

26. J. Turow, *Playing Doctor* (New York: Oxford University Press, 1989).

27. N. Reingold, "Metro-Goldwyn-Mayer Meets the Atom Bomb," in *Expository Science*, ed. T. Shinn and R. Whitley (Dordecht: D. Reidel, 1985), 229.

28. This and the subsequent quote come from *Mission to Mars* production notes (2000), Touchstone Pictures, Burbank, CA.

29. Quoted in S. Frank, "Reel Reality: Science Consultants in Hollywood," *Science as Culture* 12, no. 4 (2003): 427–469.

30. Ibid., 459.

31. B. V. Lewenstein, "A Survey of Activities in Public Communication of Science and Technology in the United States," in *When Science Becomes Culture*, ed. B. Schiele (Boucherville, Quebec: University of Ottawa Press, 1994), 119.

32. C. Penley, *NASA/Trek* (New York: Verso, 1997).

33. J. Dawson, "Dread Planet," *Guardian* (April 7, 2000): 10.

34. Quoted in P. Yam, "Invaders from Hollywood," *Scientific American* 282, no. 3 (2000): 62–63, 63.

35. Quoted in P. Yam, "Making a Deep Impact," *Scientific American* 278, no. 5 (1998): 22.

36. Quoted in Dawson, note 33.

37. Quoted in A. Breznican, "NASA Consultants Introduce Hollywood to the Stars," Space.com (August 7, 2000), retrieved March 10, 2010 from www.space.com/ sciencefiction/movies/cowboys_nasa_hollywood_000807_wg.html.

38. A. Wallace, "Suddenly, the Red Planet is Red Hot," *Los Angeles Times* (September 27, 1999): F1.

39. Quoted in Ibid.

40. For example, see coverage of the film at "Face" proponent Richard Hoagland's Web site: www.enterprisemission.com/MTM.htm, retrieved March 10, 2010.

41. R. Goodell, *The Visible Scientists* (Boston: Little, Brown, 1977).

42. All information and quotes concerning Bob Goldberg come from an interview by David Kirby, March 21, 2005.

43. P. King, "Step Right up and See the Science," *Los Angeles Times* (June 16, 1993): A3.

44. K. Reich, "Taking License with the Lava Movies," *Los Angeles Times* (April 22, 1997): F1.

45. See M. Andrejevic, *Reality TV* (Lanham, MD: Rowman and Littlefield, 2003).

46. Bradley, note 13.

47. T. Kissinger, *Copyrights, Contracts, Pricing & Ethical Guidelines for Dinosaur Artists and Paleontologists* (East Islip, NY: Dinosaur Society, 1996).

48. Personal communication from Gunderson to David Kirby, March 26, 2008.

49. Personal communication from Henderson to David Kirby, November 9, 2000.

50. K. M. Reese, "Illinois Chemist Snagged Briefly by Movie Industry," *Chemical & Engineering News* 75, no. 14 (1997): 80.

51. Publicity notes from *A Blind Bargain* found in P. J. Riley, *A Blind Bargain* (Galloway, NJ: Magicimage Film Books, 1988).

52. Reingold, note 27, 230–231.

53. Quoted in J. Ganahl, "'Outbreak' Exaggerates but Plague like Movie's Is Possible, Doctor Says," *Minneapolis Star Tribune* (March 30, 1995): 1E.

54. See J. Gregory and S. Miller, *Science in Public* (New York: Plenum Trade, 1998).

55. S. Henahan, "Interview with Frederick A. Murphy," *Access Excellence*, National Health Museum (1996), retrieved March 10, 2010 from www.accessexcellence.com/WN/NM/interview_murphy.html.

56. King, note 43.

57. Unless otherwise noted, all information and quotes concerning Chris Luchini come from an interview by David Kirby, March 18, 2005.

58. All information and quotes concerning Joan Horvath come from an interview by David Kirby, March 21, 2005.

Chapter 4

1. See A. Lovell and G. Sergi, *Making Films in Contemporary Hollywood* (New York: Hodder Arnold, 2005).

2. H. Blanke, "Memo to Hal Wallis, Re: Clothes of Errol Flynn" (July 14, 1936), Green Light Papers, Warner Brothers Pictures Archive.

3. C. Frayling, *Mad, Bad and Dangerous* (London: Reaktion, 2005).

4. Quoted in S. J. Goldman, "The Science of Hollywood," *Sky and Telescope* 95, no. 6 (1998): 28–31.

5. All information and quotes concerning Seth Shostak come from an interview by David Kirby, August 4, 2009.

6. H. M. Collins, *Changing Order* (London: Sage, 1985).

7. C. Foster, "Keanu, Morgan and Me: Argonne National Lab Goes to the Movies" (1996), retrieved March 10, 2010 from www.anl.gov/Media_Center/Chain_Reaction/chainandme.html.

8. Quoted in J. Ganahl, "'Outbreak' Exaggerates but Plague Like Movie's Is Possible, Doctor Says," *Minneapolis Star Tribune* (March 30, 1995): 1E.

9. Quoted in B. Simon, "Going Down," *Entertainment Today* 35, no. 13 (2003): 45.

10. All information and quotes concerning Michael Brett-Surman come from an interview by David Kirby, April 21, 2003.

11. All information and quotes concerning Pablo Hagemeyer and The Dox come from an interview by David Kirby, December 13, 2001.

12. V. Sobchack, *Screening Space* (New Brunswick, NJ: Rutgers University Press, 1997), 154.

13. C. Toumey, *Conjuring Science* (New Brunswick, NJ: Rutgers University Press, 1996).

14. Unless otherwise noted, all information and quotes concerning Josh Colwell come from an interview by David Kirby, January 10, 2003.

15. M. Willens. "A new chemistry," *Los Angeles Times* (July 2, 1997): F1.

16. Toumey, note 13.

17. M. Lynch, "The Externalized Retina: Selection and Mathematization in the Visual Documentation of Objects in the Life Sciences," in *Representation in Scientific Practice*, ed. M. Lynch and S. Woolgar (Cambridge, MA: MIT Press, 1990), 153.

18. All quotes by Dave Bayer in this paragraph come from D. Mackenzie, "Beautiful Mind's Math Guru Makes Truth = Beauty," *Science* 295, no. 5556 (2002): 789, 791.

19. "Notes on 'The Day the Earth Stood Still,' 20CF-1," February 1, 1951, Samuel Herrick Collection.

20. "Confusable symbols," date unknown, Samuel Herrick Collection.

21. R. Silverstone, "Narrative Strategies in Television Science," in *Impacts and Influences*, ed. J. Curran, A. Smith, and P. Wingate (New York: Methuen, 1987), 319.

22. Quoted in *Contact* production notes, Warner Brothers Pictures, Burbank, CA.

23. All information and quotes concerning Tom Kuiper and Linda Wald come from an interview by David Kirby, June 11, 2002.

24. Banned From the Ranch, "Twister: Computer Graphics and On-Set Playback" (1996), retrieved March 10, 2010 from www.bftr.com/Pages/projects/twister.html.

25. Banned From the Ranch, "The Relic: Computer Graphics and On-Set Playback" (1996), retrieved March 10, 2010 from www.bftr.com/Pages/projects/relic.html.

26. See D. Nelkin and M. S. Lindee, *The DNA Mystique* (New York: W. H. Freeman, 1995).

27. Argonne's financial arrangements with the studio can be found in M. Borucki, "For City, State Coffers: An Economic 'Chain Reaction,'" *Chicago Tribune* (April 6, 1996): 12.

28. "Argonne Extras Enjoy Work Despite 'Grueling' Hours," *Argonne News* (March 4, 1996), retrieved March 10, 201 from www.anl.gov/Media_Center/Chain _Reaction/chain960304.html.

29. Foster, note 7.

30. R. Mestel, "Lab Coats in Tinseltown," *New Scientist* 148, no. 2007 (1995): 28–32.

31. Silverstone, note 21, 318.

32. Quoted in Mestel, note 30, 28.

33. On the concept of the "invisible technician" see S. Shapin, "The Invisible Technician," *American Scientist* 77, no. 6 (1989): 554–563.

34. K. S. Suslick, "Sonoluminescence, Camera, Action!" *Engineering & Science* 40, no. 2 (1997): 4–5.

35. "Genetically Engineered Dinosaurs Bring Big Bucks to Hollywood," *Genetic Engineering News* (June 15, 1993): 16.

36. Banned From the Ranch, note 25.

37. Foster, note 7.

38. Suslick, note 34.

39. Quoted in Mestel, note 30, 29.

40. For example see J. Gettleman, "A Hollywood Prop Maker Gets Far-Out Assignment," *Los Angeles Times* (March 14, 1999): B1.

41. C. S. Powell, "When Worlds Collide," *Discover* (June, 1998): 32–33.

Chapter 5

1. L. Fleck, *The Genesis and Development of a Scientific Fact* (Chicago: University of Chicago Press, 1979), 112. I have folded Fleck's category of "vademecum science" (review articles) into textbook science.

2. B. Latour, *Science in Action* (Cambridge, MA: Harvard University Press, 1987).

3. Studio libraries and research departments previously served a similar function. See S. Frank, "Perceptual Reality and the Disappearing Hollywood Studio Libraries," *Historical Journal of Film, Radio and Television* 24, no. 2 (2004): 269–283.

4. A "Real Science of" analysis consists of evaluating how well fictional depictions correspond to real-world science.

5. W. Ley "Review in Retrospect," 1947, Willy Ley Papers.

6. W. Ley, "The End of the Rocket Society," *Astounding Science Fiction* 31, no. 6 (1943): 64–78, 70.

7. Ley, note 5.

8. These categories approximate Fleck's concepts of "popular science" and "esoteric science" respectively. Fleck, note 1, 112.

9. Quoted in C. A. Anderson, "Deep Impact: Filming a Cosmic Catastrophe," *The Planetary Report* 18, no. 3 (1998): 12–15, 13.

10. Interestingly, the novel mistakenly includes one in its prime number sequence. C. Sagan, *Contact* (New York: Pocket Books, 1997), 76.

11. This and subsequent quote from A. Abbott, "Science at the Movies: The Fabulous Fish Guy," *Nature* 427, no. 6976 (2004): 672–673.

12. R. A. Heinlein, "Initial Script Treatment for *Operation: Moon*," 1948, Robert A. and Virginia Heinlein Archives.

13. Producer Tom Jacobson refers to Golombek as his "look-of-Mars expert" in A. Wallace, "Suddenly, the Red Planet Is Red Hot," *Los Angeles Times* (September 27, 1999): F1.

14. Statistics on the Mars Pathfinder site can be found at A. Boyle, "Internet Users Follow Mars Missions," *MSNBC.com* (October 1997), retrieved March 11, 2010 from mars.jpl.nasa.gov/MPF/press/msnbc/index.html.

15. See *Mission to Mars* production notes, Touchstone Pictures, Burbank, CA.

16. R. A. Heinlein, "Shooting Destination Moon," in *Requiem*, ed. Y. Kondo (New York: Tom Doherty, 1992), 123.

17. Unless noted otherwise, all information and quotes concerning *Deep Impact* come from video coverage of this think tank meeting: Yeah Studios, "Deep Impact Think Tank Tape," DreamWorks Viewing Copy, April 28, 1997, Pasadena, CA.

18. See L. Daston and P. Galison, "The Image of Objectivity," *Representations* 40, no. 3 (1992): 81–128; and A. Irwin and B. Wynne, ed., *Misunderstanding Science?* (Cambridge: Cambridge University Press, 1996).

19. Quoted in S. J. Goldman, "The Science of Hollywood," *Sky and Telescope* 95, no. 6 (1998): 28–31, 30.

20. This and subsequent quote from *Armageddon* production notes, Touchstone Pictures, Burbank, CA.

21. Many UFOlogists believe the "Face's" inclusion was intentional on the part of director Brian DePalma, whose brother Bruce DePalma worked with prominent "Face" proponent Richard Hoagland. For example, see coverage of the film at The Enterprise Mission's Web site, www.enterprisemission.com/MTM.htm, Retrieved March 11, 2010.

22. Directors Ralph Zondag and Eric Leighton discuss the decision to incorporate talking dinosaurs in "Interview with Ralph Zondag & Eric Leighton," *Dinosaur Interplanetary Gazette* (May 19, 2000), retrieved March 11, 2010 from www.dinosaur.org/disneydinodirector.htm.

Chapter 6

1. For early debates about *T. rex*'s forelimb see H. F. Osborn, "Skeletal Adaptations of *Ornitholestes, Struthiomimus, Tyrannosaurs,*" *American Museum of Natural History, Bulletin XXXV* (1916), found in Black Hills Institute of Geologic Research, *Abstracts from 100 Years of Tyrannosaurs Rex Symposium* (Hall City, SD: Black Hills Museum of Natural History, 2005), 115.

2. For the history of the forelimb reconstructions of *T. rex* see J. R. Horner and D. Lessem, *The Complete T. rex* (New York: Simon & Schuster, 1993).

3. H. Nowotny, "Dilemma of Expertise: Democratising Expertise and Socially Robust Knowledge," *Science and Public Policy* 30, no. 3 (2003): 151–156, 151.

4. All quotes from Eugene Shoemaker, Caryoln Shoemaker, and Mimi Leder come from Yeah Studios, "Deep Impact Think Tank Tape," DreamWorks Viewing Copy, April 28, 1997, Pasadena, CA.

5. Ibid.

6. Ibid.

7. K. Zahnle, "Rocky Horror Picture Shows," *Nature* 394, no. 6691 (1998): 435.

8. Quoted in Anderson, "Deep Impact." For the study Luchini and Harmon were referring to, see J. K. Harmon, S. J. Ostro, L. A. M. Benner, K. D. Rosema, R. F. Jurgens, R. Winkler, D. K. Yeomans, D. Choate, R. Cormier, J. D. Giorgini, D. L. Mitchell, P. W. Chodas, R. Rose, D. Kelley, M. A. Slade, and M. L. Thomas, "Radar Detection of the Nucleus and Coma of Comet Hyakutake (C/1996 B2)," *Science* 278, no. 5345 (1997): 1921–1924.

9. Luchini quoted in Ibid.

10. H. Collins and T. Pinch, *The Golem* (Cambridge: Cambridge University Press, 1993).

11. U. Beck, *Risk Society* (London: Sage, 1992).

12. See D. Shay and J. Duncan, *The Making of Jurassic Park* (London: Boxtree Limited, 1993).

13. Horner emphasized to me that much of the film's dinosaur science was already present in Michael Crichton's book *Jurassic Park* (New York: Alfred A. Knopf, 1990), but it was clear to him that this material was derived from his writings as well as those of Bob Bakker: "Michael Crichton had clearly read my book and Bakker's book and probably a few others but the bird-dinosaur connection he certainly got. The dinosaur warm bloodedness he certainly got. The dinosaur behavior, eggs and the babies, and all that he clearly got."

14. For a summary of Jack Horner's positions on paleontological debates at the time of *Jurassic Park,* see W. F. Allman, "The Dinosaur Hunter," *U.S. News & World Report* (June 7, 1993): 62–72.

15. For an objective overview of the current state of the bird-dinosaur debate, see the online material accompanying S. F. Gilbert, *DevBio* (Sunderland, MA: Sinauer Associates, 2006), retrieved March 11, 2010 from www.devbio.com/article .php?ch=16&id=161.

16. S. Gallagher, "Maverick Dinosaur Expert Gets in His Digs in Montana," *Los Angeles Times* (November 21, 1993): A14.

17. Quoted in Shay and Duncan, note 12, 137.

18. Quoted in Ibid., 137.

19. See H. M. Collins, "Tantalus and the Aliens: Publications, Audiences and the Search for Gravitational Waves," *Social Studies of Science* 29, no. 2 (1999): 163–197.

20. Y. Bhattacharjee, "At the Movies," *Science* 299, no. 5614 (2003): 1841.

21. Herndon quoted in Ibid. Rogers's reaction to Herndon's work can be found in J. Campbell, "Scientist Validates Sci-Fi for Ottawa Screenwriter," *Ottawa Citizen* (March 13, 2003): C9.

22. D. Foster, "'Core' Producer Challenges Review," *North County Times* (April 2, 2003): 32.

23. Paramount Studios, "Movie has 'Core' of Reality," press release, March 14, 2003. The *PNAS* article mentioned in the press release can be found at J. M. Herndon, "Nuclear Georeactor Origin of Oceanic Basalt ^3He/^4He, Evidence, and Implications," *Proceedings of the National Academy of Sciences, USA* 100, no. 6 (2003): 3047–3050.

24. F. Roylance, "Sci-Fi Thriller 'The Core' Contains Grain of Truth," *Houston Chronicle* (March 27, 2003): 10.

25. C. Toumey, *Conjuring Science* (New Brunswick, NJ: Rutgers University Press, 1996). See also J. W. Dearing, "Newspaper Coverage of Maverick Science: Creating Controversy through Balancing," *Public Understanding of Science* 4, no. 4 (1995): 341–362.

26. See M. Bucchi, *Science and the Media* (London: Routledge, 1998).

27. M. Bucchi, "When Scientists Turn to the Public: Alternative Routes in Science Communication," *Public Understanding of Science* 5, no. 4 (1996): 375–394, 386.

28. This and subsequent two quotes are from T. Thieme, "Exposing *The Core*'s Soft Center: The New Film's Science Is Even More Confused than the Plot," *Popular Science* 262, no. 4 (2003): 96–97.

29. This and subsequent quote are from M. Reed, "NOF Review of *Deep Impact*" (1998), retrieved March 11, 2010 from sdbv.missouristate.edu/mreed/movies/review6.html.

30. H. Brooks, "Scientist Gives Film Passing Grade," *The Ottawa Citizen* (May 8, 1998): G3.

31. Quoted in N. Potter, "Was *T. rex* Really a Slowpoke?" ABC News (February 28, 2002), retrieved March 11, 2010 from abcnews.go.com/WNT/story?id=130462&page=1.

32. According to Jack Horner the film's depiction of extremely fast dinosaurs was not due to his input but to the filmmakers' preference for Bob Bakker's ideas on this topic.

33. S. J. Gould, "Dinomania," *New York Review* (August 12, 1993): 51–56.

34. R. J. Cano, H. N. Poinar, N. J. Pieniazek, A. Acra, and G. O. Poinar, "Amplification and Sequencing of DNA from a 120–135-Million-Year-Old Weevil," *Nature* 363, no. 6429 (1993): 536–538.

35. See B. Macintyre, "Fossil Find Brings Jurassic Park Closer," *The Times* (July 2, 1993): 16.

36. See the special features segment "Montana: Finding New Discoveries" on the DVD release of *Jurassic Park III*, Universal Home Entertainment, 2001.

37. For an example see "The Core of the Matter," *Los Angeles Times* (August 28, 2004): 20B.

38. See P. King, "Step Right up and See the Science," *Los Angeles Times* (June 16, 1993): A3.

39. National Public Radio initially raised a concern that Horner's discovery date was manipulated to coincide with the film's opening. See K. Masters, "Movie Marketers Turn to Subtle, Sophisticated Tactics," NPR (May 11, 2005), retrieved March 11, 2010 from www.npr.org/templates/story/story.php?storyId=4647581. Horner claimed he never "fudged" the discovery date, but rather let Universal Pictures decide when the findings would be made public. See "Paleontologist Responds to 'Jurassic Park' Flap," MSNBC (May 12, 2005), retrieved March 11, 2010 from www.msnbc.msn.com/id/7836311/.

40. Massimiano Bucchi refers to the bypassing of formal channels in science communication as "deviation." See Bucchi, note 26.

41. B. V. Lewenstein, "From Fax to Facts: Communication in the Cold Fusion Saga," *Social Studies of Science* 25, no. 3 (1995): 403–436.

42. K. LeBeau, "The K-T Impact Extinctions: Dust Didn't Do It," press release, Geological Society of America (January 23, 2002). The press release can be found at www.spaceref.com/news/viewpr.html?pid=7210, retrieved March 11, 2010.

43. L. Jaroff, "What Wiped Out the Dinosaurs?" *Time* (February 4, 2002): 13.

44. R. R. Thomas, *Detective Fiction and the Rise of Forensic Science* (Cambridge: Cambridge University Press, 2004).

Chapter 7

1. J. Baxter, *Science Fiction in the Cinema* (New York: Paperback Library, 1970).

2. See U. Beck, *Risk Society* (London: Sage, 1992).

3. See Anonymous, "Frohman's 'Invisible Ray' Serial Now Rapidly Nearing Completion," *Motion Picture World* 43, no. 3 (1920): 427; and P. J. Riley, *A Blind Bargain* (Galloway, NJ: Magicimage Film Books, 1988).

4. See C. G. Crisp, *The Classic French Cinema, 1930–1960* (Bloomington: Indiana University Press, 1997); and D. Crafton, *The Talkies* (New York: Charles Scribner's Sons, 1997).

5. P. Hardy, ed., *The Overlook Film Encyclopedia* (New York: Overlook Press, 1995), 62.

6. NASA's former director of media services Brian Welch quoted in the special features segment "Back to the Ranch," on the DVD release of *Space Cowboys*.

7. Fringe or pseudosciences that mainstream scientists consider "fantastical," such as cryptozoology, UFOlogy, and parapsychology, do not fall under the category of fantastic science.

8. Unless noted otherwise all information in this chapter concerning *Deep Impact* and all quotes from Eugene Shoemaker, Carolyn Shoemaker, Gerald Griffin, David Walker, Chris Luchini, Josh Colwell, Leslie Dilley, Mimi Leder, and Walter Parkes come from Yeah Studios, "Deep Impact Think Tank Tape," DreamWorks Viewing Copy, April 28, 1997, Pasadena, CA.

9. Several other consultants mentioned assisting filmmakers with lighting issues. Richard Terrile, for example, helped filmmakers in establishing the naturalistic placement of lighting sources for *2010, Solar Crisis, Solaris,* and *The Core.*

10. See D. P. Thurs, "Tiny Tech, Transcendent Tech: Nanotechnology, Science Fiction, and the Limits of Modern Science Talk," *Science Communication* 29, no. 1 (2007): 65–95.

Chapter 8

1. Quoted in J. Ganahl, "'Outbreak' Exaggerates but Plague Like Movie's Is Possible, Doctor Says," *Minneapolis Star Tribune* (March 30, 1995): 1E.

2. R. W. Lee, "Scaring Us Toward a Global Government," *The New American* 13, no. 24 (1997): 27–38.

3. S. Sontag, "The Imagination of Disaster," in *The Science Fiction Film Reader*, ed. G. Rickman (New York: Proscenium Publishers, 2004), 102.

4. Ibid., 101.

5. J. Black, *The Reality Effect* (New York: Routledge, 2002), 24.

6. D. Morrison, "Review of *Deep Impact*," Cambridge-Conference Network listserv (May 12, 1998), retrieved March 12, 2010 from abob.libs.uga.edu/bobk/ccc/cc051298.html.

7. Quoted in M. Roach, "Virus the Movie," *Health* 9 (1995): 78–84, 80.

8. Quoted in M. Hollstein, "Killer Viruses: Hollywood Gets the Facts from UH Researcher," *Ku Lama: The Newsletter of the University of Hawaii System* 1, no. 43 (1995): 1.

9. See S. Hilgartner and C. Bosk, "The Rise and Fall of Social Problems: A Public Arenas Model," *American Journal of Sociology* 94, no. 1 (1988): 53–78.

10. See J. Turow, *Playing Doctor* (New York: Oxford University Press, 1989); and M. S. Pernick, *The Black Stork* (Oxford: Oxford University Press, 1996).

11. For example see W. K. Knoedelseder and E. Farley, "When Fate Follows Fiction—The 'Syndrome' Fallout," *The Washington Post* (March 30, 1979): B1, B7.

12. "The San Jose Three," *Time* 107 (1976): 78.

13. Quoted in E. Farley and W. K. Knoedelseder, "'The China Syndrome': More than 'Just a Movie?'" *Los Angeles Times* (March 25, 1979): Cal3, 5.

14. For summaries of the real-life incidents on which the fictional events are based, see Ibid.; "Plot Was Familiar but the Movie Had a Different Ending," *The Washington Post* (May 1, 1979): C5; and R. Gillette, "'China Syndrome': Nuclear Reactions," *Los Angeles Times* (March 25, 1979): Cal1, 4.

15. Quoted in A. Harmetz, "Fallout from 'China Syndrome' Has Already Begun," *New York Times* (March 11, 1979): B1, 19.

16. V. Canby, "'China Syndrome' Is First-Rate Melodrama," *New York Times* (March 18, 1979): B19.

17. Gillette, note 14, 4.

18. Ibid., 4.

19. Quoted in Knoedelseder and Farley, note 11.

20. Quoted in M. Suryaraman, "Gregory Minor's Obituary," *San Jose Mercury News* (August 1, 1999): B7.

21. See Harmetz, note 15.

22. See Knoedelseder and Farley, note 11.

23. Young quoted in W. Knoedelseder and E. Farley, "'China Syndrome' Stirs Wave of Pro-Nuclear Protests," *Los Angeles Times* (March 25, 1979): Cal5.

24. For a review of data supporting a weakening of the ocean's thermohaline circulation, see B. Hansen, S. Oesterhus, D. Quadfasel, and W. Turell, "Already the Day After Tomorrow?" *Science* 305, no. 5686 (2004): 953–954.

25. NOAA's science communication specialist Mark McCaffrey quoted in A. Griscom, "The Day After Tomorrow Never Dies," *Grist Magazine* (June 3, 2004), retrieved March 12, 2010 from www.grist.org/news/muck/2004/06/03/griscom-NOAA/.

26. "Carbon Impacts Made Visible," editorial, *Nature* 429, no. 6987 (2004): 1.

27. S. Hajat, "The Day After Tomorrow," *British Medical Journal* 328, no. 7451 (2004): 1323.

28. Quoted in J. Vidal, "It's a Hell of a Town," *Guardian* (May 19, 2004): 14.

29. D. Suzuki, "Climate Change Movie Not Exactly Rocket Science," *CNEWS* (April 12, 2004), cnews.canoe.ca/CNEWS/Science/Suzuki/2004/04/21/431020.html.

30. Quoted in L. Stiffler, "Scientists Scoff as Climates Run Amok on Big Screen," *Seattle Post Intelligencer* (May 28, 2004): B1.

31. Quoted in M. Fyfe, "Here Comes the Tsunami," *The Age* (May 27, 2004), retrieved March 12, 2010 from www.theage.com.au/articles/2004/05/26/1085461831870. html.

32. Quoted in S. Connor, "Warming Up: The Debate over a Movie that Claims to be a Vision of the Future," *The Independent* (May 8, 2004): 3.

33. Quoted in Ibid.

34. The film's obviously anti-Bush message in a presidential election year led to allegations that the Bush administration was stifling discussion of the film by governmental scientific research institutions including NASA and NOAA. See Griscom, note 25; A. Revkin, "NASA Curbs Comments on Ice Age Disaster Movie," *New York Times* (April 25, 2004): 16; and *The Force of Destiny: The Science and Politics of Climate Change*, Twentieth Century Fox Home Entertainment (2004), directed by C. Kiselyak.

35. R. Williams, "In Conversation," ABC News Radio, May 25, 2006 interview with Michael Molitor.

36. Ibid. See also screenwriter Jeffrey Nachmanoff's comments on Michael Molitor's contributions to this scene in R. Emmerich, director, *The Day After Tomorrow* DVD release with commentary track including Nachmanoff, 20th Century Fox Home Entertainment (2004).

37. The producers admit casting the actor for his resemblance to Vice President Dick Cheney in Ibid.

38. S. Rahmstorf, "The Day After Tomorrow—Some Comments on the Movie," Potsdam Institute for Climate Research (2004), retrieved March 12, 2010 from www. pik-potsdam.de/~stefan/tdat_review.html.

39. Quoted in S. Connor, "Ice Age Movie Realistic—Britain's Chief Scientist," *The Independent* (May 13, 2004): 17.

40. F. Mellor, "Colliding Worlds: Asteroid Research and the Legitimisation of War in Space," *Social Studies of Science* 37, no. 4 (2007): 499–531.

41. "Terrific!" comes from David Morrison quoted in D. Stanley, "Earth Really Could Be a Bull's-Eye for an Asteroid," *St. Louis Post-Dispatch* (May 22, 1998): E7. "Zowie!" comes from Eleanor Helin quoted in G. C. Larson, "The Observatory," *Minneapolis Star Tribune* (July 1, 1998): 22A.

42. Quoted in M. Bay, director, *Armageddon* DVD release with commentary track featuring director of photography J. Schwartzman, NASA consultant J. Allen, and asteroid consultant I. Bekey, Touchstone Home Video (1998).

43. Ivan Bekey quoted in C. S. Powell, "When Worlds Collide," *Discover* June (1998): 32.

44. Quoted in Bay, note 42.

45. B. Nye, "Weird Science," *People* 49, no. 22 (1998): 14–15.

46. See W. F. Bottke, D. Vokrouhlický, and D. Nesvorný, "An Asteroid Breakup 160 Myr Ago as the Probable Source of the K/T Impactor," *Nature* 449, no. 7158 (2007): 48–53.

47. For example see Morrison, note 6.

48. For a review of the Marsden/XF11 episode and the role of the news media. see C. Chapman, "The Asteroid/Comet Impact Hazard," paper presented at the Workshop on Prediction in the Earth Sciences, Estes Park, CO (1998), retrieved March 12, 2010 from www.boulder.swri.edu/clark/ncar799.html.

49. See Mellor, note 40.

50. The Honorable Dana Rohrabacher, opening statement, "Asteroids: Perils and Opportunities," hearing before the House Subcommittee on Space & Aeronautics of the Committee on Science of the U.S. House of Representatives (May 21, 1998): 1–2.

51. For the German survey see F. Reusswig, J. Schwarzkopf, and P. Pohlenz, "Double Impact: The Climate Blockbuster, 'The Day After Tomorrow' and its Impact on the German Cinema Public," *PIK Report* 92 (2004), retrieved March 13, 2010 from www. pik-potsdam.de/research/publications/pikreports/.files/pr92.pdf. For the British survey see T. Lowe, K. Brown, S. Dessai, M. de França Doria, K. Haynes, and K. Vincent, "Does Tomorrow Ever Come? Disaster Narrative and Public Perceptions of Climate Change," *Public Understanding of Science* 15, no. 4 (2006): 435–457. For the U.S. survey see A. A. Leiserowitz, "Before and After *The Day After Tomorrow*: A U.S. Study of Climate Change Risk Perception," *Environment* 46, no. 9 (2004): 22–37. For a comparison of surveys see Q. Schiermeier, "Disaster Movie Highlights Transatlantic Divide," *Nature* 431, no. 7004 (2004): 4.

52. See coverage of the *20/20* episode at B. Vangilder and I. Hobbs, "Truths and Myths about Weather in Hollywood Blockbusters," ABC News online (April 18, 2008), retrieved March 12, 2010 from abcnews.go.com/Technology/story? id=4682216&page=1.

53. Jon Kyl, chairman of the United States Senate's Republican Policy Committee, sent out a letter to members urging them to make comparisons between *The Day After Tomorrow* and director Roland Emmerich's previous film *Independence Day* (1996). J. Kyl, "The Day After Tomorrow Will Look Like Today," United States Senate Republican Policy Committee (2004), retrieved March 12 2010 from kyl.senate.gov/ legis_center/rpc/rpc_060204.pdf.

54. Although the mission's scientists claim they came up with the name before the film came out, the timing of their grant submission in early 1999 suggests that the film was the genesis of their mission title.

Chapter 9

1. James Cameron's speech to the Mars Society was in Colorado in August 1999. The speech can be found at hompages.tesco.net/~sjwb/articles/cameron_mars.html, retrieved March 12, 2010.

2. See K. Jeffrey, *Machines in Our Hearts* (Baltimore: Johns Hopkins University Press, 2001).

3. J. Turney, *Frankenstein's Footsteps* (New Haven, CT: Yale University Press, 1998).

4. A. Nathoo, *Hearts Exposed* (Basingstoke, UK: Palgrave, 2009).

5. See R. Williams and D. Edge, "The Social Shaping of Technology," *Research Policy* 25, no. 6 (1996): 856–889.

6. L. Suchman, R. Trigg, and J. Blomberg, "Working Artefacts: Ethnomethods of the Prototype," *British Journal of Sociology* 53, no. 2 (2002): 163–179, 164.

7. J. Bleecker, "The Reality Effect of Technoscience," unpublished PhD dissertation, University of California–Santa Cruz (2004), vi.

8. All quotes from Brett Leonard come from an interview by David Kirby, February 8, 2009.

9. M. Wertheim, "Lawnmower Man," *Omni* 14, no. 6 (1992): 31.

10. There are several news accounts of Raytheon's acquisition of this technology. For example, see J. Karp, "'Minority Report' Inspires Technology Aimed at Military," *Wall Street Journal* (April 12, 2005): B1.

11. Press release, "Die Ufa Meldet," September 21, 1929, Willy Ley Papers.

12. W. Ley, *Rockets, Missiles, and Men in Space* (New York: Viking Press, 1968).

13. M. J. Neufeld, "Weimar Culture and Futuristic Technology: The Rocketry and Spaceflight Fad in Germany, 1923–1933," *Technology and Culture* 31, no. 4 (1990): 725–752.

14. F. H. Winter, *The Rocket Societies* (Washington, DC: Smithsonian Institution Press, 1983), 35–36.

15. This and subsequent quote appear in M. Freeman, *How We Got to the Moon* (Washington, DC: 21st Century Science Associates, 1993), 43.

16. Ley, note 12, 114–115.

17. "Ufa Programm Frau Im Mond," October 15, 1929, Willy Ley Papers.

18. W. Ley, *Rockets and Space Travel* (New York: Viking Press, 1947), 128–129.

19. W. Ley, "Frau Im Mond, A Film by Fritz Lang," date unknown, Willy Ley Papers.

20. Ley, note 18, 129.

21. Ley, note 12, 115–116.

22. Ley, note 18, 135. Ley indicates that Oberth returned to Berlin for the film's premiere.

23. Quoted in Freeman, note 15, 47.

24. Summaries of film reviews are found in E. A. Kaplan, *Fritz Lang* (Boston: G. K. Hall, 1981).

25. A. Geppert, "Flights of Fancy: Outer Space and the European Imagination, 1923–1969," in *Societal Impact of Spaceflight*, ed. J. Dick and R. D. Launius (Washington, DC: NASA History Division, 2007).

26. "2000 Ride Rocket to Moon in Museum," *New York Times* (January 28, 1931): 10.

27. Ibid.

28. On the concept of immutable mobiles see B. Latour, "Visualization and Cognition: Thinking with Eyes and Hands," *Knowledge and Society* 6 (1986): 1–40.

29. See H. E. McCurdy, *Space and the American Imagination* (Washington, DC: Smithsonian Institution Press, 1997).

30. All quotes in this and the subsequent paragraph come from R. A. Heinlein, "Critique of the James O'Hanlon Script," Memorandum from Robert A. Heinlein to producer George Pal and financier N. Peter Rathvon, September 18, 1949, Robert A. and Virginia Heinlein Archives.

31. R. A. Heinlein, "Shooting Destination Moon," in *Requiem*, ed. Y. Kondo (New York: Tom Doherty, 1992), 129.

32. R. A. Heinlein, "The Care and Feeding of Spaceships," Memorandum from Robert A. Heinlein to producer George Pal and production supervisor Martin Eisenberg, September 30, 1949, Robert A. and Virginia Heinlein Archives.

33. Heinlein, note 30.

34. R. A. Heinlein, "Initial Script Treatment for *Operation: Moon*," 1948, Robert A. and Virginia Heinlein Archives.

35. This quote and the quote in the subsequent paragraph come from Heinlein, note 30.

36. This and the subsequent quote come from Heinlein, note 32.

37. George Pal Productions, "Must America Engage in a Race to the Moon in Self-Defense?" *Facts About Destination Moon*, press kit (1950), George Pal Papers.

38. B. Crowther, "Destination Moon," *New York Times* (June 28, 1950): 32.

39. The radio adaptation was broadcast on June 24, 1950.

40. Quoted in "Russian Press Gives Space to Capt. Video," *New York Times* (February 6, 1954): 1–2.

41. H. Thompson, "Two Soviet Imports Open at Cameo," *New York Times* (June 5, 1958): 39.

42. *Mission to Mars* production notes, Touchstone Pictures, Burbank, CA.

43. Ibid.

44. M. Conklin, "In the Pulse of Mars," *Chicago Tribune* (March 16, 2000): C1, C4.

45. All quotes from Plait in this paragraph from P. Plait, "Review of *Mission to Mars*," Phil Plait's Bad Astronomy blog (2000), retrieved March 12, 2010 from www .badastronomy.com/bad/movies/m2mintro.html.

46. V. Sobchack, *Screening Space* (New Brunswick, NJ: Rutgers University Press, 1997), 69–70.

47. Ibid., 70.

48. Geppert, note 25.

49. K. W. Gatland, "History of Rocket Development: A Review of the Film Shown to Fellows of the British Interplanetary Society at the War Office, Whitehall, on July 6, 1949," *Journal of the British Interplanetary Society* 9 (1950): 64–70.

50. E. Burgess, "Paris, 1950, First International Astronautical Congress," from the "Record of the Formation and First Decade of the International Astronautical Federation and its Annual Congresses" CD, 1997, Eric Burgess Papers.

51. For example, see McCurdy, note 29.

Chapter 10

1. See M. Bucchi "Of Deficits, Deviations and Dialogues: Theories of Public Communication of Science," in *Handbook of Public Communication of Science and Technology*, ed. B. Trench and M. Bucchi (New York: Routledge, 2008): 57–76.

2. On the role of scientific expertise in policy, see S. Jasanoff, *The Fifth Branch* (Cambridge, MA: Harvard University Press, 1990). On conceptions of scientific expertise in the legal arena see M. Lynch and S. Cole, "Science and Technology Studies on Trial: Dilemmas of Expertise," *Social Studies of Science* 35, no. 2 (2005): 269–311.

3. See D. K. Simonton, *Creativity in Science* (Cambridge: Cambridge University Press, 2004).

4. See "Roger Spottiswood, 6th Day Film Director, Interviewed about Bond, Arnie and His Crazy Life in Fantasy Film Making," SFCrowsnest, (November 2000), retrieved March 13, 2010 from www.sfcrowsnest.com/articles/media/2000/Sixth-Day-Interview-5824.php.

5. See P. Bizony, "Shipbuilding," in *The Making of 2001: A Space Odyssey*, ed. S. Schwam (New York: Modern Library, 2000), 46.

6. For example, see J. Lanier, "A Minority within the Minority," *21C* (2002), retrieved March 13, 2010 from www.21cmagazine.com/minority.html.

7. Director of photography J. Schwartzman discusses this in *Armageddon* with commentary, Touchstone Pictures, 1998, directed by M. Bay.

8. See H. Schell, "Outburst! A Chilling True Story about Emerging-Virus Narratives and Pandemic Social Change," *Configurations* 5, no. 1 (1997): 93–133.

9. See K. Ostherr, *Cinematic Prophylaxis* (Durham, NC: Duke University Press, 2005).

10. This and subsequent quote found in S. Connor, "Spielberg Miscasts T-rex as the Bad Guy," *Sunday Times* (July 13, 1997): 7.

Index